SOUTHEAST LOUISIANA
FOOD

SOUTHEAST LOUISIANA
FOOD

A Seasoned Tradition

ADDIE K. MARTIN & JEREMY MARTIN

AMERICAN PALATE

Published by American Palate
A Division of The History Press
Charleston, SC 29403
www.historypress.net

Cover images: Courtesy of Louisiana Department of Wildlife and Fisheries, United States
Environmental Protection Agency, Mary Chailland and the authors.

First published 2014
Second printing 2014

ISBN 978.1.54021.049.4

Library of Congress Control Number: 2014951996

Notice: The information in this book is true and complete to the best of our knowledge. It is
offered without guarantee on the part of the author or The History Press. The author and
The History Press disclaim all liability in connection with the use of this book.

Dedicated to the many generations of fishermen and cooks in Southeast Louisiana, past, present and future.

If the Midwest is the nation's breadbasket, South Louisiana is its seafood platter.

—*Windell Curole in the film* No One Ever Went Hungry *by filmmaker Kevin McCaffrey*

CONTENTS

ACKNOWLEDGEMENTS

We're ever so grateful to all of the people who helped to make this book possible. It truly takes a village of like-minded people devoted to a common cause to make something happen.

For the professional resources, interview time, keen insights and a seemingly tireless commitment to Southeast Louisiana's fisheries, food and culture, we thank Marcelle Bienvenu, Nick Collins, Dr. Don Davis, Madeline "Maddie" Futrell, Jim Gossen, Tom Hymel, Brian Landry, Kevin McCaffrey, Mark Schexnayder, Carol and George Terrebonne and Liz Williams.

We also thank family and friends who've contributed significantly along the way. They've helped us greatly in a variety of ways, mainly via formal and informal discussions, recipe contributions, loaned photos and drawings, resources, connections and, above all, moral support and encouragement: Dr. Patricia King Bollinger, Mary Constransitch Chailland, Brent Constransitch, Chester Constransitch, Tynette Constransitch, Dionne Grayson, Jennifer Lloyd, Rahlyn Gossen, Adam Guidry, Joy King Guidry, Jesse King, Rudy King, Jason Saul and Frederick Stivers.

Finally, thanks to the important people in our lives who listened when we needed a sounding board for ideas or when we simply needed a supportive ear. Thank you to those people who knew just the right thing to say when we needed to hear it. Many thanks to those whose enthusiasm for our work seems endless. Finally, perhaps most significantly, our sincere appreciation goes to you, the reader, who cracked open a copy of this book today.

Our gratitude to you all is endless.

INTRODUCTION

A Book Is Born

The two of us are out at the camp, sitting, legs dangling over the side of the little dock, watching the setting sun turn the dull summer green of the marsh grass into something more like gold. From the camp shack behind us, a light crackling sound sure enough delivers the smell of frying fish—the day's catch cleaned and rough hewn with a fillet knife into manageable chunks and fried in a shallow cast-iron pan. Dinner will be soon, but for now, we are just sitting, watching the lazy waves of marsh grass dance and thinking, "I am from here," thinking about what it means to be from somewhere—what it means to be from Southeast Louisiana. The implications of this idea press down on us as thick as the humid air. The earth is home to a staggering diversity of life. You can sit here on this pier and watch life swim, walk and fly right past you. As life develops, though, so does culture. It evolves differently depending on varying environmental factors such that each culture inhabits its homeland uniquely. Intrigued by this, we discuss over the simple, gas-lit plank table the nature of being from Southeast Louisiana and what it means to be a part of this culture or of any culture at all.

We walk into the close, still air of the camp shed and sit around the table, where we talk with full mouths about how cultural exchanges have always

Drawing by Frederick Stivers, 2014.

occurred between wildly diverse cultures. We talk about the way it must have been centuries ago, when the peril of travel often limited cultural communication to isolated exchanges such as the trade of valuables and, of course, wars over resources. However, it's obvious that in the past three centuries, long-distance travel has become ever more accessible, and this easing of geographic boundaries has led to the creation of diverse melting-pot nations such as the United States. The United States is home to representatives of almost every cultural group in existence. Some of these groups can be found in urban enclaves, others in rural settings that are similar to their homelands and many are scattered across the nation, contributing their own unique traditions to the rich fabric of American culture. Today, the well-known immigrant centers of the urban Northeast, West Coast and, increasingly, the southern border have been shaped not only by their environments but also by the people who have decided to call them home. However, centers of immigration change with trade patterns and shifts in population and political priorities. At various times in its history, Southeast Louisiana, too, has seen its share of immigration. Prior to the Civil War, New Orleans was the second-largest immigration port in America behind New York City. From the well-known influx of

French Acadians to other Europeans to Southeast Asians and now Central Americans, the ports of Southeast Louisiana have been as heavily shaped by immigration as any other part of the country.

All we have to do is look at the map of the region, hanging water-stained by hurricanes on the wall, to realize that Southeast Louisiana is nothing more than a giant port, directly connected by water to a basin, which drains 1.25 million square miles of North America.[1] The interior of North America was created by sediment carried by the Mississippi River and cannot be accessed by water without passing through Southeast Louisiana. The region has been shaped by the river, the wetlands the river creates and the cultures of the immigrants who have come to make a living. These cultures were attracted by the bounty of southeastern Louisiana's vast wetland delta, which provides home for all manner of aquatic (and aerial and terrestrial) wildlife. It is the same reason that many people, including us, live here today. It is why we're out here in the dying summer light amidst the snow-like quiet of the marsh. The bounty of this place is what feeds us around this table tonight, the same way it has fed nine generations or more of Louisianians just like us.

We are quite familiar with the fact that one of the biggest facets of any culture—especially ours—is its food: what people eat, how they cook, how they grow or raise it, what they do when they eat. In Southeast Louisiana, a number of regional foods contribute to the vibrant and distinct culture. These food cultures, or *foodways*, are centered on the thin strips of high ground that texture the Mississippi River Delta. Modern Cajun fare is an invention and byproduct of the twentieth century. Two centuries of culinary evolution created this cuisine via the melding and influence of many cultures and cuisine types.[2] These foods are predominantly harvested wild from the shallow marsh waters and offshore in the Gulf of Mexico. Encompassing oysters, crabs, crawfish, shrimp and finfish, each of these foods is reflected not only in the region's dishes but also in the social fabric of cultures as varied as French, German, Spanish and American Indian. These food commodities become cultural artifacts themselves and provide a lens we can peer through to understand the development of various groups of peoples whose comparative isolation in the delta has allowed the parallel development of cultures from each other and the United States as a whole.

As modern forces like communication, development and infrastructure begin to connect and change previously insular communities, these foodways are in danger of being subsumed into the larger national

culture. Foods that were integral to Southeast Louisiana culture have been commoditized in recent years, and now their Louisianian producers compete on a global scale for consumers, forcing many workers in the harvesting industries into a no-win race to the bottom with overseas producers. Southeast Louisiana food-gathering practices, foodways and cultures are undoubtedly becoming less important to the communities; their fundamental character is changing into an echo of what they once were. We know that the people and cultures of Southeast Louisiana have always been highly adaptable and incredibly resilient, and while in some cases, this means the adoption of foreign cultures, it also means the creative preservation of cultural-touchstone foodways.

We look at what's left of our fried fish, the empty oyster shells on the floor of the camp and the empty beers and realize what it means to be from here, Southeast Louisiana—an ideal case study in cultural change and adaptation, as measured by the food on our plates.

We clean the dishes in the little gravity-cistern sink and take out the trash. We try to have a fire, but the mosquitoes chase us inside before we can even question the need for a fire on a summer night. Instead, we open the doors and shut the screens, turn the gaslight down so it won't attract bugs and keep talking. We talk about how we could never in a lifetime learn everything about just this one place, what made the people who they were, why and where they worked and what they ate.

"It's a fascinating subject," I say.

"Someone should write a book about it," she says.

The Land

To properly understand the people and the culture of Southeast Louisiana, one must first have a grasp of the geography on which all this has transpired and continues to unfold. Generally speaking, Southeast Louisiana is a vast and ill-defined region of basins that drain slowly through the marsh as the grass dissolves into the Gulf of Mexico. Bounded on all sides by water, the only border that has a defined shape is the Mississippi River to the north. What's most amazing is that the course of the Mississippi has only been made permanent and fixed since the early twentieth century via modern engineering. The remaining borders of the region—the verdant swamps and floodplain between the

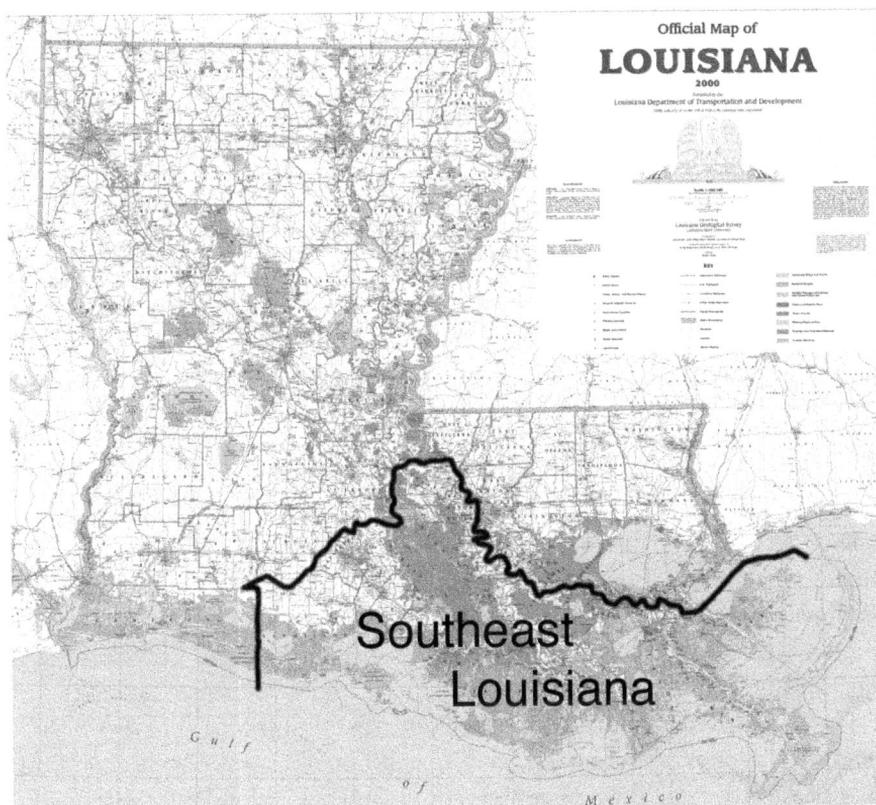

A map of the state of Louisiana with the Southeast region noted. *Courtesy of Louisiana Department of Transportation and Development, 2000.*

Vermilion Bay and the Atchafalaya Basin to the west and the seemingly endless stretches of marshland to the south and east—fade gently from land to swamp to marsh, past sandy barrier islands and finally into open water. This region encompasses a variety of agriculture and wildlife that has supported its residents for centuries. The constant presence of water defines much of the geography, economy and culture of the people who live within its reach.

The source of all water in Southeast Louisiana is rain, whether it comes down the river or falls in the region itself. This is no small amount—about sixty-three inches per year; after all, Southeast Louisiana has a coastal, subtropical climate defined by heat, humidity and rain.[3] The average high temperature during the summer is in the low nineties Fahrenheit (thirties

Celsius) with matching humidity, while the average low temperature in the winter is in the cool forties Fahrenheit (zero Celsius) range.[4] The long-lasting heat and humidity, while unpleasant, have their benefits: the growing season in the region is year-round. Even in the winter months, crops can be found throughout southeastern Louisiana. The alluvial soil is rich in nutrients, and the sun is high off the horizon year-round.

Globally, most land drains into a river, and in North America, odds are that river is going to be the Mississippi River. More than any other region along the mighty river's banks, Southeast Louisiana's geography is the most influenced by the Mississippi River, which created the land itself by depositing sediment from the North American interior into the Gulf of Mexico over thousands of years. While the current channel of the Mississippi River is maintained through a system of levees and spillways, historically, particularly on a geologic timescale, the river was notoriously fickle, creating swaths of rich, black land in lobes as it snaked through the low marshland it created.[5] The periodic flooding and receding of the river and its distributaries created ridges, or natural levees, strung across the marshes along the banks of countless lazy bayous and slow eddies in the continent's draining current.

However, the land is so low in Southeast Louisiana that it doesn't all drain to the Mississippi River. Instead, the copious rain that falls on this subtropical delta drains through one of six basins that slowly creep water into the Gulf: Atchafalaya, Terrebonne, Barataria, Breton Sound, Mississippi Delta and Pontchartrain. It's in these basins that Louisiana's famed swamps choke the waters with all manner of flora and fauna—great cypress trees and ancient alligators, birds, fish and crawfish. Louisiana's coastal zone is an expansive and prolific estuary that encompasses 40 percent of this country's coastal wetlands and 25 percent of the nation's total wetland area.[6] It's at the borders of these verdant swamps and wetlands where salt water and fresh water mingle that the marsh runs off into the horizon carrying bays of redfish, trout, ducks and oysters. Just over the horizon awaits all the bounty, all the shrimp and all the fish of the ocean.

Without people, this bounty existed unappreciated for tens of thousands of years before the first prehistoric settlers arrived and formed communities on the dry land of the natural ridges that still serve as nexuses for human settlement. To this day, towns and roads still lay along these long, thin islands that bear the names of the waterways that created them: Mississippi, Teche, Lafourche and Terrebonne, as well as any number of

smaller places named after many of the bayous and distributaries of the region's slow-moving waterways. Between these increasingly isolated spits of high ground is open wetland—great freshwater swamps and brackish marshes. Most of this land is not permanently inhabited, but it does play host to the residents of the region, nonetheless. It's in these wetlands, teeming with fish and crab, oyster reefs and shrimp-filled bays, that the foodways of Southeast Louisiana were forged. The cultures that call this place home were shaped by the serpentine patterns of this land.

THE PEOPLE

On Foodways

Without thinking about it, sit down to a meal and look at what is on your table. Everything you see—everything you eat, the food you grow, buy and cook—is all influenced by culture. Foodways are what we think of when we think about food and culture. They run the gamut from how people eat to how they interact with food. They include the history and the cultural norms that surround food. Foodways also have as much to do with economics and society as they do with the food itself. They are as much about the people as they are about the meals they consume. They illustrate the junction of food, culture, traditions and history. They're what make the memories of food that people hold so near to their hearts.

Foodways are important because they offer people a sense of place, identity and belonging. Like culture in general, foodways give people something to connect with; they define and give context to people's lives. They unite people, give them common ground to stand on and define special occasions and cherished time. Truly, foodways are the fabric of life. Think about the vast store of memories you have associated with food, the ways you felt when you ate certain meals, the memories that come back to you when you eat those foods now. The very idea of comfort food taps into these memories and associations and plays on the fond feelings we get when we feel belonging and acceptance.

People have history and emotions tied to the foods they consume. For example, it would be fair to say that a good number of Americans are

familiar with and fond of pizza. Many people today aged forty and below grew up on pizza, thanks to wide availability of the imported Italian classic. Think about being a kid and scarfing down pizza at a friend's pool party. Recall whole classrooms of kids being rewarded at school with boxes of pizza for a particular group achievement. Those are pretty common American food memories to have. In Southeast Louisiana, one is just as likely to find a person in that age group with memories that involve foods like oysters, shrimp or crawfish. Many people from the coastal regions of southeastern Louisiana simply don't remember a time when fishing in the marshes and wetlands wasn't a part of their lives and, accordingly, part of their diets.

Throughout a calendar year, people move ceaselessly. They go to work and school and take vacations, but for the majority of Americans, home is where you go for the holidays. Holidays are a place where foodways are especially evident and can be easily identified and observed. Here in the United States, people celebrate Thanksgiving yearly with a feast that includes turkey, dressing and pie. In Southeast Louisiana, of course we have this tradition too, but the turkey will likely be fried (we have the necessary equipment already), that succulent dressing is often made with oysters fresh from the marsh and the freshly baked pies are typically sweet potato or pecan, rather than pumpkin or apple.

The unique culture here in Southeast Louisiana becomes evident on other food-centric holidays as well. Easter is celebrated with the traditional baked ham, but the meal also typically includes a large pot of seafood gumbo, often packed with crabs and shrimp leftover from the seafood boil two days earlier in celebration of Good Friday. Good Friday (the Friday before Easter) is a notable holiday in the region, perhaps just as important as Easter itself. Traditionally, families gather on this day to celebrate the seafood bounty by boiling crabs, crawfish or shrimp or some combination of the three. Many businesses close, and most people have a three-day weekend for Easter, leaving time to get together and feast on the abundance from the local land and water. All across the nation it's the same—smaller groups of people take larger cultural experiences and make them more their own, bending cultural traditions to their local customs, resources and palates.

In case it's not evident yet, it's important to stress that here in Southeast Louisiana, we view food as part of the fabric of everyday life. It's not merely nutrition or sustenance. When we're eating lunch, we're already talking about what we're going to have for dinner. We may even be

talking about what we want for breakfast the next day. A common phrase heard here in Southeast Louisiana is that "we live to eat, not eat to live." Generally, we are a people who are obsessed with food, and many of us take great care in the selection and preparation of our meals. Food is sacred to us. It is something to be celebrated and honored, not just something that's consumed for the sake of filling our bellies. We devote festivals and feasts to honor our food items and our food heritage. Indeed, food and its related practices and celebrations are a large part of what defines the Southeast Louisiana cultural experience.

Characterizing the People

As many food-centered cultures do, Southeast Louisianians developed traditions to go along with their foods. They developed social constructs around dishes and paired particular foods with religious holidays. From the regular preparation of Sunday gumbo, red beans and rice on Mondays and fried fish on Fridays, to the less frequent *boucheries*, seafood boils and holiday-feast dishes like oyster dressing, the people of the region paired everything of consequence to food. Cajuns are inventive, creative and self-sufficient. Filmmaker and oral culinary historian Kevin McCaffrey summed up their approach to life well, saying, "I love the attitude of the people, and I love the way that they're willing to share. They're willing to have a 'give and take' that has meaning." The use of food as a social currency shouldn't be overlooked. It is not uncommon for food to be exchanged as a way of saying thank you or for a generous special occasion meal to be prepared to welcome guests. The ability to cook well, to make a celebrated version of a special dish, is still to this day prized and frequently a point of pride. McCaffrey also believes that one of the reasons the culture in South Louisiana is so heavily food-centric is that the people here view food as a pleasure—something to be enjoyed. He took it a step further and said, "It's a doorway, or at least an open window, to conversation and techniques and family tradition." He astutely noted that Louisiana is a place of memory and went on to add, "If you can't understand that, then you're just living here—or *residing* here. Memory is important."[7]

During our interview, all-things-Cajun expert Marcelle Bienvenu recalled a conversation she had with her father's old friend Mr. Schexnaydre when she asked him to tell her what he thought a Cajun

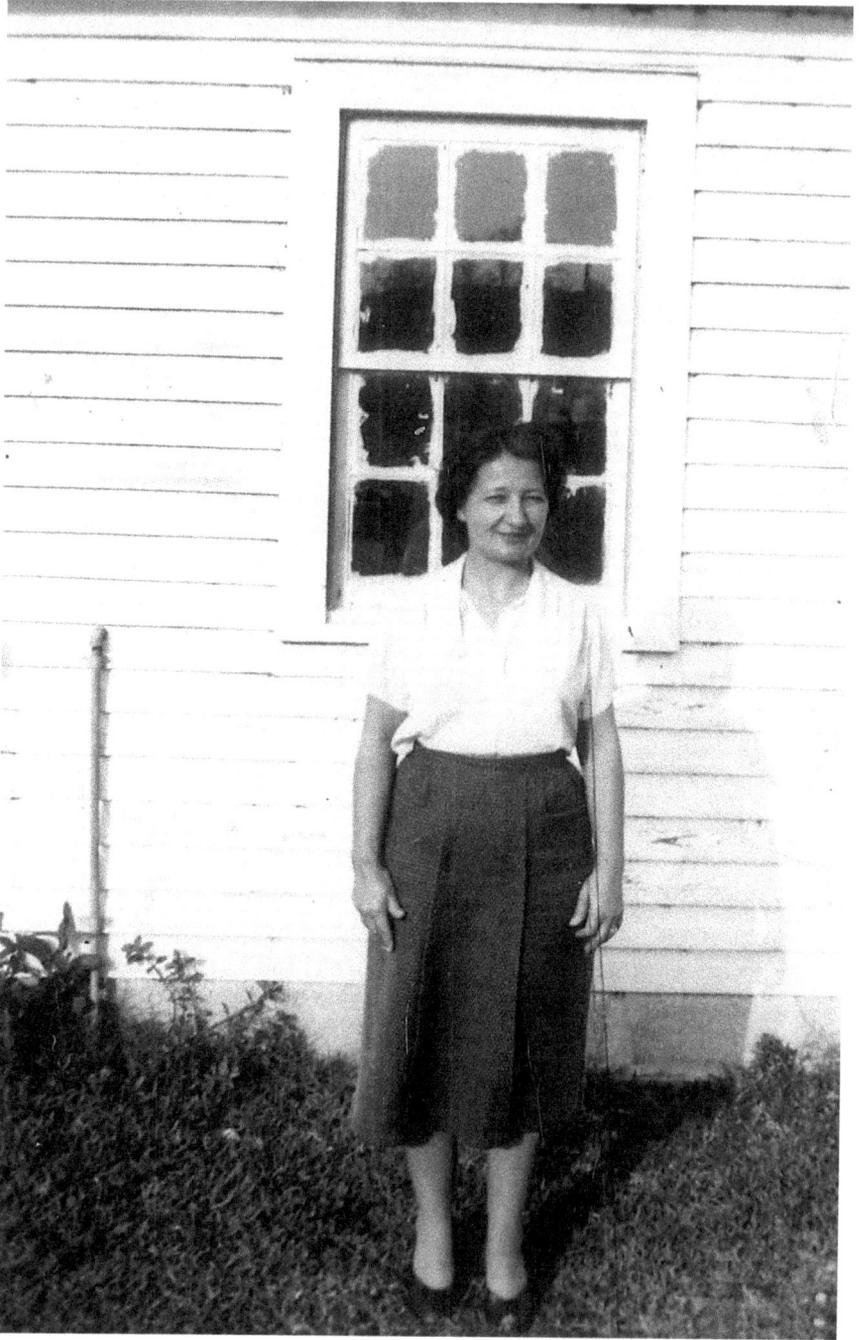

A typical Cajun woman outside her home in 1952. Pictured is Della Constransitch at thirty-seven years old. *Courtesy of Mary Chailland.*

was. In our interview, she quoted him as saying, "Well, he's somebody like me. I like to eat. I like to cook. I like to laugh. I like to dance. And I pray when I have to." That sentiment sums up Cajuns well—people who love life and enjoy it. They're just a tad religious but are always enjoying what life has to offer. Cajuns appreciate the simple things in life. They're able to laugh at themselves. They know who they are and don't give a hoot what others think about them. Hospitality still runs deep in Cajun culture. They're still genuine people who care about others. They want to sit and eat and commune with those within their sphere. To understand Cajuns best, you must experience the culture firsthand. Sit and eat with them. Listen to their music, and feel all the distinctions. They may seem like simple people—and in many ways they are—but they're also a nuanced people.[8]

The culture of Southeast Louisiana is represented by a diverse group of people. The Cajuns (Acadians), Isleños (Spanish-speaking Canary Islanders), Croats, Greeks, Germans, Africans, Southeast Asians and Chinese are present, all working in the same economy in their own unique ways. Nonetheless, what's more interesting than the diversity of these cultures is what the commingling of these cultures has produced. For having been through over three hundred years of constant immigration, the culture of Southeast Louisiana has remained remarkably separate and coherent. It is unabashedly French, of course, but with the skills and traditions of people from all over the world. It is a culture that is united through its diversity by the love of the food that surrounds it. Food is a passion—an obsession—for the people of Southeast Louisiana, and their traditions of music, fellowship and celebration are all centered on one abundant, delicious resource: the Gulf Coast fisheries. The people who fish these waters have become their own separate culture—unique in America and unique in the world.

And these people of the fisheries—they matter. They don't matter only because they provide the largest part of the United States domestic seafood supply; they matter because they are unique. In an age when culture is becoming more uniform and unique communities are subsumed unceremoniously into our national identity, we are lucky to encounter these whispers from a past age. The past has directly contributed to the politics and geography of the current day, and it has greatly contributed to our current culture. If we are to understand who we are and why we do what we do, we must study these living time capsules of independent culture.

These days, most independent culture has been erased after a century of mass communication, but hints of past customs remain in our everyday lives from the way we answer the telephone to the way we marry. As humans, the strongest way we preserve past customs is in the way we eat, so logically, a culture that values food makes for a great time capsule. Southeast Louisiana food culture is, in fact, a great time capsule of an age when people were more connected with the food they ate, the land and one another. When we look into the ingredients and dishes of Southeast Louisiana, we see the way people used to live.

Characterizing the Culture

So what kind of culture exists in Southeast Louisiana? Most simply put, it is a food culture. The people here are the type of people whose idea of luxury will almost always include a good meal. It is a food culture rooted in necessity and availability. It is a culture that adapts and adopts freely. Liz Williams, president of the SoFAB Foundation, believes that what makes Southeast Louisiana food culture unique is that it is so embedded in the overall culture that has become central to this area's identity. While we are not alone in this world in that food-centric culture, Ms. Williams does believe that we do it best here in South Louisiana.[9]

The people of Southeast Louisiana honor their food traditions in many ways, and all of them involve this sort of hat tip to the community that Cajuns relied on for subsistence. From something as simple as a home-cooked meal for the family on a Sunday after church to elaborate multi-day festivals, the love of food is celebrated and ubiquitous. It is not uncommon to discuss past meals or plan future meals while gathered with loved ones around a present meal at the dinner table. The heart of Southeast Louisiana's food heritage is the group, which usually assembles for a meal—primarily the family dinner. When different members of the family spent their time gathering food, earning income or running the household, it was seen as important to create a time when they could all get together.

But where would this culture be without the actual hunting and gathering that brings the food to the table? In the marshes, wetlands and swamps of Southeast Louisiana, it is not uncommon for people to head out in their small flat-bottomed boats for a morning or afternoon of fishing, hunting or trapping of some sort. Some people even have private

A more common sight one hundred years ago, Southeast Louisiana's wetlands were more abundant than they are today. *Courtesy of Louisiana Department of Wildlife and Fisheries.*

leases where they're able to set out crab traps and catch as many crabs as those traps can hold. Other people must fish in public access areas, hoping to catch their legal limit of redfish, speckled trout and drum fish. Fishing is a way to slow down and enjoy the languid pace of the marsh. It's a great way to get away from the hustle and bustle of everyday life and get back to a time when life's events moved a little more slowly, when life in Southeast Louisiana was a simpler affair, a time when the day's catch and what dinner would become of it were all that mattered.

When Mr. George Terrebonne, owner of the Seafood Shed in Golden Meadow, was a little boy, roughly ten to twelve years old, he used to help his father and grandfather with trapping animals for their pelts. In addition to trapping, Mr. George's father trawled, crabbed and was even a policeman. He did the fisheries and trapping work for extra income.

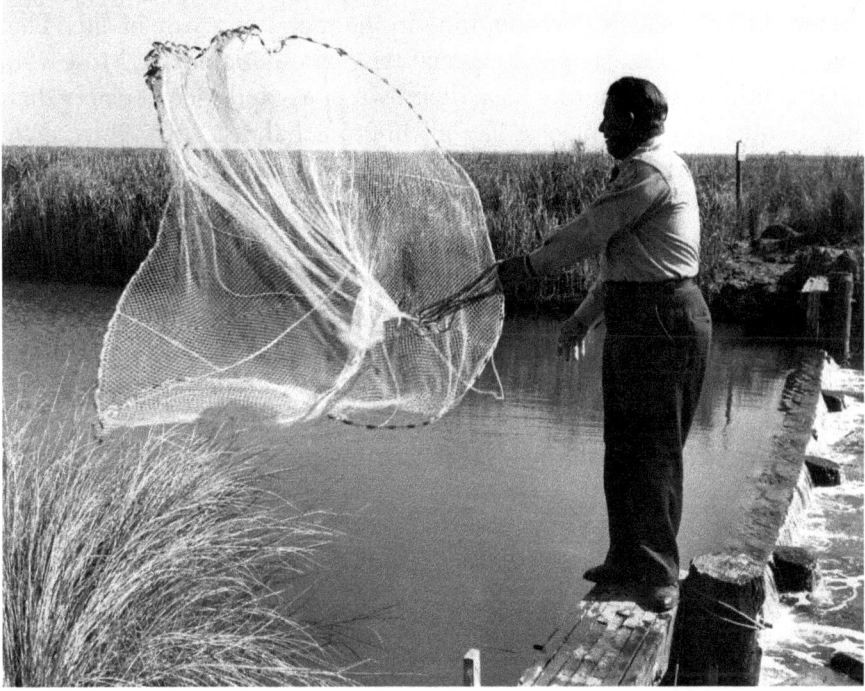

Cast nets are useful for catching bait or small fish from docks, land and boats. *Courtesy of Louisiana Department of Wildlife and Fisheries.*

Opposite: Even into the mid-twentieth century, trapping was still a viable way to make a living. *Courtesy of Louisiana Department of Wildlife and Fisheries, 1966.*

They trapped on leased land south of Golden Meadow along the West Canal and around Little Lake. His father had a systematic way of trapping whereby they would leapfrog the setting and the subsequent retrieving of the animals. Mr. George remembers that as a child, he wasn't nearly as adept at the task as his father and grandfather were, but it was his job to help out with the family, so he did. He also used to put the skinned pelts on wooden and iron *moules*, boards used to dry out the pelts before sending them to market. That was his after school job. When Mr. George was older, in his teens and before he met Mrs. Carol, his future wife, he trapped for a living in Leeville. He'd acquired his own set of traps and could make up to thirty dollars a week trapping. Oftentimes, though, he'd still give the money back to his mom and dad if they needed it. Since he wasn't living out on his own, that was just understood.[10]

Here in Southeast Louisiana, time in the marsh is a way of life. The outdoorsman in Louisiana is a special type of outdoorsman. Most who are into fishing and hunting have their own boats and special places that they frequent. These places, like all hunting haunts, carry their own nicknames based on the lore of the region. For example, in the marshes east of Golden Meadow, a grassy outpost in a small bay is known as Rat Point in commemoration of the time a redfish was caught with a half-swallowed rat in the current-sheltered waters off the point. This practice is not necessarily unusual among hunters, but what is unique in Southeast Louisiana is the year-round fishing and trapping, enabling people to go out into the marshes on a weekly, if not daily, basis. One can imagine the cultural lore packed into shallow waters where it is not uncommon to find at least one fisherman at any time of day, any month of the year.

Favorite Sons

While several culturally relevant food items exist in Southeast Louisiana, a handful are more significant than the rest. This book focuses mainly on the relevant seafood industries in the area: shrimp, oyster, crab, crawfish and finfish. These foods have shaped not only the customs of the area but also the industry and even some of the physical landscape of Southeast Louisiana. As with many indigenous foods, they have been met with their fair share of challenges and setbacks. Most are still at risk today. Take oysters as an example. Oysters of Southeast Louisiana border on being functionally extinct. It's mainly through human intervention and cultivation that they still exist in these modern times. Granted, it is human intervention and influence that have put these ancient bivalves at risk in the first place. The Southeast Louisiana oyster industry continues to be threatened by both humans and nature. Numerous hurricanes in the last ten years and the 2010 BP oil spill have been the latest in a series of threats. Shrimp are prolific in the Gulf of Mexico and in the wetlands of the Louisiana coast. But again, these creatures face challenges. From industrialization to natural disasters to invasive shrimp species, the native white, brown and pink shrimp of this region fight for survival. Indeed, the entire shrimping industry has seen a slow and steady decline in the last couple of decades. Imported shrimp and the grueling hours and work required to be a shrimper have put a damper on this once central and vibrant industry. However,

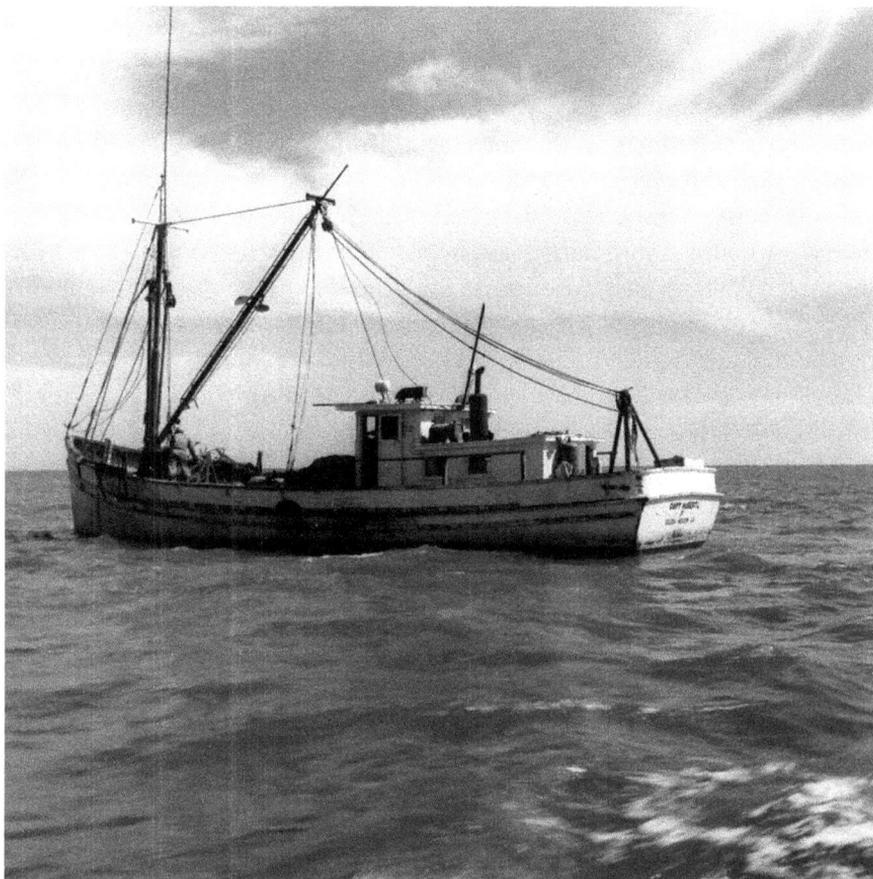

An oyster lugger based in Golden Meadow traveling in Grand Pass in February 1963. *Courtesy of Louisiana Department of Wildlife and Fisheries.*

hope is on the horizon, and the situation continues to improve for the trawlers still working in Southeast Louisiana.

Finally, the wetlands, marshes and swampy areas of Southeast Louisiana, which form the boundary between dry land and open water, teem with life. From birds to land animals to creatures of the sea, this quickly disappearing region is home to some of the most culturally relevant wildlife in Southeast Louisiana. While natural disasters have played a significant role in the diminishing size of these wetlands, it's actually development that set most of this destruction into motion. Often with encouragement from state officials with an eye on providing jobs

to the region, the oil and gas industry carved up hundreds of miles of wetlands with long, straight canals, allowing salt water from the Gulf of Mexico to slowly make its way in and systematically destroy most of the plant and animal life that depends on it. Ironically, it was these attempts at improving the region that have proved to be its greatest threat.

The story of Southeast Louisiana and its food culture may seem sad at times, but it's a story filled with hard work, hope and resourceful people looking for solutions. While no easy answers are found to the problems that plague the area, residents, industries and government officials are slowly coming around to mitigating the damage done by a century of poorly managed exploitation. This process is slowly unfolding, but hope remains for the area and these precious foods that are so vital to the traditions of Southeast Louisiana. Sadly though, the foodways of Southeast Louisiana, along with other small regional food cultures in the United States, are endangered. Since these traditions and cultures often seem foreign to the rest of America, the larger culture seeks to assimilate these outliers as part of a natural progression toward nationwide homogeny. Even in Southeast Louisiana, we can see people losing touch with the land and water. They continue to more widely adopt the nationwide culture, in favor of what many see as their parents' and grandparents' traditions. Technology has brought people together more than ever before in history, but that connectivity comes at a cost. Inevitably, it leads to the dilution of the old traditions and the introduction of newer foodways and cultural experiences.

While the adoption of the nationwide culture will continue in Southeast Louisiana, hope remains. Through it all, groups of culturally dedicated individuals remain active in Southeast Louisiana. These groups include people who commit their lives to practicing and passing on these foodways and also extend to some people who take the time to document and study the foodways of Southeast Louisiana. These documentarians practice and hope to preserve what they hold near and dear to their hearts so that the culture can stay well and alive for future generations. It's impossible to have a constructive idea of who we are as a people and a culture without understanding the past. To understand where we came from, we must understand the culture of our predecessors. Once that culture is learned and understood, we may see the value in the seemingly ancient, stodgy practices. We may come to understand that it was culture, like food, that helped our ancestors through difficult times and can help us. Accordingly, the best way to tell the story of foodways in Southeast Louisiana is through the people who embody the fight to understand and preserve them.

PART I

THE PAST: ORIGINS AND PAVING PATHS

A GLIMPSE INTO THE PAST

We know that it's true because everyone we interview has a grandfather who remembers it: the plenty. Plenty plays out in a variety of scenarios—oyster boats so laden they're under water in the middle, boats returning from the marsh knee-deep in trout, ducks lined up across the porch, crabs that would bite on a hand line in seconds, thousands of pounds of shrimp shoveled by hand at the docks; the list of bounty goes on and on in the old stories. Aside from an exceptional humidity and penchant for hurricanes, it seems that Southeast Louisiana was a paradise to those who first settled here. The waters were plentiful, the marshes stock full and the swamps verdant. The fields were black with nutrients and the air thick with birds. All that they had to do, it is said, was go out and get it.

That's not to say, of course, that it was easy. Life in the bounty of the delta lands was hard but rewarding. Calorie for calorie, it seems that nutrition was one thing nobody who could work lacked in Southeast Louisiana. Everything else—well now, that was a different story because alongside the tales of plenty are accounts of the hardscrabble improvisation of rudimentary existence. Just because the shrimp was in the water didn't mean it was going to jump into the kitchen. It had to be caught, and the further back in the past we get, the more work this catching seemed to take and the more it required backbreaking labor. Nowadays, people love technology because it entertains them and connects them, but that hasn't always been the case. Along the bayous and bays of Southeast Louisiana,

Drawing by Frederick Stivers, 2014.

technology that seems humble and rudimentary today, like the trawl net or gas engine, revolutionized the act of feeding oneself.

The more people we talk to, the easier it becomes to imagine life back then. Echoes of a simpler, subsistence-level living still ring in the lives of people working in the fisheries. They waited above clear water for the shrimp to appear. They picked oysters off of natural reefs. Nowadays, they may use the newest GPS on their boats, but their knowledge of the land, disappearing at a rate faster than cartographers can keep up, comes from the same place it has come for generations: experience. Experience is the knowledge that Europeans first learned from American Indian tribesmen; experience is the knowledge that each successive wave of immigrants brought to the fisheries; experience is the knowledge that can't be written down, only passed from generation to generation over the course of years on the water.

This, it seems, is where all that plenty comes in, or at least from where it originates. A time existed in Southeast Louisiana when a fisherman worked in many fisheries, shrimping when the shrimp ran, oystering when the oysters were fat, crabbing in the off-season. The average resident had experience plying the waters for whatever was good eating or profitable

selling. Nowadays, all the old men tell us, people just do one thing, prepare for one thing and bank on the success of that one thing all year round, and even the specialists are slowly disappearing. Talking to some of the last oystermen down on Bayou Lafourche, we hear time and again that they don't worry about the oysters disappearing, they worry about the experience of oystering being lost. They worry that the knowledge of when to plant oysters, how to avoid being robbed by drum fish, when to harvest and how to sustainably do so will be lost to a generation of kids who have better opportunities than to ply the waters. This loss is already occurring, and to many fishery workers, it is as real as the land melting away around them.

We do quite a bit of driving down curving bayou roads, hugging the still water on one side, scraping by weather-beaten houses on the other, imagining when this wasn't a sleepy community but a booming economy of plenty. Shrimp boats used to line the bayous, forcing bridges to open on a regular basis and snarling traffic. Today it seems the traffic takes precedence—people have to get to work, pick up the kids at school and go to the grocery store. The plenty is still out in the water and wetlands. The Gulf of Mexico is enormous, and the delta lands of Southeast Louisiana serve as the swampy northern reach of the life cycles of hundreds of species of animal. What has changed seems to be the attitude about the plenty—the idea that plenty is less a calling and more of a birthright for someone else to claim.

But it's difficult not to sit back when the old men are talking and close our eyes, smell the soft smell of hewn cypress and kerosene lanterns in the humidity. The old men talk about tying boats together in the marsh and cooking the day's catch off the bow. They talk about raising their families on seafood not because they liked it but because it was what they had. They reminisce about sitting under trees and talking in the failing evening light. There was plenty then, as there is now, but it seemed so much more vital because back then, plenty was all they had, it was how Southeast Louisiana survived. Plenty was a gift that allowed a culture to develop unhindered by time and energy-intensive methods of obtaining nutrition. Plenty was a gift that allowed life to carry on at a pace slow enough to appease the oppression of the climate. Plenty was a gift that allowed a cuisine rich and varied to arise, a cuisine like no other, a cuisine that exists to this day on tables across Southeast Louisiana and even the rest of the world.

2
EARLY SETTLERS IN SOUTHEAST LOUISIANA

The Melting Pot in the Swamp

It is easy to forget that Louisiana is one of the older European settlements in the United States. When the French first arrived on the densely wooded shores of the Mississippi River Delta in the late seventeenth century, the land was not uninhabited. Like the expansion of most of European North America, the land and resources of the "discovered" territory were taken, in some form or another, from native inhabitants who could not remember a time when they lived anywhere else, following the high ground as it snaked a changing course through the marsh. According to one source, as early as 1700, the lower Louisiana American Indian population was already reduced to roughly 5,500 people.[11] Though it is probable that native population numbers were already in decline even before Europeans came to the region,[12] shortly after Europeans began to settle in earnest, the American Indian populations in the region were reduced to insignificant numbers, either by being bought out or forced out of their ancestral lands.[13]

The interactions between these vastly different cultures—the Europeans and some Chitimacha Indians—could be violent or, at other times, cooperative.[14] Southeast Louisiana was a vast wilderness at the time of European discovery, and French adventurers like the Le Moyne brothers (Iberville and Bienville) from New France (present-day Montreal) had little issue with using the generosity of the natives to their advantage. This generosity would have included not only exploitable trade agreements but also help with navigating, foraging and general survival skills in the unfamiliar swampy land. This stands in stark contrast to the practices of the early English colonists, who occasionally chose starvation over the adaptation to native ways.[15] The American Indians may have also showed the early Europeans where to settle, though not directly. The native people of these lands occupied Southeast Louisiana for over ten thousand years, so they were adept at moving as needed—say when the Mississippi River changed course and obliterated former growing sites and freshwater sources.

Adaptation of lifestyle was an important trait in early Louisiana as the territory was harsh, unfamiliar and unforgiving. Many of the early immigrants to Louisiana were unprepared, to say the least, for life in a deltaic region. It is important to note that Louisiana, like Canada at the time, was not considered a French colony but a territory equal to any other on the French mainland.[16] It can be noted with no small irony that this was actually the English colonists' original request to King George—not independence but *equality*. Well, French territories were—at least bureaucratically—equal.

English colonists saw themselves as settling a new world—building new cities, forming new businesses and setting about making names for themselves in what they saw as a blank canvas, a land of opportunity. French settlers in Louisiana, on the other hand, could be seen as moving across the vast territory of France to a different, but no less French *département*.[17] This departmental equality paradoxically helped form an identity within early Louisianians as French but also gave them a kind of cultural security necessary to absorb the customs of other people. The absorption of other cultures—the mixing of traits and ingredients from whatever was at hand—became a famous trait of the people of Southeast Louisiana. It could be said that, culturally speaking, the very first French settlers in Southeast Louisiana immediately set out making the region's first gumbo.

The early French and Acadian settlers were also considered highly resourceful people. They were opportunistic and took advantage of

what they found. Prior to the Spanish coming in and imposing order on the French citizenry, life was rather unorganized and chaotic here in Southeast Louisiana. The people here did not receive much support from the French crown and were by and large left to their own devices for survival. Being as such, the people here developed an independent spirit that lives on to this day.[18] People eventually figured out what they needed to do for survival because they had no choice. They relied on themselves and others to teach them. The American Indians were instrumental in teaching the early settlers about survival in this area by showing them how to use materials to build early homes and how to use some of the native ingredients in this area like sassafras and corn. The Germans, many of whom were farmers by trade and knew quite a bit about agriculture, fed the people of Southeast Louisiana via their farming and by teaching people how to farm the lands.[19]

The French settlers couldn't rely on the long and perilous supply chain to their home for familiar ingredients, and they didn't wait for shipments of salt pork. The French settlers looked at what the American Indians who preceded them were eating, and they were catching fish and trapping game. It turns out that while the authorities in the royal house of France were trying to figure out how to raise a cash crop in Louisiana, the settlers discovered the bounty of the delta. In order to reap this bounty, immigrants fanned out along the natural ridges and bayous, settling in places with access to good trapping and good fishing.

People needed only to go out and get it. The first big waves of settlers attracted by the bounty of Southeast Louisiana were the Acadian exiles—French citizens expelled by the suspicious English from their homes in Nova Scotia. Looking for fertile, unclaimed land, they settled in the alluvial soils of Louisiana, farther west than most of the Germans, who lived north of New Orleans along the Mississippi River. But it was the Acadians who set the tone of the region and built the basis for a unique culture that thrives to this day. Many other smaller ethnic groups settled in pockets in Southeast Louisiana, and the influx of immigrants to Louisiana hasn't stopped since. With every new wave comes new traditions that are eventually absorbed into the culture of the region.

But what was the catalyst to all of this change? Why do cultures with a common root grow and change separately with time and isolation? Different environments certainly play a part, but the biggest reason for change in Southeast Louisiana is immigration. It is easy to think of the region as full of French nationals. After all, Louisiana was part of

France for the better part of a century, and the original inhabitants were French. However, the story of people in the Mississippi River Delta lands does not end with the French; the French are just the beginning. The French settlers were largely refugees of political and social issues—some were prisoners, others disgraced members of well-to-do families. They lacked most of the basic skills necessary to build a new world. It was perhaps into this void of expertise in anything beyond survival that the Spanish, Greeks, Italians, Germans and Croats injected themselves into coastal life.

Non-Franco Europeans took to the marshes as well, finding niches to fill in the bounty of the wetlands. Canary Islanders, for example, founded the colony of the Isleños, east of the Mississippi River. It remains a Spanish-speaking settlement of Louisiana fishermen to this day. In the late 1800s, immigrants from present-day Croatia settled and developed much of the modern oystering business.[20] This slow trickle of immigration into the region and the relative room in the natural economy for these immigrants allowed for a rare combination of economic development and cultural preservation. Being extremely robust, culturally speaking, and so isolated, the early Acadians were able to absorb the impacts of these new cultures and, in doing so, created what we think of today as the modern Southeast Louisianian.

This is because settlement patterns were isolated. They were originally sited on high ground along navigable waterways, near natural resources like oyster beds or timber, which was integral to the development of the region. Much of this region was originally forested with vast tracts of cypress trees that thrived in the freshwater runoff from the rivers and bayous. The deep red-brown and rich scent of cypress was part of the tapestry of Southeast Louisiana life. Entire communities were constructed in clusters of economic opportunity. They were isolated outposts against the wilderness of water around them, from which they drew their sustenance. The houses, built off the ground on brick pillars or wooden stilts, sat low against the long horizons of the coast. The whole scene lends itself easily to flights of fancy.

Though it's easy to think about most past cultures curiously, thinking that it must have been an interesting time to be alive, this past is much more recent in Southeast Louisiana, which up until the early twentieth century probably had more in common with colonial America than with the industrial East Coast. This was a land of self-sufficiency; it was a land of local concerns and local solutions. Prior to the patriotic surge of

World War II, the communities along the bayous were just as likely to associate themselves with France as with the United States. It was truly a land apart, and it developed accordingly.

Southeast Louisiana adopted the French way of thinking—the inward-rather-than-outward focus on society that often comes with socio-politically weaker societies. Instead of building empires, the French settlers of Southeast Louisiana focused on building societies, not through great legislation or government planning, but through the individual emphasis on the value of the place and people that make up a home.[21] It was their inward focus that led Southeast Louisiana to its own versions of the French language that had dialects that varied from bayou to bayou. They adopted the fishing, oystering and agricultural methods of emigrants from Europe to Africa as their own.

And so the Southeast Louisiana way of eating slowly came into being. It manifested itself as a social practice, defined by the contradictions of abundance and scarcity, wealth and poverty, isolation and community. The settlers of Southeast Louisiana were poor in cash and possessions but were not poor in resources or neighbors. They put both to work helping them survive and, in the process, constructed a unique society. Ingenuity lay at the heart of this process, and its importance cannot be overstated. These are people who, for over 250 years, have worked the coastal wetlands of Louisiana for a living, learning its patterns and how to optimize their processes to maximize the returns on their efforts. For much of the region's history, the payoff was survival in a place people could call their own, where they could be free to live as they saw fit and eat what they loved.

The Acadians

While Southeast Louisiana certainly was a melting pot of cultures and ethnic groups, one group dominated them all. Each ethnic group had strong cultural heritage, but it was the Cajun culture that subsumed most of the rest into its way of living. In that case, it is worth examining the Cajuns, who started as the Acadians, in greater detail so that an understanding of this group can be achieved. Understanding who the Cajuns are and how they came to be is vital in understanding the culture and heritage of Southeast Louisiana. Indeed, to this day, no other ethnic

group remains in such large, distinct numbers in the region. When the Acadians first arrived in Louisiana, they were not what are known today as Cajuns. That ethnicity took time to develop and grow.[22] Similar to the people of Southeast Louisiana today, the original people who became Cajuns were conservative, family oriented, religious and tied to their lands. But then again, this made them like most other people of the Western world in the early eighteenth century. These were common values and attitudes held during the period.[23] Therefore, it wasn't the simple peasant-like lifestyle that distinguished these people but the specific circumstances of their lifestyle that made them unique.

In 1755, at the onset of the French and Indian War, the first group of what became known as the Acadians was exiled from their homeland in Nova Scotia, the former French Acadia. The English had taken control of the area and wanted to rid it of the six thousand to eight thousand French-speaking, Catholicism-practicing, pastoral people who occupied the area. The English feared that these people would ultimately turn on them and cause trouble. Preemptively, they decided to expel the people from their ancestral homeland. The exile was later labeled the *Grand-Dérangement*, which translates literally into "large disturbance" because it was a long, hard, difficult process of relocation and settling into new territories.[24] While this outcast group of Frenchmen ended up in many different places in the colonial United States, a significant number of them ended up in Louisiana by way of New Orleans. The local government settled these outcasts in places like St. Martinville, present-day Lafourche Parish and Lafayette.[25] However, it took many years for them to actually come to settle in Louisiana. In fact, twenty years passed between the first and last arrival groups. The first group from St. Domingue arrived in 1765, and the last arrived in 1785, hailing from French port cities like Morlaix and St. Malo.[26] During those twenty years, the Louisiana colony was in a state of unsteady political, social and economic change. These are the times and conditions in which the Acadians arrived. They were a people who suffered many years at the hands of the instability and unrest of others.

At this point, New Orleans was the center of life in the southern part of the Louisiana territory. Having been a formal city since 1718 and first settled by Europeans as far back as 1699, the city served as the hub of activity and civilization in this part of the New World. Although the Spanish ruled when the Acadians arrived in Louisiana, the people living in the area were French, by and large. The French had first colonized the

area, and it was known as a haven for French-speaking Roman Catholics. It's no surprise then that Louisiana became the place where the largest sect of Acadians ended up. In all, it's estimated that over three thousand people migrated to the Louisiana territory in several large waves in that twenty-year period from 1765 to 1785.[27]

Most of the Acadians had no desire to live in the city, mainly due to the work they were trained to do—hunting, trapping and even fishing.[28] Even though people were spread out in the rural parts of Southeast Louisiana, the Acadians still managed to cluster together to form communities. They were drawn to each other and chose to seek residence near one another, as opposed to living in total isolation. Their community-oriented nature can be attributed to this phenomenon. In 1766, the Spanish governor Antonio de Ulloa noted that the Acadians were a "people who lived as if they were a single family." While Acadians grouped together amongst themselves, at first they chose to remain isolated from the other ethnic groups living in their areas. This is quite interesting and fascinating considering that they shared a language, religion and French heritage with many other settlers in the area. It seems that they figured (correctly) that the old higher-brow Creole population would look down on them and not accept their ways and culture. In the end, the Acadians sought to maintain life as closely as possible to the way it was when they lived in the old days.[29]

For a period of time, this lifestyle worked for the Acadians. They enjoyed a comfortable, if somewhat meager, existence. It must have seemed that they could finally settle and move their lives forward. The days of the *Grand-Dérangement* were behind them and life could go on, simply and peacefully. Indeed, life was stable in the initial settlements for a few decades. All of that changed around 1795, when sugarcane came into its own as a cash crop in Louisiana.[30] The lust for land in the more rural areas was unquenchable. Once again, the Acadians were moved from their lands—this time bought off for rock-bottom prices and forced to move even farther south to coastal areas.[31] While it did affect a significant number of people, some areas were untouched by the agricultural development craze.[32] After the second unsettlement, the Acadians resettled into three main areas.[33] Some moved out to Southwest Louisiana, where they became farmers and cattle ranchers. Many moved into the swampy lands of the Atchafalaya Basin and Barataria Basin, where they commonly became fishermen and trappers. The final place they migrated to was along the coastal marshland, where fishing,

shrimping, oystering and trapping became the dominant lifestyle. Despite the geographic split, the Acadians continued to share religion, language, a historical ethnic background and a laid-back lifestyle.[34]

It is critical to note that not all people of Acadian descent lived this pastoral, simple lifestyle. Some of the Acadians had aspirations to become landowners and wealthy plantation owners. At this time, anything considered "Anglo" was fashionable. As a consequence, the upper crust of the Acadian people started to adopt the Anglo lifestyle.[35] A separate class of "Genteel Acadians" developed, and they had more in common with the Creoles than with their agrarian Acadian counterparts. By the nineteenth century, a clear distinction between the two groups had become observable.[36] The Genteel Acadians assimilated to the society of the Anglo-Creoles and were accepted as civilized people. The other Acadians, gradually assuming the identity of the Cajuns we know today, became more disdained and looked down on by the other classes of people, including the Genteel Acadians.[37]

If this explains the origin of modern Cajuns, how did the *term* Cajun develop? Basically, it is an Anglicized and shorted version of the word "Acadian." Starting as *Cadien* (phonetically, *Ca'jin*), it was a term that the Acadians used to describe themselves. Over time, it morphed into the word "Cajun."[38] Initially, Cajun was a pejorative moniker. It was a way for the Anglos and Creoles to label the lower-class Acadians as "others"—people not like them.[39] These dominant groups looked down on the Cajuns because of their simple lifestyle and outlook on life. They were seen as lazy, uneducated, materially impoverished and lacking ambition. However, somewhat paradoxically, they were often observed as being hospitable, family oriented, fun loving and easygoing.[40]

The main reason the Cajuns developed a mostly negative reputation is that they were seen as lacking a Protestant work ethic that was much revered by the nineteenth-century Anglos.[41] Anglos in the region were practical, hardworking, pious people. They had little to no tolerance for those who were different from them, although that can also be said about many ethnic groups and nationalities of the time. While the Creoles and Genteel Acadians adopted a mostly "Anglo" work ethic and outlook on life, the Cajuns stubbornly remained in their old, simple, come-what-may ways. They were not influenced or changed in the early years by the opinions of others. The disdain between the groups was mutual, and they generally took to staying away from each other as a way of dealing with the hostility of class disparity.[42] For many years, the Cajuns even

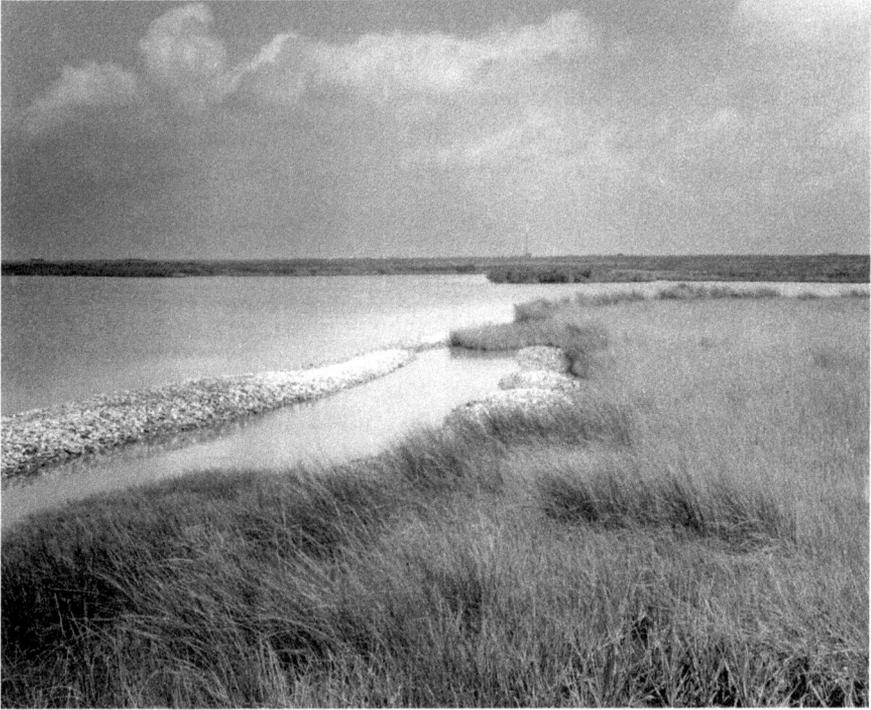

Cajuns are resourceful, wasting little. Reefs constructed of discarded oyster shells act as nurseries for fledgling oysters as well as erosion barriers. *Courtesy of Louisiana Department of Wildlife and Fisheries.*

shunned the English language, refusing to use it in favor of their native French tongue.

Although other classes looked down on them, the Cajuns were able to take care of themselves and their own people, which garnered them a reputation for being self-reliant.[43] This seems contradictory considering that they were also seen as lazy, but this reputation for laziness is more the result of their culture and values being misunderstood by those who valued Anglo ideals. The Cajuns were hardworking, community-oriented people who banded together to help any one of their own in need. They were self-reliant in the insular community sense but not in the individual-self sense. A great example of the community-oriented nature of the Cajuns is the practice of *coupes de mains*. Literally translated into "strokes of the hand," *coupes de mains* were large work-based parties designed to rally the community to help a neighbor in need. Sometimes

it was raising a barn; sometimes it was helping a poor widow. The host family for a particular *coupes de mains* would rely on the community's help, but in exchange, they would feed workers. People were all too eager to help others in need because they knew they might soon find themselves in the same situation. It was noticed when a person or family wasn't present at one of these events.[44]

Food-centric *coupes de mains* were a necessity prior to modern refrigeration since it was much more difficult to store meat and other perishable food items. One of the best examples of the *coupes de mains* is the communal *boucherie*. Slaughtering, butchering and processing a whole hog or calf is quite labor intensive and, in those days, provided more meat and byproducts than one family could handle alone. Groups of families would get together and purchase hogs and calves on a rotational basis. For example, six to eight families may have pooled resources to rotate the weekly *boucherie* between the families in the group. Proceeding in this manner, families were ensured a steady supply of meat, while only having to pay for the hog or calf when it was their week to host. Seasonality determined whether they slaughtered hogs or calves. Calves were fat and healthy enough to be slaughtered in the spring and summer months, while hogs fared better in the fall and winter after they'd fattened up from summer feeding.[45] For the Cajuns, work and play happened in tandem during these events. Since this was a weekly occurrence, people were familiar with one another and socialized while they worked. They were daylong affairs that helped the Cajuns reinforce their social ties with one another. The day started with the male host slaughtering the calf or pig. The males in attendance would then help with bleeding the animal and the butchering and crackling making. The women would work on preparing dishes with the meat and entrails such as stews, sausages, bacon and salt pork. As with so many aspects of the Cajun culture, the divisions of labor ran in line with gender-based roles. The women took care of the indoor tasks, while the men dominated the outdoors. This practice of the *boucherie* continued in earnest until electricity became commonplace. After that, Cajun women had access to grocery stores where they could buy pre-cut and prepackaged meats.[46]

Although Cajuns were essentially financially poor and fairly simple people, they were also endlessly hospitable and welcoming, even with outsiders. However meager, Cajuns always offered coffee or refreshments to visitors.[47] Even the poorest families would take pride in offering something to guests, whether it was a cup of coffee or a slice of cake.[48]

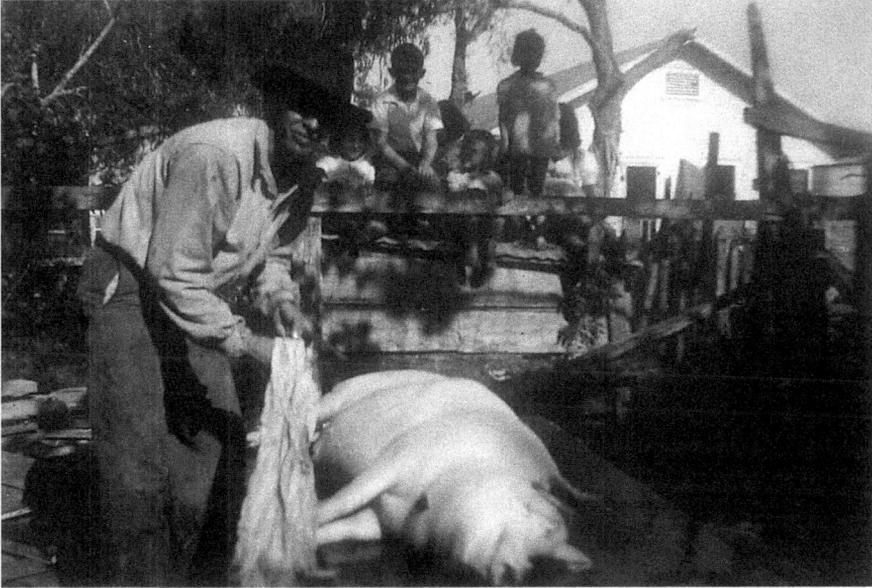

A Cajun man prepares a pig for a *boucherie*. Early twentieth century. *Courtesy of Mary Chailland.*

Once they had properly welcomed someone, Cajuns would show off their fun-loving nature. The Cajuns were known for being hospitable and loved to entertain folks. The hospitality was not just limited to family and friends—Cajuns never met a stranger they weren't happy to entertain and feed.[49] Interestingly, Cajuns were even hospitable to groups known to look down on them, namely Anglos and Creoles. Accounts exist by people who were truly shocked at how friendly, accommodating and hospitable the Cajuns were to these outsiders and strangers.[50] Despite the severe poverty that Cajuns traditionally faced in their earlier existence, warm, genuine hospitality has always been central to how they interact with fellow human beings. An anonymous Louisiana author quoted in the book *Stir the Pot* said, "It was the Cajuns who originated the hospitality for which Louisiana is famous."[51] Everything we've researched, read and know to be true certainly supports that statement.

All communities have structure—a way for members to know their responsibilities to themselves and to the greater assembly of peers. The gender-specific roles assigned to divide labor and responsibility were an important part of that structure, especially among rural, agricultural cultures like the early Cajuns. This even bled into the realm of hospitality,

where the men typically were the greeters and entertainers to guests, while the women prepared the food and served the coffee. This was a natural extension of the typical gender-based roles played in the home. The women dominated inside of the house including tasks such as child-rearing; housekeeping and laundry; indoor meal preparation and cooking; tending to chickens and managing their eggs; and assisting with field work when necessary. Men were responsible for the realm outside the home—crop work, livestock care, home maintenance and repairs and outdoor cooking. Men also hunted and fished as needed for supplemental food.[52]

When communities are impoverished, especially in the times prior to the modernization of the twentieth century, people rely on the company of one another for entertainment. Most communities in Southeast Louisiana in the eighteenth and nineteenth centuries were small and isolated in the rural areas, so all the people had to keep them entertained and occupied were their friends, family and neighbors. They would get together and visit in part because there was little else for them to do. The remoteness and isolation bred stronger familial and community ties.[53] Instead of being dominated by the blind valuation of material wealth that characterizes much of today's society, social life dominated Cajun society in the nineteenth century. Families and communities were tightly knit and did what they could to help each other thrive. They were also known to "make the *veillée*," a tradition of coming together at the end of the day to talk about the day's events, do light work around the house and sing folk songs. Historically, *veillées* were informal, late-evening social gatherings that people partook in, mainly in winter months, post–fall harvest.[54] Family and friends would gather in the winter months when life moved at a slower pace since fewer crops needed tending. These gatherings consisted of storytelling, conversation and, at times, music.[55] It was not uncommon, especially in the nineteenth century, for men and women to socialize separately, as was the norm. Again, gender-based roles were clearly divided. Never afraid of some hard work, Cajun men frequently spent this social time repairing farm tools, carving useful objects and weaving baskets.[56] The women would typically spin or card yarn into household items.[57] Overall, the *veillée* was a time for socializing, relaxing and bonding with loved ones.

Cajuns tended to be an inward-looking people who valued family and living an enjoyable life above all else. Work was just a means to food for survival—it was not a noble pursuit for Cajuns. They leaned on the

hedonistic side of life, enjoying pleasures like eating, drinking, gambling and dancing.[58] Their general outlook on life was one free of care and worry. While they faced hardships, they weren't the type of people who allowed it to affect their overall nature. They've been described as people who were "cheerful in their adversity."[59] This can be seen in their folk songs, which typically included social themes like love, courtship, satire and the enjoyment of living, as opposed to the religious and virtuous folk songs prevalent in Anglo society.[60] Since they were relatively simple people who strived to meet only the most basic needs, Cajuns also had a reputation for being modest. They built simple homes and lived quite simple lifestyles. The homes of the Cajuns were mostly plain structures built by the occupant with materials easily gathered from their surroundings.[61] They were not pretentious or frivolous homes in any way—they were meant to provide shelter, not to be representative of status.[62] In the same vein, most Cajuns didn't seek to fill their homes with possessions. Simplicity was their preference—they seemed to relish being people of the land. They also shunned conspicuous consumption. At the end of the day, their desires were merely to work hard, provide for their families and live simply.[63] Especially in the early times, when people were quite poor, they were just looking to survive, and frugal traits like thriftiness were seen as virtues.[64]

Finally, it is worth noting and exploring the influence of Catholicism on the Acadians and early Cajuns. Remember, part of the reason the English exiled the original Acadians from Acadie (Nova Scotia) was because of their Catholic faith.[65] But by all accounts, by the nineteenth century, the Acadians who eventually became the Cajuns weren't deeply religious people. While many present-day Cajuns are devout Catholics, early Cajuns were considered more culturally Catholic than religiously Catholic.[66] Since they were an isolated group of people, they didn't always have access to clergy, which means they didn't often attend services.[67] They attended Mass when possible but didn't think much of it when they weren't able to do so.[68] They weren't the types of Catholics worried about the state of their souls, like many religious people in the present day are prone to doing, Catholic or not.[69] Faith was just seen as a fact of life—much like breathing and eating; it wasn't something about which they thought deeply. It's been noted that in the early nineteenth century, even when church services were available, it was typically the women and children who attended.[70] The men were more often seen standing outside the church congregating for conversation rather than receiving

the good word. It is telling that while the Cajuns were fond of music and songs, little to no religious context can be found among them.[71] To further show their traditional, rather than religious, devotion to Catholicism, the Cajuns were exposed to and eventually came under the influence of Afro-Caribbean practices as well.[72] Most notable is the belief in and use of the *gris-gris*, part of the voodoo belief system that included use of and reliance on *traiteurs*, traditional medicine healers for minor maladies and pains.[73] Another interesting example is that Cajuns were also highly superstitious and believed in zombies and ghosts, although this can likely be attributed to their lack of education more than anything.[74]

It is impossible to understand modern Cajuns without acknowledging and studying the trials and tribulations of the Acadians. Though much is made of Cajun resilience, this resilience is much older than Cajun culture, older even than the Acadians. This resilience has its roots in the struggle for survival—a struggle that occurred against nature and against governments, in the midst of geopolitical upheaval and great discovery. That the Acadian culture survived in any form, much less as a distinct culture, is a testament to the pride and strength of these people. But the pride of the Acadians never stopped the culture from growing and changing, and it is not just strength and pride but a willingness to adapt that has resulted in the Cajun culture of today.

Assimilation: One Big Pot of Cajuns

Cajuns, though identified as a distinct ethic group, were and still remain adept at assimilating people into their culture. While different ethnicities tended to stick with each other when arriving in South Louisiana, over time, they commingled with groups like the Cajuns. Intermarriage between groups became commonplace and has been well documented throughout time. Cajuns intermarried freely with other ethnic groups including French, Spanish, Germans and, to a lesser extent, Anglo-Americans and American Indians. Afro-Caribbean slave culture and its descendants who populated Louisiana and shared a common French-Catholic heritage also heavily influenced the Cajuns. All of this cross-pollination resulted in a new ethnic group—the Cajuns (an umbrella term we now use freely), who number well over half a million people today.[75]

Houses were a more common sight in the marshlands of South Louisiana in the nineteenth and early twentieth centuries. *Courtesy of Louisiana Department of Wildlife and Fisheries.*

While late eighteenth- and nineteenth-century Cajuns by and large married within their ethnic group, marriage to outsiders was not frowned upon. Interestingly, what typically happened after marriage is that the person who married into the Cajun culture became part of it, up to and including cutting off contact with their original outside families.[76] Oftentimes, English, Spanish, German, Italian, Irish, native French and even some Creoles married into the Cajun society and ostensibly became Cajun by doing so.[77] They adopted the lifestyle and value systems of Cajuns in the process.[78] Typically, and perhaps speaking to the appearance of Cajun women, when an outsider came in to the community, it was a foreign male who came in and married a Cajun woman. Since the women did the child rearing, the cultural assimilation for the offspring into full Cajuns was pretty fluid. This intermarrying practice allowed for the Cajun ethnic group to grow larger and more diverse over time, while retaining a coherent identity. Understandably, though, these practices also led to the first significant dilutions of culture.[79]

While individual elements of all of the component cultures of Cajun culture are still evident today, they combined to form what is now thought of as a central Cajun heritage. Of all the varied cultures mixed in the blood of Southeast Louisianians, the traditional Cajun culture remained dominant until the Americanization process took hold and became dominant in the region. After the Civil War, the fisheries industries became more formalized and attracted labor into the area. Accompanying this influx of labor, more and more folks began marrying into the Cajun culture. By the mid-1880s, the swamps and marshes of Louisiana held hundreds of communities with populations ranging from ten to over one thousand people.[80] The practical sensibility, resourcefulness and common-sense nature of the Cajuns made living and working in the marshes possible, and the shared knowledge of the ways to survive in this environment helped to cement cultural ties between long-standing residents and newcomers alike.[81] If they didn't know what to do, they figured it out, asked around and spread the answer to their neighbors; new aspects to the culture were developed out of necessity all the time.

By the mid-1920s, technology had progressed as such that the fishermen could move from the wetlands to the end-of-the-road communities.[82] This put them one step further away from the lands and one step closer to mainstream society. The concentration of fishermen into communities further helped to create a sense of togetherness and belonging. While the communities were isolated from the outside, they required a high degree of self-sufficiency to survive. They were bustling worlds in their own right. By nature of their proximity to one another and their common means of survival, the disparate peoples lumped together in these communities slowly melded into one people—the people we call Cajuns today.

Thus the modern colloquial Cajuns are not the insular communities they are often thought to be. This reputation comes from their fierce independence and self-reliance, but this trait has been bred over the centuries through many different bloodlines. The luxury of exclusion has rarely been afforded to people who live on the level of subsistence, and the people of the region are, and have always been, smart enough to know a good idea when they see one. *Pirogues, bateaux*, shrimp boats and oyster luggers are vastly different from each other because the plans for these structures have come from vastly different cultures that solved these unique problems in unique ways before importing them to Southeast Louisiana.[83] The people of Southeast Louisiana adopted all variations freely for their uses.

We found a great example of assimilation during the research for this book. In an interview, Cajun food historian and author Marcelle Bienvenu recounted a story of a Mr. Schexnaydre from St. Martinville. When Bienvenu was a little girl, she asked her father what kind of name "Schexnaydre" was. He told her it was German, and she asked how come he was speaking French if he was German. Her father explained that while his family was of German descent, he'd lived in South Louisiana so long that he became Cajun just like everyone else around those parts. If you were to ask Mr. Schexnaydre what he was, he'd say Cajun. His family became assimilated into the Cajun culture because they lived and worked among Cajuns. For all intents and purposes, they were Cajun, just of German—not French—ancestral heritage.[84]

A great story of the Cajun assimilation of people of other ethnicities was hidden right here in our own family.[85] Addie's third-great-grandfather, a man named Nical Constraenchil, was originally from Austria, thought to be from Kershaw, though little evidence remains to this date that can verify that. Even Nical's exact first and last names are debated. Seven different versions of his full name exist in official documents, ranging from his marriage license to census data to his death record. Sketchy record keeping was common in the late nineteenth and early twentieth centuries, especially when it concerned immigrants who came in through lesser-known ports and points of entry like Nical did. Even to this day, the extended family descended from Nical has many different versions of the spelling of his name. Addie's branch of the family spells it "Constransitch."

Best we can surmise, Nical landed in Southeast Louisiana sometime around 1878 after crossing the Atlantic as a passenger. The circumstances surrounding his arrival, including the port he landed in, aren't clear. Family stories indicate that he was sent here by his family to avoid being drafted into the Russian military, which he was in danger of due to his age and his family's stature in his motherland. Documents and personal accounts show he spent a little time living in New Orleans until he eventually made his way down to the coast to Chenier, a small fishing village near Grand Isle. He moved a few miles north to Leeville, where he met and married Josephine Clementine Lee, a resident of Leeville and a member of the family after which the town was named.

It is believed that Nical and Josephine didn't even speak the same language. The family lore goes that by the time Nical met Josephine, he spoke seven languages, none of them French, while Josephine would have spoken French since she was a Cajun girl from the coast of Louisiana.

He is reported to have refused to learn to speak French since he spoke so many languages already. How he was able to survive and thrive in a French-speaking area is a mystery, but somehow they made it work.

Eventually, Josephine and Nical had many children, one of whom was a son named Valance. Valance is Addie's great-great-grandfather. All of Nical and Josephine's children were raised speaking French as Cajun children. Even though Nical refused to learn the language, he still lived like a Cajun and had children who were Cajuns. Eventually, Valance married another Cajun woman named Daisy. They had several children, one of whom was named Valance Jr., born in August 1914. He is Addie's great-grandfather. All of these people primarily spoke French, although by the time Addie was born, she remembers Valance Jr. speaking English but in a distinct French style and demeanor. Even Addie's grandfather, Gerald, son of Valance Jr., was a French-speaking Cajun. Of course, he knew and spoke English well, but he and her grandmother Lois would often converse in French, especially when they wanted to keep conversations private from the kids and grandkids because none of the younger generations spoke much French. Some were able to understand and speak a bit, like Addie's Uncle Brent, who worked with his maternal grandfather trawling during summers off from school. But by and large, it's Addie's grandparents' generation who were the last fluent French speakers. These were people born in the 1930s, and by the time that generation had children in the late fifties and early sixties, they were no longer deliberately teaching their children the French language—the end of a journey that began over 150 years earlier in the mountains of Austria.

3

THE EVOLUTION OF
CAJUN CUISINE

Since the Acadian and subsequent Cajun culture has been the prevailing culture in Southeast Louisiana, it's fitting that these people's cuisine is also what came to dominate plates in the region. What is thought of as Cajun cuisine today is a far cry from the food that the original Acadians ate when they arrived in Southeast Louisiana, and this is a testament to how quickly cuisine and food cultures are able to evolve, especially when they are so heavily influenced by ingredients and techniques adopted from other ethnic groups. The original Acadians would not recognize what people eat today as "their food," and that's because it's not. Like everything else, the cuisine of these people changed and adapted to accommodate the best possible options available at the time. Cajun cuisine didn't evolve or form in a vacuum. It actually evolved greatly over the last two hundred years based on thousands of individual households cooking a basic set of dishes in their unique way. While many similarities exist among regional dishes, it is easy to see how no two gumbos are ever exactly the same. Cajun cooking tends to stick more to general guidelines than hard and fast rules. This ambiguity is the result of an informal evolution among a population that spent much of its pre–World War II existence as illiterate folks who passed traditions on orally, not in written form.

At this time, life in Southeast Louisiana was simultaneously simpler and more difficult. The foods of the region speak to a time when the grocery store was not an option and cooking was an hours-long affair.

Many of the cultural celebrations and practices of the people of Southeast Louisiana are based on foods made from ingredients found in the region and influenced by the lifestyles of the people who obtained those ingredients. The region has historically contained a population of people who did not fare nearly as well as the wealthiest or even middle class of their time. While not destitute, more often than not, they were not people of means. It is no surprise then that resourcefulness has played a significant role in the development of both the food and culture. Overall, cuisine in Southeast Louisiana is centered on maximizing available ingredients. The 2005 book *Stir the Pot*, a historical account of the evolution of Cajun cuisine, painstakingly details the foods and foodways of these early settlers. Much of what follows is based on the in-depth and highly detailed research presented in that book.

The original Cajun cuisine evolved mainly from the people's willingness and ability to incorporate the food items available to them, as well as their creativeness in using those foods. The original French settlers in present-day Canada were poor peasants, and when they lived in New France, as it was called, their diet consisted mainly of simple soups and wheat-based breads.[86] It was documented that in 1755, around the time of the expulsion, a favorite food for the soon-to-be Acadians was *soupe de la Toussaint*, which contained turnips, cabbage and occasionally pork (if available).[87] They rarely consumed meat because they were poor and didn't have access to salt, the key agent in preservation. However, the northern frontier offered a variety of wild animals for these early pioneers. Most significant of these were pork, poultry, fish and wild game.[88] These items were much more readily available for catching and consumption on the frontier than they were in the French motherland.

The first major change in these people's diets came when they arrived in Louisiana. Since barley and wheat, two of their staple grains, did not grow well in the hot, humid climate in which they were now living, the Acadians had to devise new ways of getting grains and basic sustenance into their diets.[89] Thankfully, the government provided the new settlers with corn seed. The Acadians were unfamiliar with this grain, being from so far north, but they had little choice but to teach themselves how to grow, harvest and cook with these crops.[90] Some of the American Indian tribesmen, being intimately familiar with corn, helped show early settlers what to do with the strange new grain.

Interestingly, corn served as the base of the Acadian diet until rice replaced it in the early twentieth century. Until the late nineteenth

century, rice was a marginal crop grown sporadically throughout South Louisiana. While it was the Germans who first introduced commercial rice production to the area, it was not done on a large scale until immigrants from the Midwest brought steam-powered irrigation to the area.[91] Rice needs ample and steady amounts of water to thrive, and prior to mechanization, it simply was not possible to maintain consistent, commercial-sized rice crops in southern Louisiana. Prior to irrigation technology, rice was used more as a fallback crop, something grown in small quantities just in case the corn crops failed. This rice was typically called providence rice, as it depended on rainfall for the moisture it needed to thrive.[92]

In addition to the staple crops like corn and providence rice, Acadians grew fruit orchards and planted large gardens for their supplementary vegetables. The Acadians were known for their large gardens with distinct variety. In *Stir the Pot*, the authors report extensively on early crop varieties, and they note that the Acadians grew legumes, herbs, large cabbages, lima beans, English peas and sweet potatoes as well as maintaining large apple orchards, from which they used the fruit for both eating and cider production. They also grew various fruit trees like peach, apricot, plum, pear, fig, pomegranate and pecan plus grapevines—especially muscadine.[93] It seems that the early settlers were adept at farming and growing the food they needed to survive.

While this was eventually the case, these crops took time to establish. The Acadians lived meagerly in the years immediately following their resettlement as they adapted to their new latitudinal position. They turned to the waters, woods and swamps of southern Louisiana to find meat to eat.[94] Once they established basic skills for their new hunting areas, they began to hunt, fish and trap in earnest. Eventually, the Acadians hunted many of these species into or near extinction. Multi-day fishing and hunting expeditions were common among the Acadians and, later, the Cajuns. Because nature only provided so much bounty for the growing group, they took to raising animals such as pigs, chickens and cows for consumption as well.[95] With open, dry land at a premium, raising large livestock herds and growing intensive grains was done on a limited scale for domestic (personal) use rather than for export and food identity. Further, with settlements starting in the eighteenth century, the region developed in an age when importing food was expensive. Therefore, dishes were not historically prepared based on appetites but rather based on what could be grown or caught by these fishermen,

The swamps of Weeks Island in Iberia Parish. Nowadays, this island is used for salt mining by Morton. *Courtesy of Louisiana Department of Wildlife and Fisheries, 1966.*

farmers and hunters. Over the last two centuries, residents of Southeast Louisiana have made the most of what they have, managing to turn what appeared to be very little into a celebrated abundance.

Like their French brethren, the Cajuns were masters of utilizing elements and practices from different cultures and adopting them as their own. Cajun cuisine was not just born out of a French way of cooking. It's much more complicated and nuanced than that. The early Acadians, and then Cajuns, had culinary influences from the French, of course, but also from the Italians, Germans, American Indians and Africans. Those are the main influences, but hints of further influence from people like the Isleños, Croats and Spanish are present as well. To say that Cajun cuisine is a melting pot cuisine hits the nail on the head. Not only did what evolved into Cajun cuisine vary by geographic region, but it could also vary by household within that region.[96] Early Acadians were resourceful people who leaned on others already in the area to help them figure out what could be grown and what they were to do for food in this new area. They liberally adopted ingredients, cooking techniques and approaches to cooking as it suited their needs. What we know today as "Cajun cuisine" is an amalgamation and evolution of two centuries of collaboration and

assimilation of different food cultures and approaches to cooking. Just as the term *Cajun* became a melting pot for the group of people living in South Louisiana, so did the cuisine evolve as a mishmash of many different ethnic backgrounds, namely French, African, Spanish, German, American Indian and Anglo-American.[97] Key dishes from the Cajun recipe catalogue can be traced back directly to influences of these groups.

The two groups the Cajuns borrowed most notably from were the African and American Indian populations. *Filé* powder, well known in Cajun gumbos as early as 1803, was first introduced to them by the American Indians, as was cornmeal, the base for the traditional dish *couche-couche*, a cornmeal porridge eaten frequently by early Acadian and Cajun settlers.[98] The natives also taught early settlers about crawfish and oysters.[99] While some settlers were familiar with them already, they weren't accustomed to having them in readily available quantities. American Indians were also known to offer assistance to early settlers ranging from identifying which plants were acceptable to eat to showing them how to process items like turning the sassafras root into *filé* powder. Other foods that can be attributed to the natives who introduced them are corn, pecans, muscadine grapes and persimmons.[100] These were all part of the local vegetation by the time early Europeans (pre-Acadian populations) arrived, but many of these were foreign and unknown to the settlers. Education by native people allowed the newcomers to understand how to incorporate these items into their diets.

Maque choux, a corn and tomato dish, was derived from a dish the American Indians ate, which the early European explorers called *sagamité*.[101] While a version of this dish has been around in South Louisiana for well over three hundred years, it evolved considerably when Europeans, especially the Cajuns and Afro-Creoles, began to settle and colonize the region. While the Cajuns made the dish a mainstay in their diets, they got the idea for using bell pepper and tomato from the Afro-Creoles.[102] Jambalaya is another example of a dish that the Cajuns adopted and made their own. Jambalaya is quite close to the Spanish *paella* in cooking method and types of ingredients included. While it cannot be said with certainty when jambalaya first appeared in Southeast Louisiana, the authors of *Stir the Pot* believe it was sometime in the eighteenth century.[103] The sausage that's used in dishes like jambalaya and gumbo can trace its roots back to the European charcuterie cultures that were brought over to the New World and re-created here with local ingredients.[104] Gumbo itself originated from African culture and roots.

Further, food historian and author Marcelle Bienvenu believes that the Germans have not been given their fair share of credit in the pantheon of Cajun food history and cuisine. It was the Germans, with their sausage making skills, who introduced foods like *andouille* to the people of South Louisiana. The Germans have a strong heritage of sausage making as well as beer brewing, and they brought that knowledge over to the New World when they immigrated.[105]

Ultimately, the early settlers developed a uniquely American cuisine, one of the last American cuisines still identifiable as an independent food culture today. It was a food culture based around necessity, yes, but also around the complex tastes of earthy vegetables and animal fats (from the French) and spice (from the Africans). George Washington Cable noted the cooking prowess of the region's householders in 1880, especially when it came to cooking meats.[106] But the cuisine of this time was nothing out of the ordinary—except gumbo. The first reference of gumbo is found in 1803 in conjunction with a gubernatorial reception in New Orleans and then again in 1804 by someone observing a house dance in Acadiana.[107] The authors of *Stir the Pot* posit that even before Louisiana's statehood, gumbo had surpassed *soupe de la Toussaint* as the preferred dish of the newly dubbed Cajuns. Gumbo was a staple in the nineteenth century, often served at Sunday dinner and after a *bal de maison* (house dance).[108] While the exact origins of gumbo are not fully known, once it hit the scene, it was quite popular with Cajuns as well as the city dwellers up in New Orleans. It is fitting that the Cajuns probably invented gumbo, a dish widely known for its ability to incorporate everything, for the people of Southeast Louisiana incorporated everything into their foods while maintaining a basic simplicity of preparation that remains core to the cuisine to this day.

Oral historian and writer Kevin McCaffrey astutely noted that gumbo is a perfect microcosm through which to study subtle differences in the Cajun foodways.[109] Not only did recipes vary from bayou to bayou, but they also varied from home to home. On top of that, when someone married into the family, they usually brought in their own recipe, and oftentimes a single family had two recipes. Also, note that the term "recipe" is used loosely. Since Cajun French was more an oral tradition than anything else, recipes were a loose organization of ingredients and steps. It was more to note the technique and general ingredients used, not to give someone a road map of how to cook a dish. Even the most iconic of Cajun dishes have no set recipes. Sure, they have standard sets of ingredients or commonly used ingredients, but since communication was

not universal during that time, people just used what they had accessible to make these dishes. If something wasn't available in their region, they'd substitute. Since the Cajuns spent a large part of their existence living on the subsistence level, they simply learned to make do with what they had. This "making do" and maximizing what was available helped to shape what is now known as Cajun cuisine.[110]

While Cajuns were quite fond of gumbo, and centered many a social gathering on its consumption, they were equally fond of coffee. Coffee is a staple of the traditional Cajun foodways. It is the most revered beverage, with alcohol trailing close behind. It was considered rude to turn down an offer for a cup of coffee in someone's home.[111] In the past, coffee was the lubricant for social gatherings, big and small, formal and informal. Coffee acted as a unifying agent—something that could be enjoyed at a kitchen table while old friends caught up on recent happenings. Along with gumbo, coffee was traditionally served at the house dances of the nineteenth century.[112] Along with alcohol, coffee was the preferred social beverage of nineteenth-century Cajuns. Coffee was typically consumed in the early to midday hours while alcohol, especially tafia and whiskey, was consumed from the afternoon hours onward.[113] Coffee was indeed the universal drink of the Cajuns. Even poor families offered coffee, if nothing else, to visitors. Housewives frequently bartered eggs for coffee since they typically had a glut of hens and eggs to spare.[114] To this day, coffee is still widely consumed in Cajun country by young and old alike.

A tradition that illustrates the deep love and reverence Cajuns had for coffee, especially in the nineteenth century but still practiced to this day, is the ritual of "high coffee." In *Stir the Pot*, the authors detail the scene:

> *Cajuns consumed the social stimulant in a ritualistic fashion. Guests who were not part of the immediate family were treated to the pomp and circumstance of Cajun high coffee. The hostess brewed the elixir in the kitchen and served her company in the living room. Children often acted as wait staff, presenting the coffee in the home's best demitasses and saucers on a serving tray, alongside the family's finest sugar bowl and silverware. The hostess served the robust, syrupy concoction either as café noir...or café au lait...perhaps accompanied by a slice of cake or sweet dough pie.[115]*

Like coffee, alcohol played a prominent role in the Cajuns' daily lives. In the pre–Civil War era, Cajuns relied heavily on tafia, cheap rum made

from molasses and sugar refuse and distilled in the West Indies. After the war, whiskey became more readily available, and the Cajuns moved on to that.[116] They also developed more of a taste for beer at that time. Cajuns had a reputation for being drinkers and sometimes for not being able to hold that alcohol very well. Cajuns used alcohol not only as a means of intoxication but also to socialize with one another, especially during holidays and special celebrations.[117]

While regional and sub-regional differences exist within the pantheon of Cajun cuisine, commonalities and similarities exist as well. *Stir the Pot* does a great job of highlighting and explaining the differences and similarities. We've included here some relevant examples that illustrate the evolution of Southeast Louisiana cuisine with additional discussion. In the nineteenth century, salt pork, poultry, corn and seasonal vegetables dominated the plate and cuisine. While corn has all but disappeared from Cajun cuisine, with the exception of the previously discussed *maque choux* and corn bread, it was once the main staple grain on which virtually every meal was based. Dishes like *couche-couche* could be found at both breakfast and supper. Pork and chicken continue to be staples, along with rice, which serves as the base starch for nearly all Cajun dishes. Rice is particularly important because it acts as a stretcher for meats and vegetables, thus lowering grocery costs. Braised meats and gravies are also common among Cajuns as hearty but relatively inexpensive meals.[118]

Not only does continuity exist in the types of ingredients used, but continuity is evident in preparation techniques as well. One-pot meals were, and still are, common throughout Southeast Louisiana.[119] In the eighteenth and nineteenth centuries, families did not own extensive numbers of cookware items, nor did they have much time to prepare exotic dishes. In regards to cookware, early Acadians and Cajuns used two types of pots—a cauldron for slow cooking and a deep skillet for frying.[120] Simple one-pot meals were prolific in the nineteenth century, and that tradition continues today. Home cooks especially value cookware made from cast iron for its versatility. It's useful on the stovetop, in the oven and can even be placed over an open flame, such as with outdoor cooking. Many of today's Cajun cooks still feel that cast iron is superior to other cookware for its ability to hold heat, its durability and the ease with which it can be cleaned, presuming it's properly cared for by its owner.[121] Not surprisingly, nearly all of the iconic Cajun dishes today are cooked in a single pot: gumbo, jambalaya, *étouffée*, *court-bouillon*, *fricassée*, white beans and even boiled crawfish.

Regional differences in cuisine were inevitable considering the expansiveness of Southeast Louisiana. For instance, people east of the Atchafalaya Basin were able to easily obtain wheat from New Orleans, so they ate bread long before people in Lafayette and westward were baking bread.[122] A communal bread oven was documented in Grand Isle as early as 1890. It was used daily as a means to keep everyone on the island supplied with fresh bread, an important dietary staple for the population at the time.[123] The regions closer to New Orleans, especially along the coast, were also more apt to eat like New Orleanians. They were known to eat red beans and rice on Mondays and prepare beignets out of uncooked bread dough. Of course, the coastal areas also consumed more seafood than the prairie and other more northern areas. The northern and prairie areas were more prone to eating beef and pork by way of sausages (*boudin* and *andouille*) and from the bounty of the *boucherie*. The lower-lying areas were better for fishing, while the areas at higher elevation provided better farming and grazing lands. The Cajuns in the lower Lafourche Parish and Terrebonne Parish region started using pasta earlier than other Acadian locales due to the migration of Sicilian immigrants from New Orleans to the region.[124]

The differences between Cajun cuisine (the cuisine of the country) and Creole cuisine (the cuisine of the city of New Orleans) mostly come down to cooking techniques. They tend to use similar ingredients but prepare them in different ways. In Creole cuisine, food is often fried. Two main reasons explain this. The first is that deep-frying is an African tradition that was brought over by slaves. Secondly, frying was popular in Creole cuisine because it was a quicker way to cook. In an urban environment like New Orleans, people were concerned about leaving food cooking too long lest a fire take out the house. Often in Creole cooking, seafood is flash fried and then covered with sauce. *Trout Amadine* is a great example of that. The trout is breaded and flash fried, covered in a butter and almond sauce and served.[125]

As we've discussed, in Cajun cuisine one-pot cooking techniques dominated the culinary landscape. The practice of braising meat was common, and food was often smothered during the cooking process. Since the Cajuns primarily lived out in the country or in coastal areas, they had easier access to wood for building fires that would burn for hours. Also, since the lifestyle of Cajuns was more rural and agricultural, they oftentimes had to cook while they worked. This is where one-pot, slow cooking comes in handy. Dishes like gumbo lent themselves well to this type of cooking technique.[126]

While many people think of seafood as the backbone of Cajun cuisine today, that's actually a quite modern development. Prior to the Civil War, seafood was caught as part of personal endeavors into the marshlands and salty waters of the Louisiana coast. Such trips were not feasible for all Cajuns, especially during the post–Civil War era when most people were destitute due to the collapse of the state's economy. The focus on subsistence living meant that Cajuns in the region were largely limited to cooking whatever they could out of whatever was in season and able to be caught and killed. It is difficult for a cuisine to develop in an environment of such scarcity. However, with the arrival of the economic boom brought by the ability to export seafood, the eating in the region became a little more stable and a little more predictable, and the conditions were ripe for the development of a more complex, codified cuisine, as opposed to the improvisational nature of eating and cooking that had dominated the scene through the early days of Cajun existence.

While Cajun cuisine, lacking a large population base or academic background, appears to be a kind of "little cuisine that could," it's easy to see how the cuisine has survived this long. It has always been based on necessity—the simple act of providing nourishment for one's family. While other cuisines got caught up in what was canon and what was bastardized, Cajun cuisine evolved as ingredients and techniques evolved. When cheaper nourishment was available, it was incorporated into dishes that changed readily to match those new ingredients. The flexibility and simplicity of Cajun cuisine, combined with an appreciation of flavor, have made it a staple in homes across Southeast Louisiana to this day, and it continues to evolve. It seems that the foundations of the cuisine laid centuries ago are strong enough to bear the weight of whatever modernity throws into the big iron pot.

4

THE BUILDING BLOCKS
OF MODERN SOUTHEAST
LOUISIANA CULTURE,
INDUSTRY AND FOODWAYS

The first significant culture and lifestyle shift for the Cajuns in Louisiana came with the Civil War in the 1860s. While the Cajuns didn't typically participate in the war by choice, many were recruited to serve.[127] After the war, politics and socioeconomics changed in ways that altered the Cajun existence. At this time, the Cajun population numbered somewhere between thirty thousand and thirty-five thousand, and they still existed as a separate, distinct ethnic group.[128] That cohesiveness was about to change with the impending arrival of the railroads. Developing alongside the railroads was an Anglo viewpoint that stigmatized French culture in the mainstream. French culture mainly survived by being practiced in the home with music, gatherings and cooking and within the Catholic church.[129] While the Civil War was not significant in the process of Americanization, it did bring in more people to the Cajun culture. When the Civil War ruined the state's economy, it leveled the playing field for many of Louisiana's ethnic classes, and with this, the intermarrying between Cajuns and other ethnic groups happened at an accelerated pace.[130] Historian Shane K. Bernard believes that more than any other event, this "post-bellum blending process" created the people we now think of as Cajuns.[131]

The economic hard times faced by the Cajuns and other residents of Louisiana after the Civil War lasted for decades, unfortunately. It wasn't until the post–World War II era that people finally fully recovered from the crisis.[132] In the period during and after the Civil War, food was in

short supply. This was due to a host of factors including destruction by Union forces and widespread foraging practices by both Union and Confederate troops that led to decimation of crop yields.[133] During this time of peril, Cajuns banded together to ensure that everyone had food and no one starved or went hungry.[134] The Cajun community was no longer limited to small, inward-facing communities, either. Especially in the post–Civil War era, downwardly mobile Creoles and Anglos found themselves increasingly lumped in with Cajuns. At first, this was attributed to the fact that they were all poor and low on the socioeconomic ladder.[135] Eventually, marriages between these downtrodden groups cemented the relationships and social bonds between the Cajuns, lower-class Creoles and Anglos.[136] As with so many other ethnic groups, the Cajun culture assimilated these folks into their group as their own.

Even the Genteel Acadians faced hardships. While this group included a distinct sugar cane planter faction, few attained the status of wealthy, successful planters.[137] The Civil War had devastating effects on Acadian planters. After losing their low-cost labor source and economic model with the freeing of the slaves, many of these Genteel Acadians were forced into poverty.[138] This pushed some of them further away from the Anglo lifestyle they were seeking. Some ended up joining the ranks of the Cajuns along with other downwardly mobile Anglos, recent French immigrants and poor Creoles. The term *Cajun* was soon applied as a catchall for the socially downcast, despite a person's background or ethnic origin.[139]

During the Reconstruction period, black slaves were freed from their original plantation homes and allowed to move into the general population. This caused racial tensions all around, even in Cajun country. Anti-black sentiment was heavy in that period, especially among economically and socially disadvantaged groups like the Cajuns. Also during the Reconstruction period, more people in general were moving around in the state and encroaching on the once-isolated lands of the Cajuns.[140] The Cajuns themselves began to change during Reconstruction. They were still fun-loving, family-oriented people, but they increasingly became violent with one another and within the population.[141] They took to carrying knives and guns around with them and would fight amongst each other for sport and fun.[142] The community, by and large, accepted this behavior and did not see it as disturbing. This was not surprising, as the nineteenth century was still a time of gunfights and duels, although both were illegal at that point. While this increase in violent behavior

hasn't been explained in an official capacity, it's posited that it can be attributed overall to the threat posed by the increasing influence of outsiders—those seeking to usher in change in this new Reconstruction period.[143] Throughout this time however, the Cajuns maintained their sense of family and kinship. They remained tightly knit, and families stuck together for generations.

During the late nineteenth century, life once again changed drastically for the Cajuns. The first inklings of mindset changes from the older to younger generations appeared. George Washington Cable was the first to observe this via his writings. He noted that even as early as the 1870s, young Cajun men and women were starting to abandon the traditional ways and aspire for material success.[144] The younger people started speaking English as a way to achieve upward social mobility, something that was previously unheard of in the Cajun culture.[145] To add to this, even more significant changes laid ahead with the completion of the Southern Pacific Railroad line in 1880.[146] This was the first tangible break in the Cajun rural-isolation lifestyle.

In 1880, the completed railroad connected New Orleans to Houston. While this directly linked both major cities for the first time, it also opened up opportunity for settlements along the rail line. Many formerly isolated communities and people were now connected to the broader world. Whole new communities and towns developed as an outgrowth of this progress. The connectivity between groups and people increased the contact Cajuns had with the outside world. Anglos began moving into traditional Cajun areas to provide services like doctors, lawyers and clergy.[147] Since at this time many of the Cajuns remained uneducated, outsiders had to be brought in to fill these professional and service gaps, much to the chagrin of some Cajuns.[148]

Development of the Fisheries Industries

Modern Southeast Louisiana food culture is largely centered on the lifestyle and products of the region's abundant fisheries. The five main fisheries industries in Southeast Louisiana are shrimp, oyster, crab, crawfish and finfish. Each of the fisheries industries in Louisiana has its own story of origin, and the industries themselves are different in many ways. However, similarities exist between these industries as well. All started on small

scales as family endeavors, and as technology advanced, each industry grew and became more specialized in its own way. Mechanization, boat motors, developments in better nets and other essential equipment and even the commercial production of ice all played transforming roles in the growth and modernization of each industry. The post–Civil War era saw the formalization of these industries from what had previously been more of a loose band of individuals. The driving forces behind this formalization were technological advances that grew the market beyond what was even thought possible.

While shrimp and oysters were eventually canned and shipped all over the country, local demand for fresh seafood, especially in New Orleans, was ever present. New Orleans was the richest city in the country prior to the Civil War, which means that many people with highly sophisticated palates wanted and received fresh seafood. Even before the industries were formalized, a market for fresh seafood existed in New Orleans. At first it was for oysters and shrimp, but later, this expanded to finfish like flounder and redfish.[149]

Further, the introduction of the railway system and decreased transportation time caused a decrease in practice of traditional food storage methods like smoking, salting and preserving in vinegar.[150] What was once a several-day affair, transportation to New Orleans by rail could deliver products in hours. Once icehouses and ice factories became commonplace after the turn of the twentieth century, commercial fishing and hunting industries burgeoned. Perishables like fish, shrimp and oysters could now be easily shipped to markets in New Orleans and beyond. Prior to the railroads making the shipping of refrigerated products possible, commercial fishing was limited to areas that were geographically close to New Orleans, mainly in St. Bernard Parish and surrounding areas.[151] Now the whole Louisiana coastline was linked within a day of the New Orleans markets.

The Shrimp Industry

Although the other fishing industries came into existence in the nineteenth century, shrimping actually arrived in the 1700s. While not as robust as what it evolved into, the shrimping industry did see its meager beginnings in the eighteenth century with people dragging seine nets by hand.

Sometimes they were in skiffs and other times on land or in shallow water. This practice was observed and noted by historian La Page du Pratz in 1774. The French brought seine nets over with them to the New World and used them to catch the shrimp available in the lakes and marshlands south of New Orleans.[152] Prior to that, one of the earliest documented shrimp-gathering methods involved placing a handful of cornmeal in a burlap sack that was cut in half to allow for a large opening. This bag was lowered into the water so the shrimp could enter the sack to feed on the cornmeal.[153]

The industry remained small scale and highly localized until Chinese immigrants brought their shrimp-drying techniques to South Louisiana in the later quarter of the 1800s. The Chinese brought this ancient practice first to San Francisco and then into Louisiana as a means to get more product back into the Orient.[154] Shrimp were dried on huge platforms out in the middle of the marshlands. Once these drying platforms were implemented on a large scale, the first market expansion for Louisiana shrimp was created.[155] A more portable product meant that, for the first time, shrimp caught in South Louisiana could be shipped elsewhere.

The process of drying shrimp was long and labor intensive. Not only the Chinese worked in the shrimp-drying industry, but many Cajun fishermen did as well.[156] After the shrimp was caught and delivered to these platforms, it was sorted and prepared for cooking. The shrimp was first cooked in large cauldrons and then laid out to dry on huge outdoor cypress platforms.[157] Workers used large wooden rakes to turn the shrimp to ensure even drying.[158] Prior to mechanized separation, the heads, tails and shells had to be removed manually. Workers would cover their shoes and "dance the shrimp," whereby they crushed the dried shells and heads with their covered feet. What remained was later sifted by either utilizing a large wire-cloth frame or by throwing them up in the air during brisk winds.[159] In the heyday of shrimp drying, it's estimated that Louisiana had eighty of these platform outposts, which averaged an acre in size.[160] An accurate count was never garnered due to the destruction brought by the hurricanes of 1893, 1915 and 1926.[161]

Not long after shrimp drying came into play, canning made its debut. Shrimpers and processors now had a second way to export shrimp to other markets. By the 1880s, canning was widespread.[162] Along with the expanded market came increased demand. Americans had developed a taste for shrimp, and it was nearly insatiable from the beginning.[163] Once commercial ice was available on a large scale, the shrimp-drying portion

of the industry dwindled into an Asian specialty market.[164] When shrimp could more easily and effectively be packed and shipped fresh, consumer demand rose significantly. The accessibility of fresh shrimp eventually negatively impacted and reduced the demand for canned shrimp.

At the turn of the century, the equipment used for harvesting shrimp underwent major developments and improvements as well. True commercial shrimping began in 1915 when the otter trawl, which originated in North Carolina, made its way to Louisiana.[165] Motorized boats and improvements in nets allowed the industry to keep growing through the early twentieth century.[166] In our interview, Mr. George Terrebonne, who grew up in the shrimping industry, had an interesting story about his grandfather and great-grandfather who used a hand-pulled seine to catch shrimp.[167] They'd go to the beach on Grand Isle and push-pole the boat to where they wanted to catch shrimp. Back then, fishermen were better tuned into nature and knew when to go out looking for shrimp by how the tides were—they knew which tides to work. When the tide was right, the water near the beach was clear enough to see through to the bottom. The shrimpers would look for the whiskers of the shrimp sticking out of the sand. They'd wait until the tide would change again, and then the shrimp would come out of the sand. At that point, they'd pass the seine by hand and catch them. One day when they were out pulling the seine, they heard a noise. It was another small boat with a small three-cylinder engine on the back. The owner of that boat threw a trawl into the water and sped up the motor. This man was trawling for shrimp. Mr. George's great-grandfather turned to his son, Mr. George's grandfather, who was a child at this point, and said, "You see that there? That's the end of the shrimp." This was back in 1910, as best Mr. George can estimate.[168] Little did they know, plenty of shrimp were in the Gulf at that time. Over one hundred years later (in the present day), we are still going strong with the shrimp supply. Combined with motorized boats, the otter trawl eventually replaced the hand-operated seine because it was a more efficient and effective means of harvesting shrimp.[169] The otter trawl allowed shrimping to take place year-round, hauling in unprecedented shrimp-harvest loads. The 1930s became a time of prosperity for commercial shrimpers. The introduction of the otter trawl, commercial ice and motorized boats combined to rocket the industry into more modern times.

By 1930, motorized boats had become more commonplace. After mechanization of boat motors and with the introduction of better trawls,

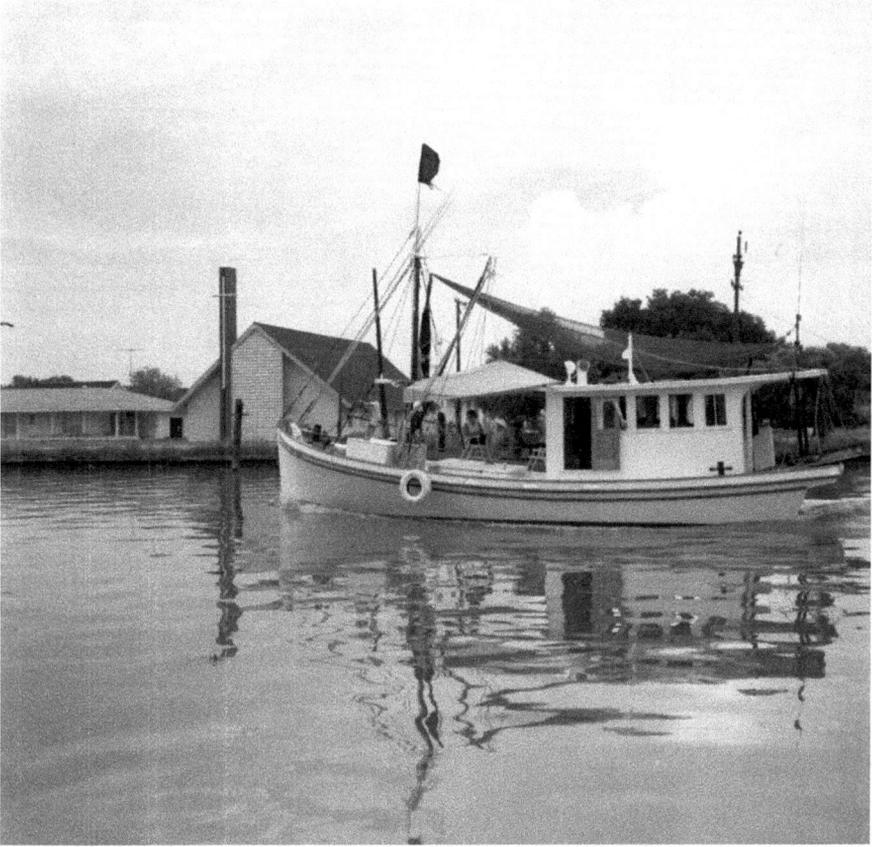

A small shrimping boat heads up Bayou Lafourche, just north of the town of Golden Meadow. *Courtesy of Louisiana Department of Wildlife and Fisheries.*

the commercial fishing industry grew rapidly. In 1880, only half a million pounds were harvested. Contrast that with the 16 million pounds in 1919 and then to the 32 million pounds harvested in 1920.[170] The number of fishermen increased rapidly after mechanization as well. For example, in 1917, only 4 trawls and 300 seines were commercially licensed in Louisiana. Twenty short years later in 1937, the number of registered trawls climbed to 2,313 while the seines dwindled to 35.[171] Mechanization allowed fishermen to expand into deeper water farther offshore. No longer were they bound to the shallow lakes and wetlands. The annual harvest numbers exploded in the 1930s, providing yet another boon for shrimpers. In 1937, the first "jumbo shrimp" were discovered and

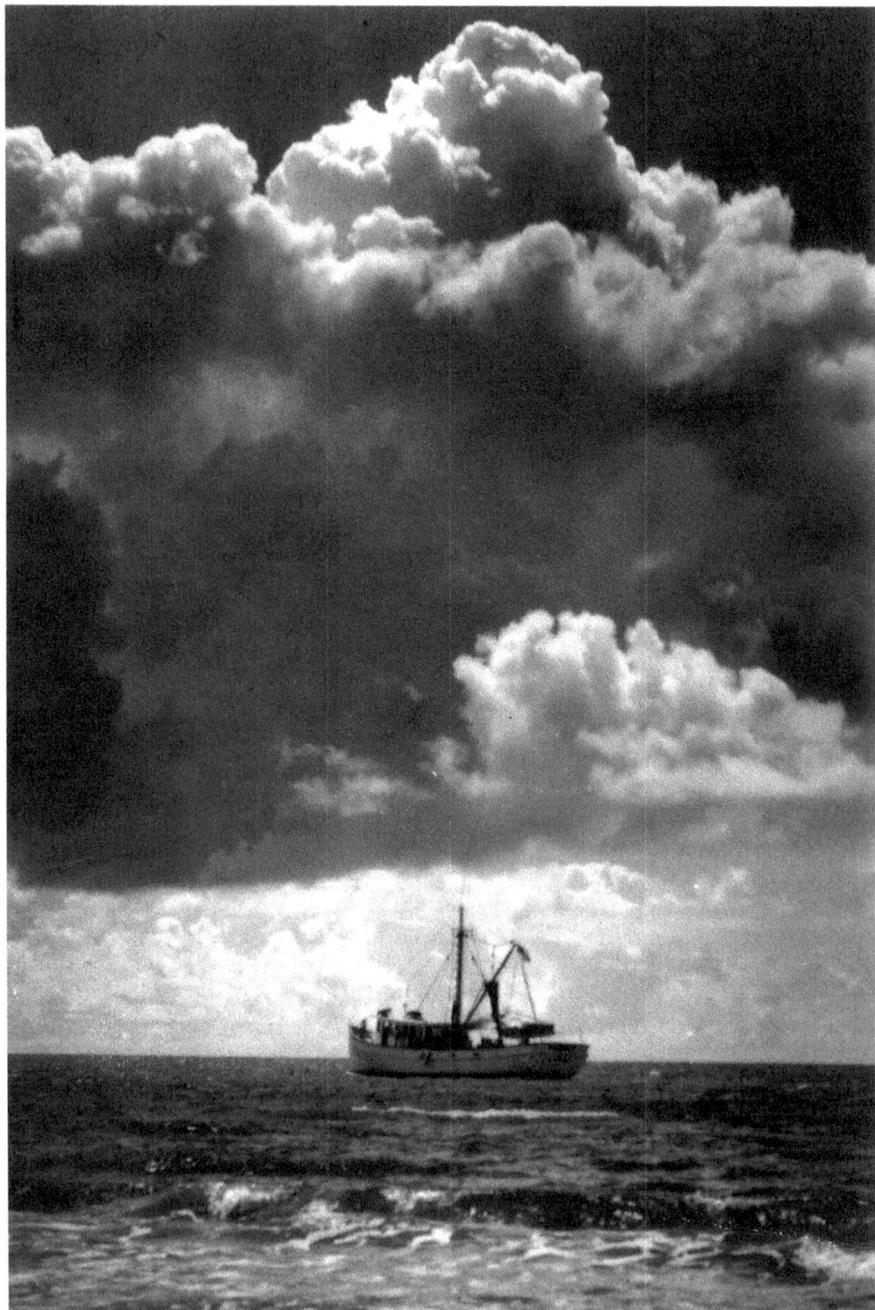

This large boat, named *Paris T*, was used for many years to trawl the deep waters of the Gulf of Mexico. *Courtesy of Mary Chailland.*

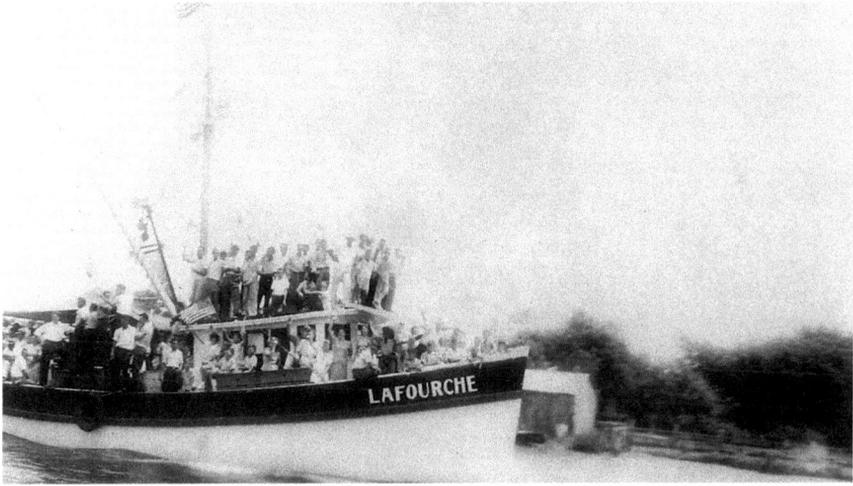

Riders wave to spectators in the annual Blessing of the Fleet celebration in southern Lafourche Parish, most likely in Golden Meadow. *Courtesy of Mary Chailland, early twentieth century.*

caught in the Gulf of Mexico's deeper water. Before this time, boats were confined to inland and coastal waters around Louisiana (within three miles of the land borders).[172] The advent of jumbo shrimp changed the shrimp industry forever by providing an upper-tier, premium product for trawlers to pursue in the deeper waters of the Gulf.

All of these changes combined to modernize the industry and the way of life for shrimpers. How shrimpers and marsh dwellers lived in and interacted with the wetlands were changed forever by these modern advances. After World War II, the American taste for shrimp increased. Prior to that time, shrimp was something that coastal people ate. Due to all the modern advances made with catching, processing and shipping, shrimp became more readily available for the average American consumer.[173]

A cultural practice that is still observed to this day and best associated with the shrimping industry is the annual "Blessing of the Fleet." This was an outgrowth of the pervading Catholic faith and is rooted in old-world French traditions, says Liz Williams, president of the SoFAB Institute. The Blessing of the Fleet is a sacred ritual in which Catholic priests bless the boats as they go out to sea.[174] After the boats were blessed, the people on dry land proceeded to celebrate the opening of the season and what they hoped was the coming bounty from those fishing trips. Ms. Williams said that having a ritual like this helped the people to acknowledge the inherent

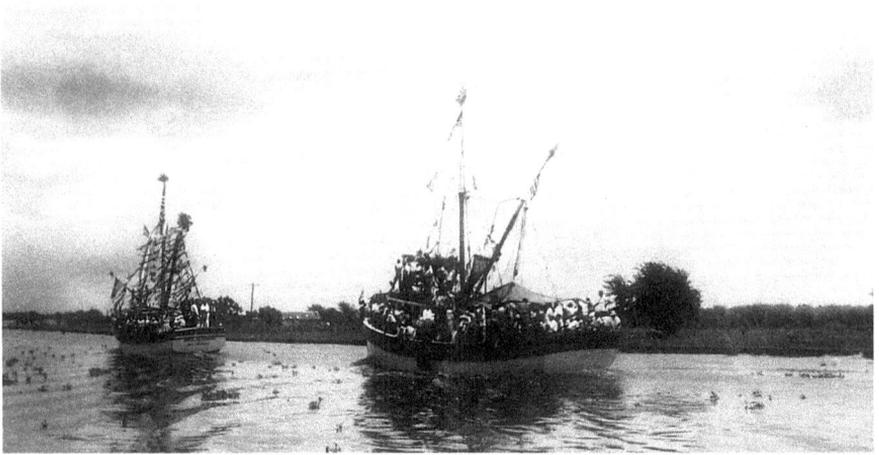

Boats riding in a Blessing of the Fleet parade on Bayou Lafourche. *Courtesy of Mary Chailland, early twentieth century.*

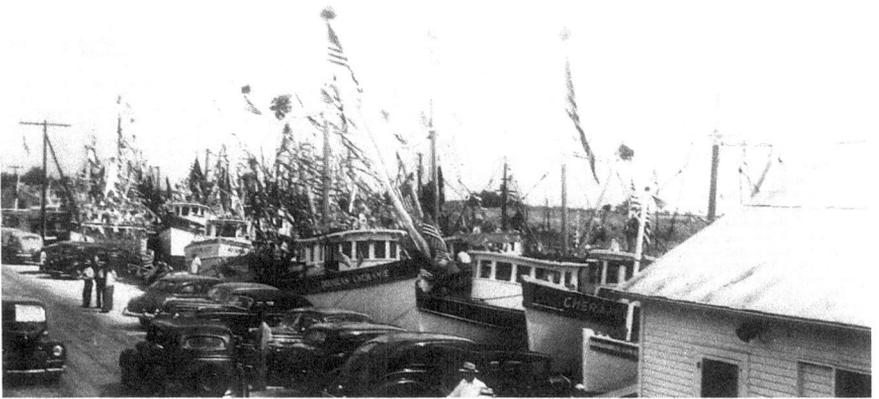

The Blessing of the Fleet was once a wildly popular celebration because so many people were fishermen. *Courtesy of Mary Chailland, early twentieth century.*

danger in the act of fishing and that the people felt they needed God's protection.[175] Knowing how dangerous this work was and how critical it was that their efforts be successful, early settlers kept up these traditions even as they resettled in Louisiana. Since Cajuns are still social and religious people, the practice remains active to this day in the shrimping

communities in places like Golden Meadow, Delcambre and Dulac but more as a cultural celebration than the mostly solemn occasion of the past. While it is still a holy occasion, these modern blessings of the fleet are usually done in conjunction with seafood-related festivals.

While the Vietnamese are a largely contemporary arrival to Southeast Louisiana, they have had a significant impact on the fisheries, especially shrimping. Sent over by the Catholic Church after the Vietnam War and the American withdrawal from the country, many Vietnamese settled along the Gulf Coast.[176] The Vietnamese took to the shallow wetlands of the coast and its fisheries-based lifestyle well; these days, one in twenty fishermen in Southeast Louisiana is Vietnamese.[177] The Vietnamese population is prevalent in Southeast Louisiana, especially in the Intracoastal City area.[178] The Southeast Asian influence on Louisiana is not limited to Vietnamese fishermen—crabbers in Vermilion Bay are also often Cambodians and Laotians.

In modern times, Asian immigrants, especially the Vietnamese, dominate the offshore fisheries. They're most often the people these days who own the big boats that are operating in the deeper state and federal offshore waters.[179] They're also involved at every level of the fisheries; they not only fish but also own processing plants and docks. They have been quite successful in many cases. What they basically did was to fill a niche that was left wide open when Anglo and Cajun fishermen began abandoning the fisheries for what they saw as better work in the oil field. Like many immigrants, the Vietnamese are resourceful and hardworking, and many have managed to make a great living from the fisheries and what they have to offer. In the modern Anglo-Cajun fisheries culture, it is not uncommon for a fisherman to own a house and vehicles along with owning a boat. The fisherman's wife may or may not help in the business. Sometimes she has a job outside of the home, not related to the business at all. But sometimes, the family does come together and pool resources and all work in the family business. In the Vietnamese community, it was not uncommon in the late 1970s and early 1980s for everyone in the family to live and work on the boat. They'd have no house or other dwelling or transport other than that boat.

Being coastal people, the Vietnamese were often fishermen in their homelands, and they came here to South Louisiana and capitalized on the opportunities that were available once Cajuns and other people "native" to this area decided to move on from fishing to oil field work and other industries.[180] The shrimping industry requires hard work and

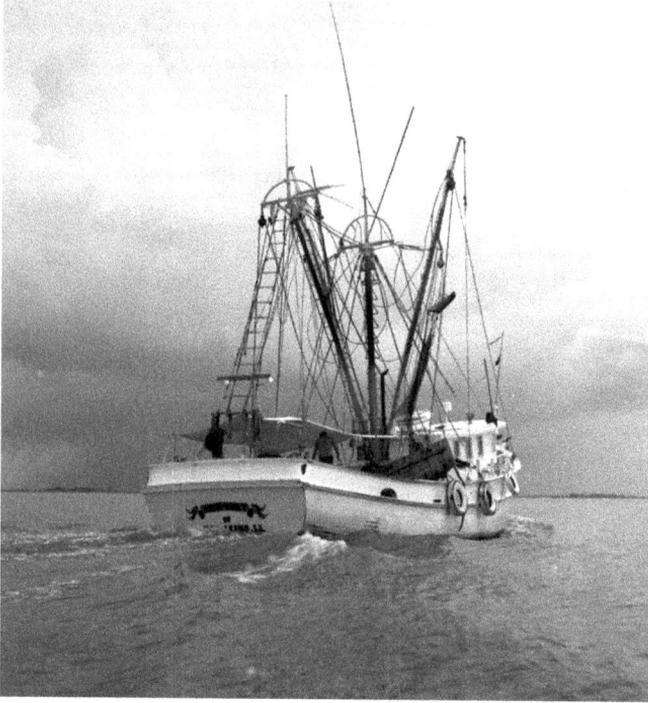

Left: The larger shrimping boats, able to spend more time out at sea, are often owned by Vietnamese fishermen these days. *Courtesy of Louisiana Department of Wildlife and Fisheries.*

Below: This boat, with its large booms (outriggers), is typical of the appearance of modern shrimping boats. *Courtesy of Louisiana Department of Wildlife and Fisheries.*

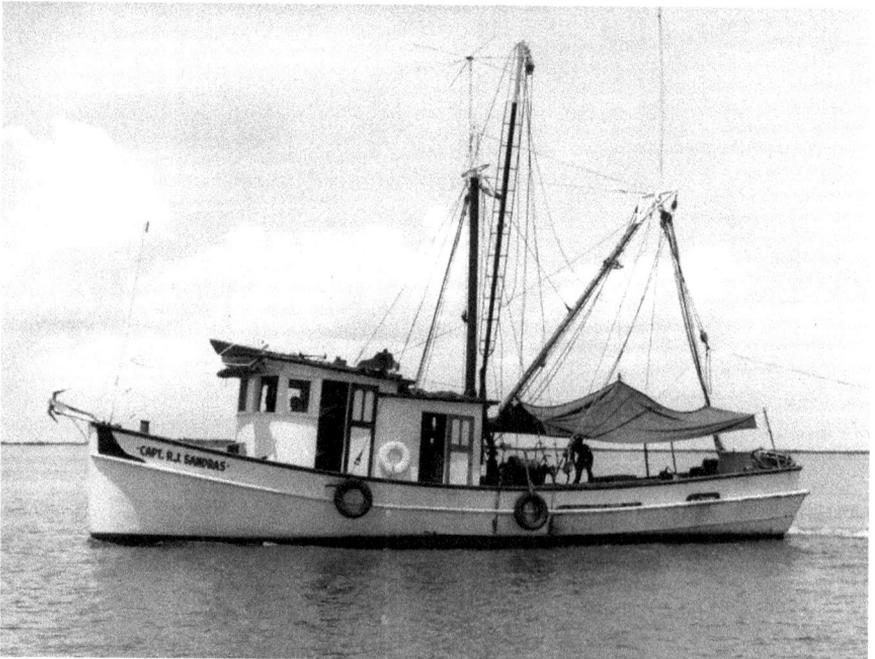

a substantial monetary investment, but neither of those deters those who are determined. Many of the Vietnamese immigrants came over directly from Vietnam, from a recent warzone. They were used to life being difficult and having to struggle. Except this time, they saw a way to freedom. They could own their own businesses. They could make money and provide better lives for their children and families. To many, the choice seemed like a better alternative than continuing to suffer in their native lands. They saw all the opportunity just waiting to be capitalized on here and knew that they could prosper applying the know-how they already had from being fishermen in their homeland.

When you look at today's Vietnamese fishermen—the current crop of young men and women coming into adulthood and slowly taking over for their parents' generation—you see a whole different type of fishermen. These are shrewd businessmen and women who are both knowledgeable and savvy. Many times, they graduated high school at the top of their class. Most of them don't have accents, either, like their parents did. Sure, they're Vietnamese by birthright, but they are Anglicized just as today's Cajun and Isleño young adults are.[181]

The Oyster Industry

While the shrimping industry has the distinction of being the oldest fishery industry in Southeast Louisiana, the oyster industry was close behind. Similar to the shrimp industry, prior to modern mechanization and refrigeration, the oyster industry had a modest and local start. Although oysters were meticulously hand harvested and consumed by American Indians and early settlers, the modern oyster industry didn't take shape until the mid-nineteenth century.[182] Prior to refrigeration and canning, these highly perishable bivalves had a short shelf life and had to be consumed upon picking.

While Cajuns living near Houma in Terrebonne Parish are generally credited with fostering early development of the oyster industry in that area, it's the Croats (the ethnic group of people who hail from present-day Croatia) who were the most significant ethnic group in terms of development of the oyster industry.[183] They were the first Europeans to become actively involved in the oyster industry. Being from the Adriatic Sea area, they were born near the water and had experience working

Fossilized oyster shells can still be found today in the shallow waters off the coast of South Louisiana. *Courtesy of Louisiana Department of Wildlife and Fisheries.*

Opposite: Oyster tongs were used prior to the development of the more efficient oyster dredge. Tongs were easy to use; older children often operated them. *Courtesy of Louisiana Department of Wildlife and Fisheries.*

with and handling boats, so it was only natural that they secured work in the burgeoning oyster industry. The Croats and then later Dalmatians chose oystering as their profession because it was dependable, profitable and not unlike other sea-bound work they were used to in their native land.[184] Additionally, oystering required no specialized skills other than, of course, being able to handle a boat, to which they were already accustomed. They began oystering in the decade between 1850 and 1860, living a fairly isolated existence for many years,[185] and they are given credit for having the strongest impact on the direction and success of the industry.[186] Like the Cajuns, Croats had a strong work ethic, but where they differed is that the Croats spent their time not only oystering but also figuring out the science behind it. They spent years figuring

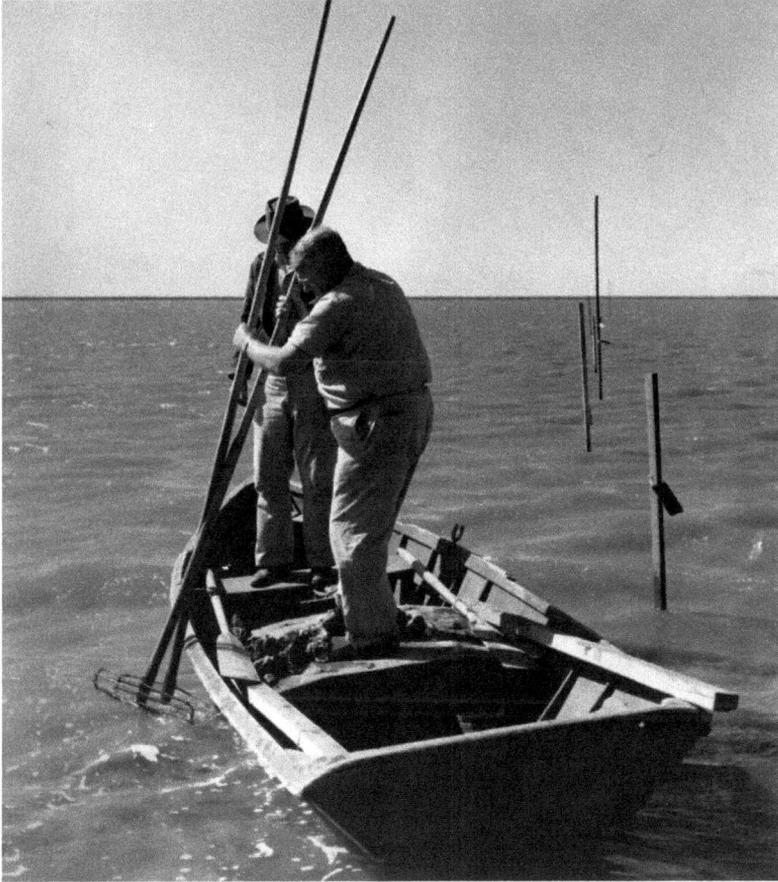

out which waters and salinities were optimal for growing oysters.[187] The modern oyster industry was born out of these efforts.

The first innovation in harvesting oysters was oyster tongs. Instead of picking the oysters by hand, oystermen could now use long tongs to pick the oysters from the bottom of the oyster reef. The tongs alone created a higher level of efficiency in the industry. While still labor intensive, for the first time, oysters could be picked with speed and improved economics. Since it still took most of an oysterman's time and effort to manage picking oysters, early oystermen spent their lives at or near their oyster reefs. In 1893, most oystermen were still living a solitary existence out in the marshes among their leases and reefs. Freight boats would even come out to the areas to pick up their oysters, so the oystermen had little reason to leave.[188]

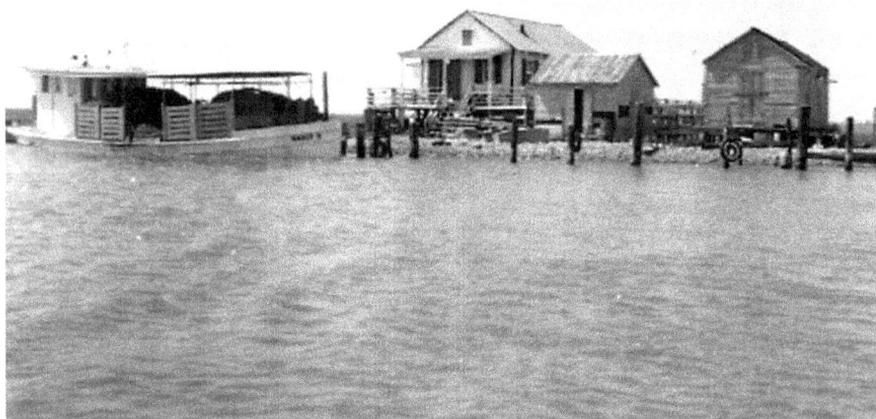

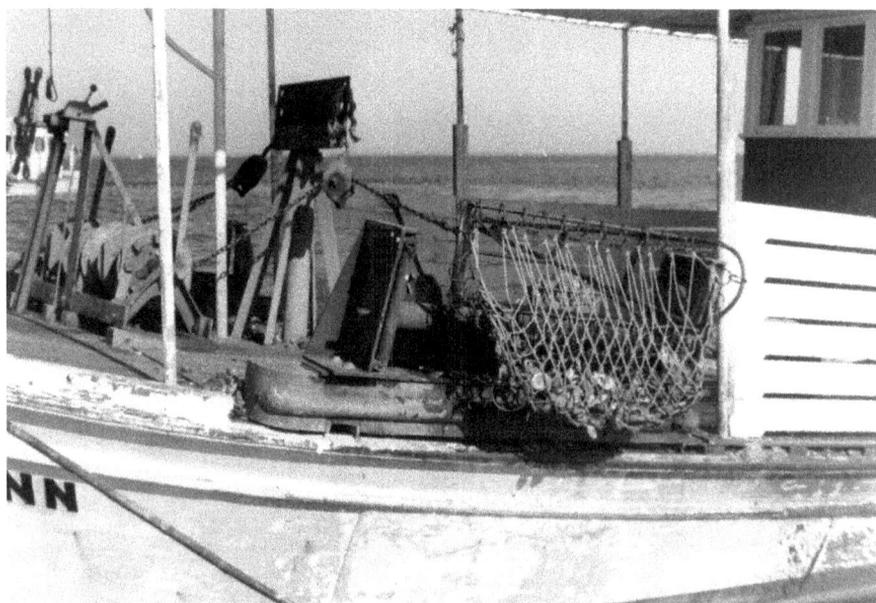

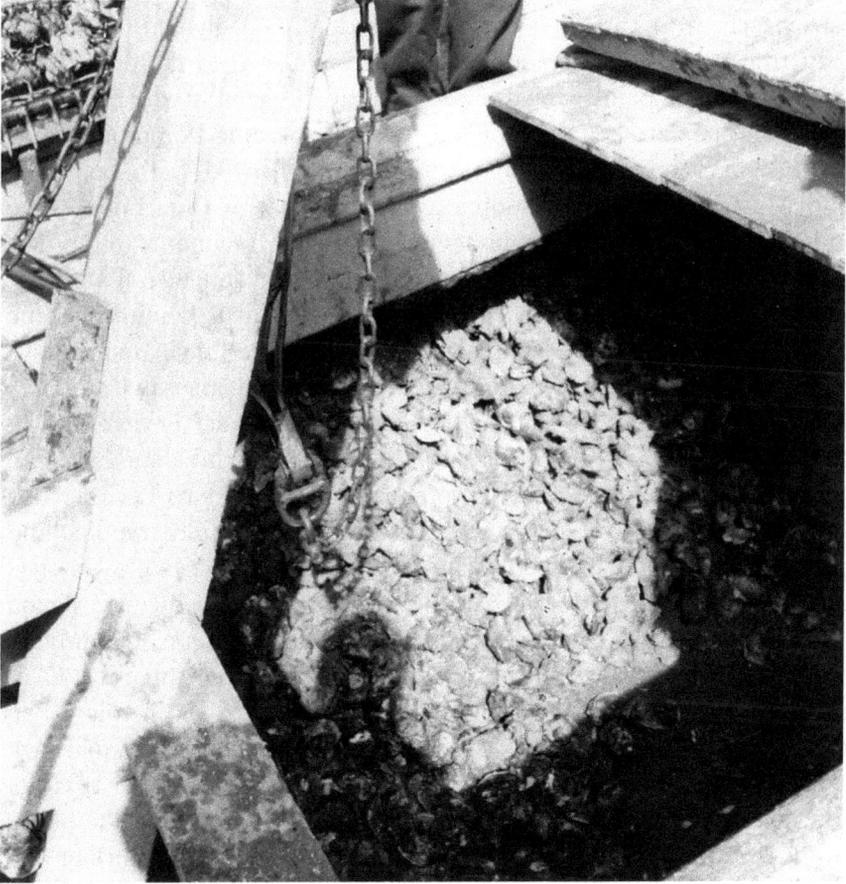

Dredges allow for larger harvests, often resulting in full lugger holds. *Courtesy of Louisiana Department of Wildlife and Fisheries, 1963.*

Opposite, top: Prior to the turn of the twentieth century, it was standard practice for oystermen to live on their oyster leases, sometimes with their entire families. *Courtesy of Louisiana Department of Wildlife and Fisheries.*

Opposite, bottom: Oyster dredge on a lugger. *Courtesy of Louisiana Department of Wildlife and Fisheries.*

While oystermen could make a good living tonging for oysters, it was ultimately labor intensive and highly inefficient. It was only with the advent of the oyster dredge in 1905 that fishermen were finally able to leave their leases and live farther inland, thus ending many of the isolated marsh communities.[189] When dredges replaced tongs as the primary harvesting tool, deeper waters became new fertile frontiers

for oystermen to harvest.[190] An oyster dredge is a V-shaped iron frame with ring mesh enclosures attached. It is connected to the oyster boat or "lugger" by chains, which are located at the head of the frame. By 1920, mechanized versions of the dredges became commonplace.[191] Further, once mechanized boats and motors followed, both Louisiana and Mississippi became national leaders in oyster production.[192] The industry is an important component of the region's economy to this day.

The Collins family from Golden Meadow in southern Lafourche Parish has been oystering since the turn of the twentieth century.[193] Some of the reefs where they historically grew and farmed their oysters have been around for nearly one hundred years, namely the reefs in Caminada Bay, just west of Grand Isle. Nick Collins's grandfather Levi Collins Jr. started those reefs. He started by working in the marsh behind his camp on Caminada Bay. After seeing some success in the bay, Levi decided to move into Bayou Thunder. He was already successfully trapping and catching turtles in that bayou, so he figured he would try to grow oysters as well. He'd start the oysters in the marsh and bring them to Bayou Thunder to mature. At this time, Levi only had a pirogue. The process was not mechanized at this point and was highly labor intensive. Over time, Levi built himself a bigger and better pirogue. Then he moved on to a mechanized boat as soon as that was feasible. It was a small two-horsepower motor—just enough to get the work done. Then Levi got to thinking about how moving his oysters from the marsh to the bayou produced a tastier oyster. He took that line of logic one step further and decided that if the bayou made a tasty oyster, then Caminada Bay could be even better. With his motorized boat, he was able to do just that. That's how the Collins family started oystering in Caminada Bay. Levi leased land in the bay and started moving his seedlings to the bay to grow. Over the next twenty to thirty years, Levi's work in that bay built up three reefs that would eventually produce some of the most delicious oysters in Southeast Louisiana.

Levi was the first to bring oysters into that bay, and for many years, the Collins family was known for their Caminada Bay oysters. A big part of their reputation, which is still strong and positive today, was built on their renowned Caminada Bay oysters. However, today those reefs sit dormant below the surface in Caminada Bay. Nick said proudly, "I could go find those reefs right now with a cane pole, no electronics." The Collins family eventually had to stop oystering in Caminada Bay because it became too expensive to do so. The oyster seedlings always had to be brought into

Caminada Bay by hand. Back when fuel wasn't so expensive, it was worth the time and effort to do something like that. These days, Nick figures it would cost double to triple what's normally spent on growing an oyster to get those prized Caminada Bay oysters. Sadly, it's just not worth it anymore to take on such a task.

However, the Collins family is still producing high-quality oysters. They're just grown in different bays and bayous now. Nick attributes the high quality of his oysters to the way that they deliberately farm and work the oyster reefs. This means that they don't just drop the oyster seed and hope for the best. No, Nick and his crew are out on those leases busting up clumps of oysters or knocking smaller oysters off to allow them room to grow. They harvest what they need to fill their orders for the day, and then they spend the rest of their time working the oysters that are still growing. If left alone, oysters grow in large massive clumps all together that make it quite difficult to harvest and sell them. Each time they work the oysters, they're breaking up that thinner "paper" shell and forcing the oyster to regrow it. This means the shell grows back a little thicker the next time, which protects the oysters and produces a healthier, higher-quality oyster in the end. Working the oysters as they go, the farming practices of the Collins family ensure a higher-quality product. It costs more to produce oysters in this fashion, but it's something that needs to be done. The Collins brand of oysters has been going strong for many years, and Nick is focused on keeping that going. The Collins family and its employees take pride in both their work and oysters, which is evident by their reputation and how sought after the oysters are.

Not only does the farming method pay off in a higher-quality product, but Nick also attributes this deliberate farming to the main reason they're in business right now at all. Ever since the BP oil spill in 2010, oyster seed has been nearly impossible to find. The public grounds on the east side of the Mississippi River were decimated. This is where most oystermen get their oyster seed. Since the Collins family was farming oysters, they had their own seed, which provided a starting stock. They were not solely reliant on public grounds. They do use those public grounds when they can to harvest seed, but in lieu of that, they're producing their own. Oysters take several years to mature, so lots of planning and deliberate working of the stock must take place. They lost some of their own stock in the oil spill, but thankfully, they have leases on the west side of Bayou Lafourche, and those areas weren't as affected by the spill. Overall, oysters aren't nearly as prolific as they once were, but the demand is still

If not broken up by human intervention, oysters can grow into large clusters like this. *Courtesy of Louisiana Department of Wildlife and Fisheries.*

Opposite, top: An oyster lugger, called the *Captain Bouvier*, loaded down with hundreds of sacks and thousands of oysters after a prolific harvesting period. *Courtesy of Louisiana Department of Wildlife and Fisheries.*

Opposite, bottom: An oyster lugger in Grand Pass in February 1963 along the eastern border of Louisiana's public oyster seed grounds. *Courtesy of Louisiana Department of Wildlife and Fisheries.*

strong. This year, Collins barely had enough stock to do his own retail business plus a few little wholesale contracts. He noted that the factories are "mad" at him for not having more oysters. He laughed and said, "They're offering top dollar, but I don't have them." Time will tell if his stock will rebound and his once fertile grounds will start producing again.

Collins recalled in our interview the time during his youth in the 1980s when oysters were much more plentiful. He would return home after school and football practice and help with the oyster business. Collins's older brothers and his father, Wilbert, would offload the oysters from the

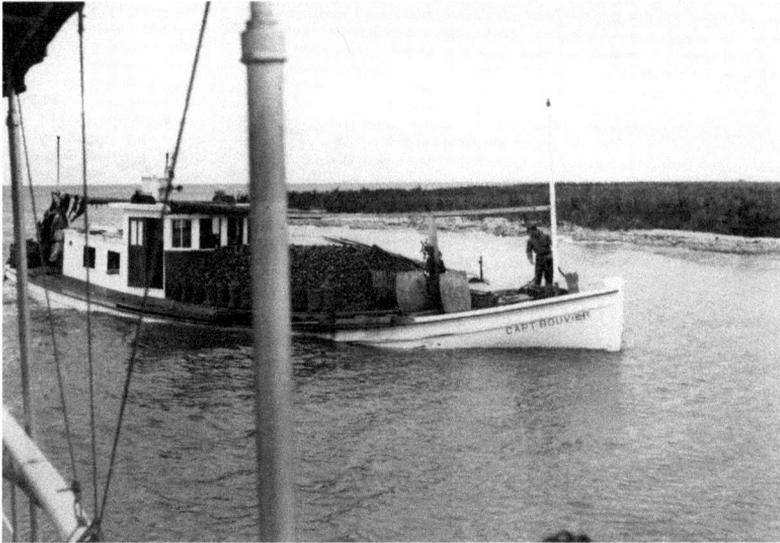

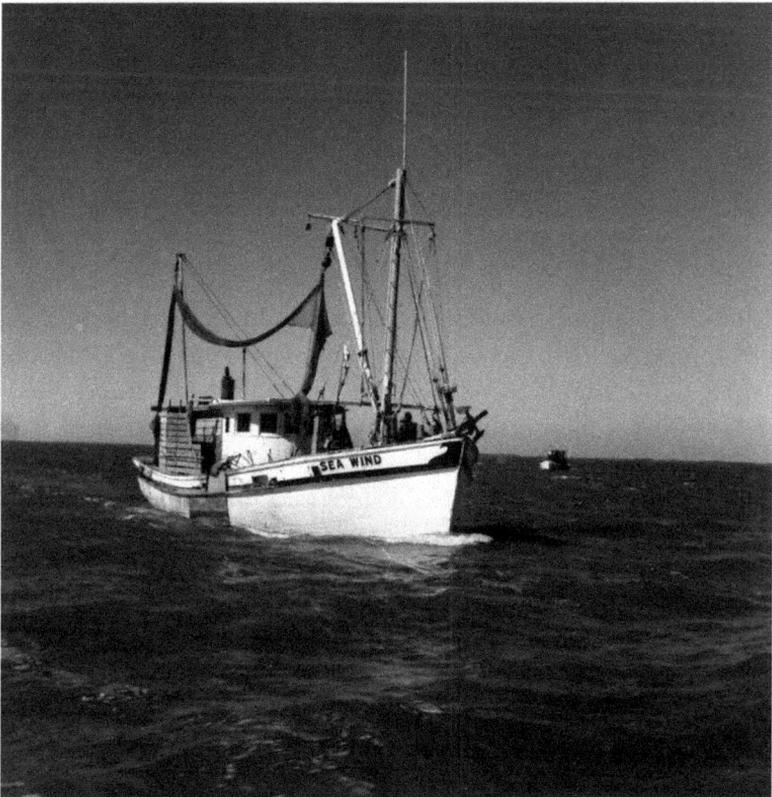

boat while Nick and his grandfather, Levi, would sack the oysters. It was not uncommon for them to be sacking eighty to one hundred sacks of oysters per day. Some days would even yield up to two hundred sacks. This is how Nick Collins grew up—with oysters in his blood. He's been on oyster boats since he was a little boy. Before he could even walk, his dad would tie his walker to the middle tent rack on their boat, the *Captain Wilbert*. Being a fourth-generation oysterman, Collins naturally wants to pass it on to his son, but between diminishing oyster stocks in the area and a cultural shift away from hard manual labor, Collins isn't so sure he'll be able to convince his son to take over the business when he's an adult. Then again, will the Collins family even have oysters to harvest? The times of two hundred sacks per day are over, at least for now. Collins considers it a great day when he can harvest just over one hundred sacks. The oysters simply aren't there to harvest.

An oysterman's dwelling built on what looks like a foundation of oyster shells on his lease. *Courtesy of Louisiana Department of Wildlife and Fisheries.*

Opposite: Oyster luggers line a Louisiana bayou. These boats are built with shallow bottoms to allow for entry into the shallow waters of oyster beds. *Courtesy of Louisiana Department of Wildlife and Fisheries.*

Although the oyster industry has recently fallen on some rough times, all is not lost. Don Davis, director emeritus of oral histories at the Louisiana Sea Grant College Program, thinks that what is likely to happen is that the oysters will migrate, not become extinct.[194] While oysters can tolerate some salt water, they cannot tolerate fresh water, so these freshwater diversion projects can actually be a threat to oysters. Oysters do best when they're growing just on the fringe between salt and fresh waters—they thrive in brackish water. While this is good news for the oysters, it's potentially bad news for the fishermen. A fisherman's lease is where it is. He may have tens of thousands of acres leased from the state, but if the oysters can no longer grow on that land or in that water because of a salinity imbalance, that fisherman is out of luck. It is nearly impossible to obtain additional leases. Most of them are tied up with other leaseholders, leaving some fishermen with leases that just can't produce.

The Crab Industry

The crab industry is newer than the oyster and shrimping industries. In North America, the crab industry started as recently as 1875 in Maryland.[195] By the 1880s, a market had formed in Louisiana, especially in New Orleans, for blue crabs.[196] At first, the fishermen and trappers of Southeast Louisiana would catch crabs in their spare time or during the off-season as a way to supplement their incomes.[197] They already owned boats, and crabs are abundant in the same waters in which they fished for their primary seafood items. Additional tools needed were minimal at first because crabs were caught and harvested using a trotline, a long line outfitted with cheap bait. Indeed, meager equipment meant that harvesting was also slow and time consuming. As time passed and the crab market became more lucrative, equipment became more sophisticated and evolved into what is used in the commercial industry today—crab traps.[198]

A crab trap is merely a cage made of chicken wire or something comparable covered in a vinyl coating. These traps are baited, and the crabs swim into a tapered narrow opening to access the bait. However, once inside the trap, the crab cannot escape, as the hole that it entered into is now too small to exit. Crab traps are laid in areas where they can be completely submerged in water. Typically, a small Styrofoam buoy is the only way a fisherman can find his traps. Otherwise, the metal-cage part is completely submerged.

Over the twentieth century, the crab industry grew as America's taste for the crustacean grew nearly insatiable. As with the other fisheries, mechanization, ice and improvements in transportation helped to grow the crab industry by leaps and bounds. While crabbing can still be side work for fishermen, today some fishermen crab exclusively, although it's more common to find an oysterman picking crabs when the oysters aren't in season. Since events like the BP oil spill and the onslaught of hurricanes that took place in the early twenty-first century, crabs aren't as prolific as they once were, and they certainly aren't as profitable due to rising fuel and operational costs. However, despite all those factors, Louisiana is a still a top crab producer, responsible for 50 to 70 percent of the Gulf's crab catch each year.[199]

While hard-shelled blue crabs are wildly popular, people also seek soft-shell crabs and buster crabs. Soft-shell crabs are created when adult crabs shed their shells, approximately fifteen times in a lifetime.[200] About two

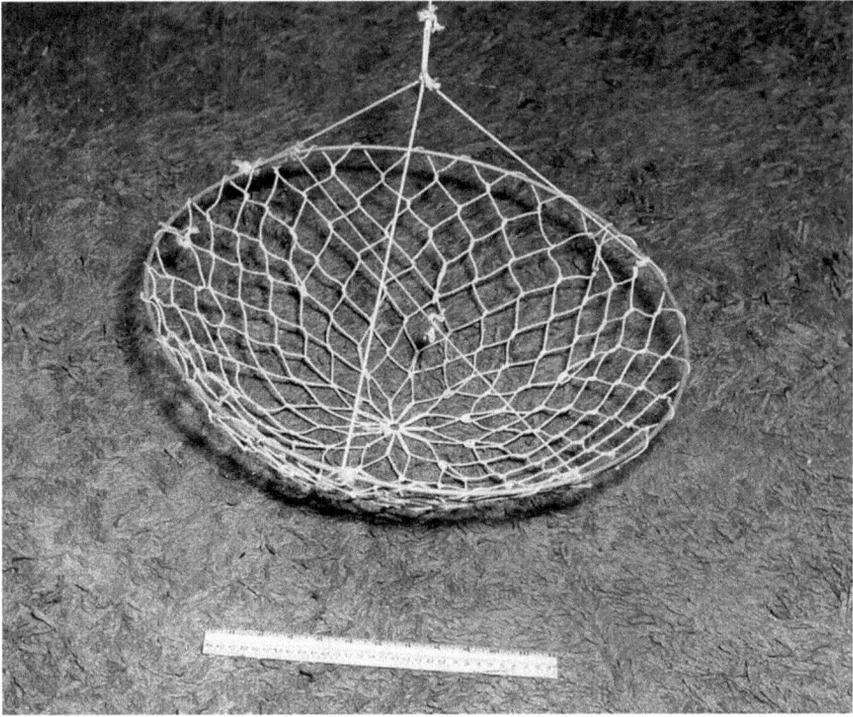

Crabs can be caught a variety of ways, including this wide, basket-like net, cast by hand. *Courtesy of Louisiana Department of Wildlife and Fisheries.*

hours after molting (shedding the shell), a crab is in the soft-shell state.[201] The crab is totally defenseless at this point and is prime for picking. In this helpless state, the crab instinctively seeks shelter. Over time, crabbers have developed an ingenious way to capitalize on this. Crabbers looking for soft-shell crabs use devices called *serias* to lure the crabs for catching.[202] Utilizing branches and binding materials, crabbers construct these false hiding spots for soft-shell crabs. The *serias* are baited, and the crabs are harvested daily.

Buster crabs are also a type of soft-shell crab. Whereas the soft-shell crab is in a freshly molted state, the buster crab is a soft-shell crab that's not quite "busted" out of its shell yet. These are a special type of crab that many restaurants use for high-end dishes. Moving soft-shell crabs to market quickly is critical. Just two hours after the crab hits the soft-shell state, it begins another phase and grows what's called a paper shell. These paper-shell crabs are much less valuable than true soft-shell crabs,

so great care is taken to stop the shell regeneration process.[203] Freezing the crab quickly helps to tame this process and ensure the highest dollar received for the product.

THE CRAWFISH INDUSTRY

As with the crab industry, the crawfish industry is a more modern development. The first commercial crawfish transaction took place in 1880.[204] However, crawfish were being consumed in Southeast Louisiana long before that time. When European settlers arrived, they told accounts of the Indians eating the crustaceans. That wasn't much of a surprise to Europeans, especially the French, as they had been consuming something akin to crawfish in their homeland commonly referred to as *langoustine*.[205]

Prior to 1959, crawfish was not a significant part of the Cajuns' diet, nor of anyone's for that matter. Before the Civil War, the only notable use of crawfish was in affluent homes in the region to make crawfish bisque, which they'd tried in the posh restaurants of New Orleans. Poor and less affluent Cajuns were known to only consume crawfish during flooding seasons. Notably, after 1875, Catholics began to consume crawfish more often during the Lenten season, a practice that thrives in earnest to this day. These crawfish were typically just by-catch from locals seining for freshwater fish. Even in the early twentieth century, crawfish boils were still mainly confined to the Lenten season. Interestingly, while crawfish bisque was seen as the height of cuisine, boiled crawfish were something that only poor people ate. Just like lobster, the crawfish had a reputation at the time of being poor man's food, a trash seafood item that people ate to "make do." It wasn't until the Breaux Bridge Crawfish Festival, in 1959, that crawfish started gaining traction as a desirable food by reinventing the crawfish's image. It was also around this time when already peeled crawfish began to make its debut, thus making it even more widely available for consumption.[206]

Crawfish are found in brackish waters and are either harvested naturally or in cultivated ponds. For years, crawfish were caught from their wild habitats and consumed locally. Throughout the Depression era, advances in refrigeration and transportation made moving and transporting crawfish and other seafood more realistic and commonplace. With this evolution in transportability came the increase in crawfish consumption.[207] Crawfish

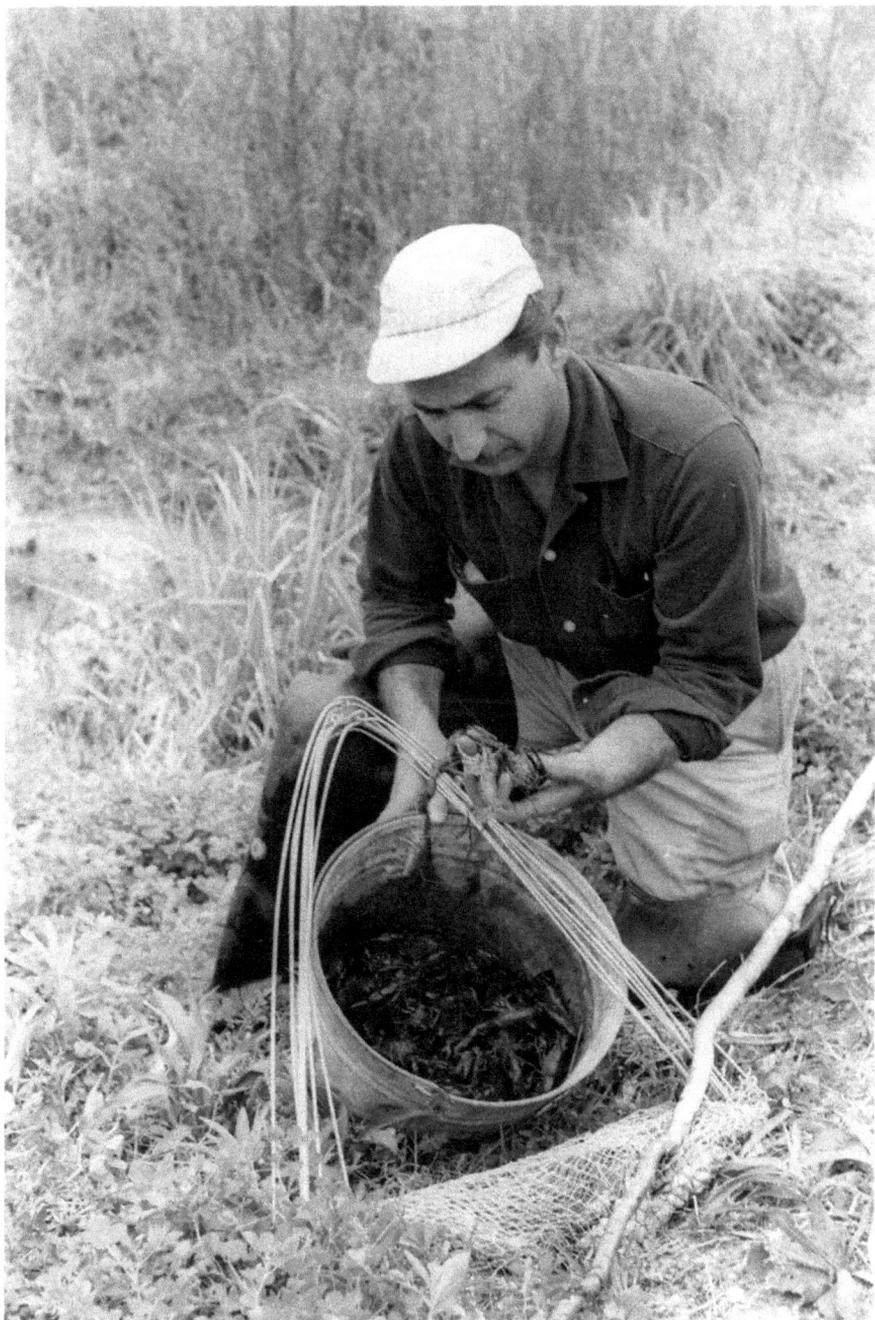

A Wildlife and Fisheries agent working with a crawfish trap. *Courtesy of Louisiana Department of Wildlife and Fisheries.*

could now be shipped into larger markets like Baton Rouge and New Orleans. As a result, demand and consumption grew.

In 1950, the Louisiana state legislature decided it was time to act. With the increase in consumption and popularity of crawfish, it became evident that production needed to increase. The legislature empowered the Department of Wildlife and Fisheries to study the effects of raising crawfish in ponds.[208] People had learned that crawfish could be raised in flooded-out rice fields, but the state had never put science behind it up to that point. When the commercial crawfish industry started, all crawfish were wild harvested in brackish waters. The Atchafalaya Basin was a fertile area for wild crawfish to flourish. It wasn't until the 1960s that farm-raised crawfish arrived on the market.[209] The delectable crustaceans—now often cultivated in local rice fields, enclosed woodlands and marshlands—are now in steady supply.[210] An added bonus is that crawfish production helps rice farmers supplement their incomes, which is needed because the price farmers get for rice is currently quite meager.[211]

Marcelle Bienvenu, a locally based Cajun cuisine authority, grew up in a time when crawfish was still considered "poor man's food." Her daddy would lament that they were so poor they had to buy crawfish. To that, Bienvenu smiled and said that she used to think, "Thank God I'm poor."[212] However, crawfish increased in popularity in Southeast Louisiana as production methods improved and became more reliable. Crawfish are wildly popular in Southeast Louisiana, especially around Good Friday and the Lenten season when many Catholics abstain from meat, especially on Fridays. Today, most of Louisiana's crawfish are farmed in controlled ponds and water areas, but this is where the similarities with farm-raised agriculture end. Crawfish in ponds aren't fed formulated feeds. They subsist on the natural vegetation in the ponds and rice fields where they grow.[213] Additionally, the crawfish ponds aren't seeded with hatchery-reared young. Instead, the farms rely on adults left from the previous season to populate the ponds with naturally produced young.[214] So while most of the crawfish in Southeast Louisiana are farmed, it's done in a natural manner.

Although farm raising has contributed greatly to the reliability of the supply of crawfish, that supply can still vary greatly depending on several environmental factors. Few people make their living on crawfish rearing alone, as a result.[215] While science and careful control have improved the output of these crawfish farms, those outputs still vary.[216] Today, while most of the crawfish consumed in Southeast Louisiana is farm-raised, a small percentage of it is still caught in the wild in places like

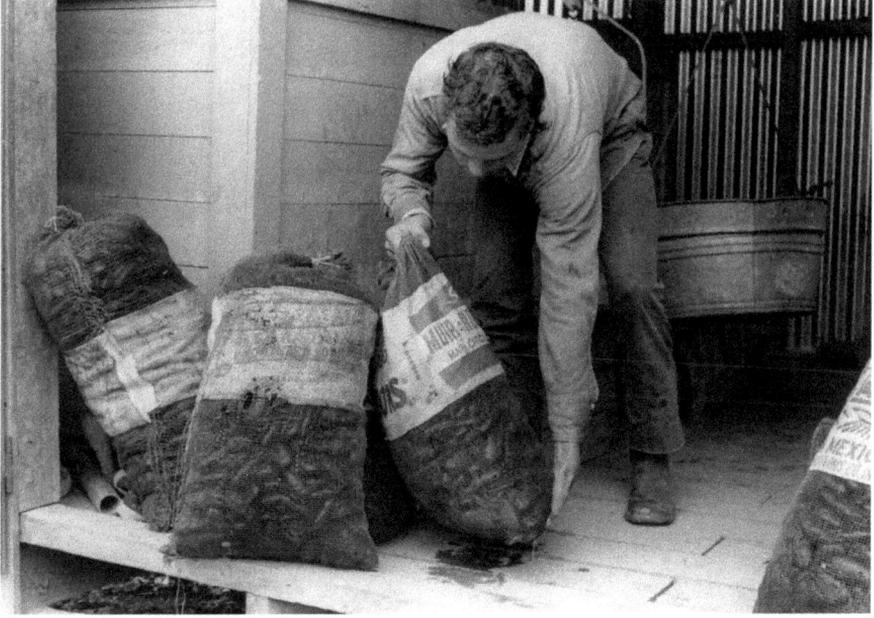

Worker handling several large sacks of crawfish, presumably for public sale. *Courtesy of Louisiana Department of Wildlife and Fisheries.*

the Atchafalaya Basin. The Basin still has the right salinity level for wild crawfish to grow and flourish. Since the year 2000, fewer than 20 percent of Louisiana's crawfish come from wild habitats like this one.[217]

THE FINFISH INDUSTRY

Southeast Louisiana is also home to a wide and diverse variety of finfish. These fish have been harvested since the time of the American Indians using trotlines, traps and hoop nets, and the Indians were also adept at spear fishing and using bows and arrows to angle fish.[218] Many early European settlers came from fishing communities and quickly realized that finfish were abundant. In addition to some of the methods the natives employed, early Europeans, Acadians and Africans also used hand-cast seine nets and wind-powered boats to increase catch hauls.[219] This process, however, was highly time consuming and quite hard work. Nets were heavy and required much manpower.

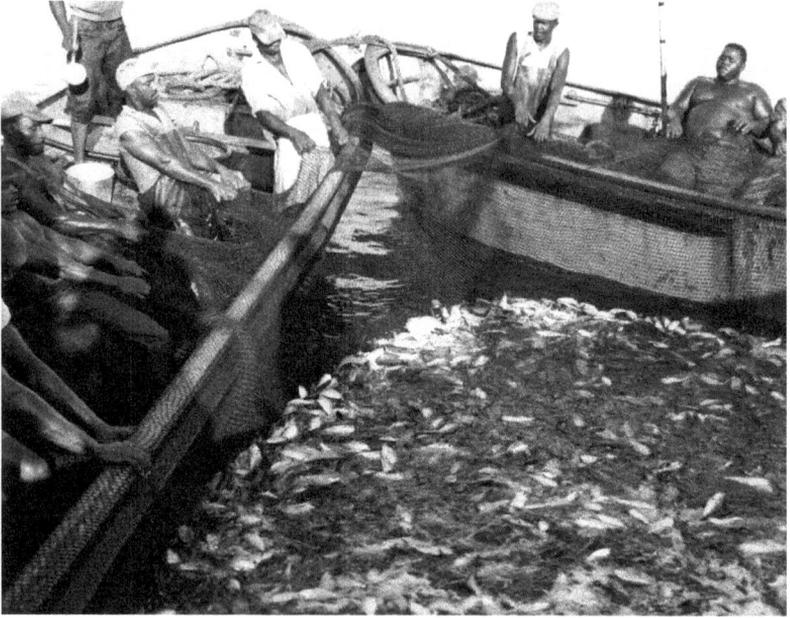

Menhaden is plentiful in the Gulf of Mexico off the coast of Louisiana. *Courtesy of Louisiana Department of Wildlife and Fisheries.*

Wildlife and Fisheries agents and staff touring a catfish farm in 1965. *Courtesy of Louisiana Department of Wildlife and Fisheries.*

As with all the other fishery industries, the introduction of motorized boats and more sophisticated nets increased the viability of the industry. In the early twentieth century, these advances, coupled with America's increased appetite for fish, created a boon for the fish industry.[220] Southeast Louisiana has both freshwater and saltwater fish available for commercial consumption. Saltwater (and brackish water) fish are more widely popular because they are available more abundantly than some of the freshwater species of fish. Further, copious amounts of menhaden are harvested each year for industrial use.

Although many species of fish are found in the Gulf of Mexico, popular species of saltwater fish—or Gulf fish as they are commonly known—include snapper, grouper, black drum and amberjack. In order to control the balance between sport and commercial fishermen, limits on size, weight and quantity are put in place to ensure that the fisheries are able to repopulate in a timely manner.[221] The most popular freshwater fish caught and sold commercially are catfish, which are especially popular in the Des Allemands area.

Marsh fish like speckled trout and redfish are no longer available commercially due to overfishing. This is because back in the 1980s, Chef Paul Prudhomme created the iconic Cajun dish, blackened redfish. This dish was so popular that it put a strain on the local redfish population. Some conservationists feared that the redfish would be blackened into extinction. As a result, the United States Department of Commerce banned commercial fishing in federal Gulf waters in 1986. Early in 1987, Louisiana banned both commercial and recreational fishing in its waters.[222] While it is legal to recreationally fish for redfish in Louisiana waters today, the commercial ban is still in place.

EARLY TWENTIETH-CENTURY MODERNIZATION

When viewed via the lens of history, the twentieth century was a time of great change for the Cajuns and their traditional culture. By the turn of the century, the lumber industry was firmly established, and the first inklings of the oil industry appeared around 1901.[223] Compulsory English-based education was established in 1916, and this helped to expand literacy among the Cajuns, who were nearly all illiterate prior to that time.[224] Many Cajuns were opting into participating in these new

developments. Many thought they had no choice but to go along or get left behind. However, some Cajuns resisted and moved ever further into the recesses of their own culture and societies. This remained especially true in the marsh (swamp) and coastal areas—they became the last bastions for the old Cajun ways of life.[225] The railroad wasn't near them, so they weren't as affected by change at the beginning. However, the oil industry rolling into town was another matter entirely. Over time, the oil industry came to pervade even the most remote places because that's often where the oil was discovered. This time period serves as the first significant crack in Cajun culture and was the road to the ultimate demise of the culture dominating people's lives. Americanization was soon to follow, led by a staunch Anglo-Saxonism—the belief that the Anglo way of life is superior to all others, and therefore everyone should conform to it, by free will or by force.[226]

The 1920s and 1930s brought even more change for the Cajuns. During his tenure as governor, Huey P. Long paved the way for the oil industry to take hold in Louisiana. Improved roads further decreased rural isolation. Long also introduced educational reforms that promised (and sometimes delivered) the Cajuns access to schools and learning materials for the first time.[227] By this point, all children were required to attend school. However, in 1921, French was officially banned from public schools. No longer could children be instructed in either French or English. Long sought to produce a more literate state—in English, not French. This made French monolingualism a sign of a low, inferior class.[228] While Long did institute positive changes, he also ensured the demise of a positive outlook on Cajun cultures and ways of living.

Through all this, the rural Cajuns held on to their culture and customs fiercely. Still isolated from much of the change and progress, the rural Cajuns were observed in this time living as they had fifty to one hundred years prior.[229] They still lived simply among their families. They chose to remain uneducated as long as they could and still embraced the subsistence lifestyle. Throughout the 1920s, 1930s and even into the 1940s, those who still lived as Cajuns were looked down upon socially by others and thought to be ignorant, outdated and uncultured.[230] However, they continued to maintain a reputation for being hospitable and tightly knit.[231] Throughout this time, the Cajun culture can be viewed as a microcosm of the greater culture at large. In the early twentieth century, people from all types of different ethnic backgrounds were highly encouraged to assimilate to the broader American culture. Historical ties and differences were encouraged

to be minimized or disappear entirely. In hopes to Americanize people, they were made to feel ashamed of their backgrounds or were highly encouraged to abandon them. Historian Shane K. Bernard maintains that the Americanization process is among the most significant events in the Cajuns' history—right alongside the expulsion from Nova Scotia.[232] However, as we'll soon see, none of the negative societal pressures impacted the Cajun way of life as much as World War II.

Technology Ushered in Changes

Just talking to people in Southeast Louisiana, you get the sense that no other place in America has changed more drastically over the past one hundred years. At the dawn of the twentieth century, this region had no paved roads (few roads at all) and no electricity. Boats were the primary form of transportation and were steam, wind or human powered. They were used in every facet of life to transport people and goods from the producers residing in the marshes, bays and bayous to the consumers in places like New Orleans. It can be said without hyperbole that life was a simple affair for most in Southeast Louisiana, who existed at a level perhaps just a little above basic subsistence. Near the coast, the majority of residents were engaged in the fisheries, not only for the money they got from selling their catch but also to provide food for their own families, as they had for many decades—perhaps even a century—before that.

Technological and procedural innovations began to lay the foundation for momentous change in the late 1800s. These changes came, as many have, with the influx of immigrants. We know that the Chinese immigrants first brought shrimp-drying techniques to Southeast Louisiana.[233] Once dried, the shrimp could be transported, without spoilage, to distant markets, and the first non-local consumers of Louisiana shrimp were Chinese immigrant communities outside of mainland China, hungry for a taste of home.[234] They found it in Louisiana shrimp, which was exported to places like Cuba, where the largest non-American community of Chinese immigrants was based, numbering around 120,000.[235] It was immigrant markets that first proved the demand for the products that Louisiana fisheries had to offer, and this provided an additional economic incentive to work in the waters of the Louisiana shores.

With the increase in markets and the accompanying surge in demand, the structure of fishery production began to grow more formalized. No

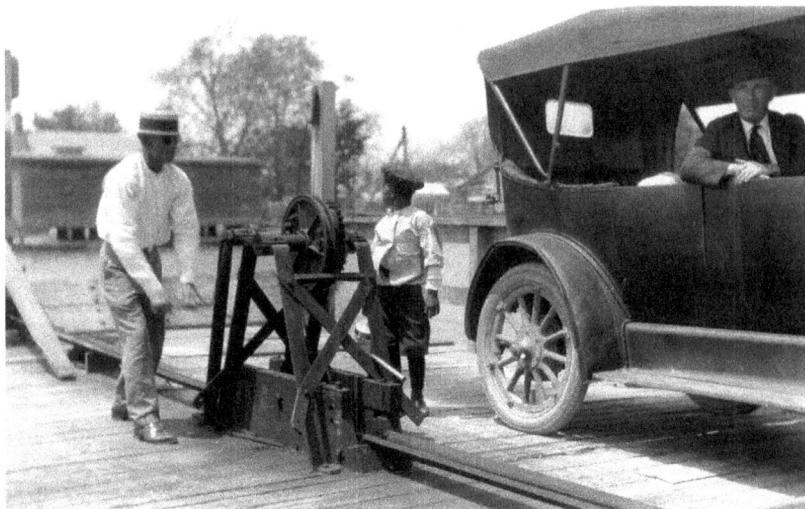

Prior to bridges, hand-powered ferries allowed cars to cross smaller bodies of water. Early twentieth century. *Courtesy of Louisiana Department of Wildlife and Fisheries.*

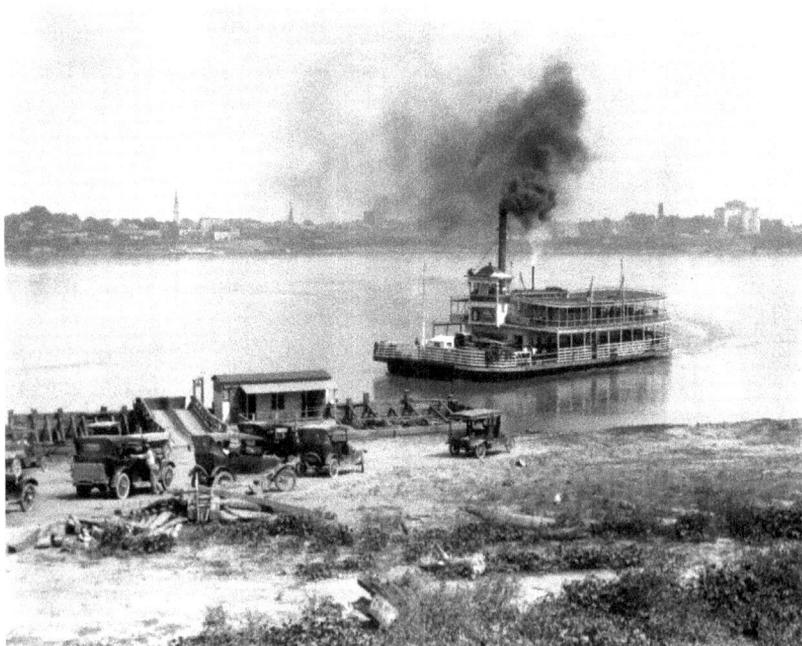

Port Allen in 1922. Even in the early twentieth century, steamboats remained a popular way to transport goods on the river. *Courtesy of Louisiana Department of Wildlife and Fisheries.*

longer limited to person-to-person selling, methods of mass distribution were necessary. Shrimpers and oystermen sold from docks to distributors and packing plants, which in turn shipped the product to hungry markets around the country. This allowed fishermen to utilize evolving harvesting techniques to catch larger amounts of everything. A market existed for all if it. Nothing was going to spoil on the docks, waiting for someone hungry to come along. Shrimping and oystering became industrialized, and with that industrialization came the economies of scale, which colluded to make harvesting the fruits of Southeast Louisiana more profitable. The first icehouses appeared in Morgan City around 1876, and this allowed many Cajun farmers to now become fishermen.[236] The Atchafalaya Basin provided rich and fertile fishing grounds, and the newly laid railroad was able to transport the catch to New Orleans quite efficiently.[237] Eventually, canneries popped up in the area and allowed for shrimp and oysters to be sold on a national scale. Most of the canneries east of the Atchafalaya Basin canned seafood for export to northern and northeastern markets, with the highest concentration being in Terrebonne Parish and Lafourche Parish.[238]

The fishery industries received a further boost around this time with the advent of manufactured ice in New Orleans in the 1860s, which allowed shipment of Louisiana seafood to much bigger markets on the nation's rapidly expanding rail network.[239] The combination of environmental control and relatively expedient transportation meant that few places existed Louisiana seafood couldn't get to, if the demand made it worth the shipping cost. Aside from the East Coast, with its own well-developed fisheries, the demand existed, especially among inland areas like the booming city of Chicago, which quickly became one of the top consumers of fresh Louisiana oysters.[240]

Ice has its limitations as well; it eventually melts, and the packed products can spoil, so the advent of canning in the early twentieth century was another piece of the puzzle that allowed Southeast Louisiana to grow the market for its seafood.[241] Once preserved, sealed oysters could be shipped around the world without concern for spoilage, and Southeast Louisiana found itself competing directly with the Northeast to provide goods like oysters to the rest of the country. The canning business exploded; a single cannery in New Orleans was known to consist of fifteen canning plants and a fleet of canning barges producing a quarter of a million cans of oysters a year.[242] Evidence exists in canning labels of the time that shows Southeast Louisiana canners encouraging the association of their oysters with the established, well-known producers of Cove Street

in Baltimore.[243] This was the beginning of marketing Louisiana's seafood. Oysters harvested in Southeast Louisiana would be sold as "Cove" oysters by Southeast Louisiana companies with names like the Baltimore Packing Company, which admitted, only in the fine print, that the point of origin was in Louisiana.[244] At the height of canning in the early twentieth century, over three thousand oyster luggers provided oysters from Southeast Louisiana to the canneries in New Orleans.[245] They were mostly sail powered, as merely fifteen of the total known oyster luggers at this time were motorized craft. The canneries constituted an enormous sector of the fisheries labor force in Southeast Louisiana at the time.[246]

Motorized craft was yet another advancement that changed everything in Southeast Louisiana. They reduced the time it took to get the fisheries products from the harvesting site to the consumption or packing site.[247] Trawling, a procedure dependent on being able to move the boat consistently through the water, was introduced to the region from the Atlantic coast after the First World War and allowed for larger catches with less effort than the traditional method, which involved crews of men playing out a net from a sailboat. Additionally, motorized craft allowed oystermen and shrimpers to settle in consolidated "end-of-the-road" communities rather than live isolated in the marsh near their oyster beds and the shrimp bays. They could live in larger communities and commute quickly to their work sites farther out in the marsh, no longer having to sacrifice precious harvesting time in transportation. The social structure of Southeast Louisiana was changed.

Gas engines also brought roads and expedient land transportation to the bayous and bays. Communities that were isolated and relied on shuttle boats to ship their products were now able to move goods to production centers themselves on the expanding network of roads. However, goods flowed not only out of the marshes and swamps but also into the region from other parts of the country. Because they had a product in demand elsewhere, trade was brisk for Southeast Louisianians, and their standard of life began to improve drastically.

The advent of gas-powered transportation had another profound effect down in the marshes and bayous when, in 1901, oil was first discovered in Southeast Louisiana.[248] This created an economic incentive to develop what had previously been thought of as somewhat of a provincial, rural backwater. Oil also provided more jobs and income to families in Southeast Louisiana, who found they no longer had to rely on the vagaries of the seasons for their livelihoods. The wetlands that bordered the Gulf

This swing span was the first bridge in Leeville over Bayou Lafourche carrying Louisiana Highway 1. It was replaced in 1970 by a lift bridge. *Courtesy of Louisiana Department of Wildlife and Fisheries.*

took on a new role as an energy factory. Access canals were cut through the maze of bayous and bays, platforms were built and tank farms were planted. The vast wilderness that was once known only to shrimpers, fishermen and oystermen was mapped. Roads were paved, telephone lines were run and electricity was brought to the little communities at the end of the road. The labor force and population changed as people came to the area looking for jobs in the oil fields. The bayou country developed at a steady clip, quickly catching up to the rest of the country with the encouragement of a state government that desired a more American culture (and increased tax base) from what had long been a neglected corner of Louisiana. As American cultures and traditions seeped into the

The original bridge crossing Bayou Lafourche in Leeville has resided in Port Fourchon since the 1960s. *From the authors' collection, 2014.*

bayou country, they pushed out long-held French traditions now thought of as old and stodgy. The French language, for example, was banned in public schools and government, and it began to die out from neglect. In fact, a generational line following the baby boomers traces the death of Cajun French in Southeast Louisiana.

The Oil Industry Arrives

While oil was discovered in 1901 in Southeast Louisiana, the modern oil industry officially began in 1934 with the successful use of a submersible drilling barge.[249] Louisiana has never looked back. Early exploration for oil was limited to land-based techniques during the Depression era. National demand for oil was low at that time, and exploration for oil was not done on any major scale until after World War II. This ushered in modernization at a staggering pace. The next step to tapping into and

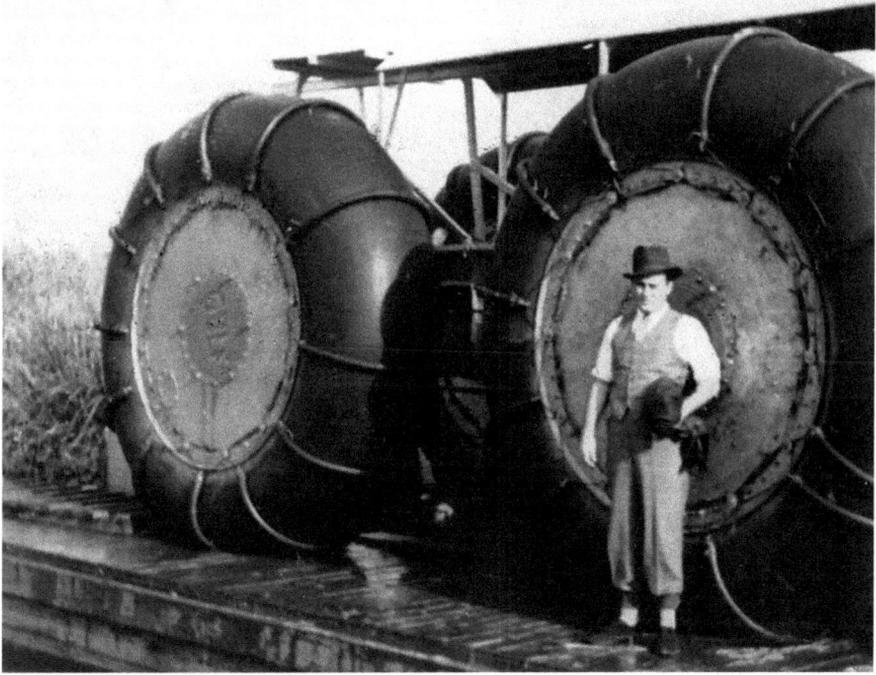

The oil industry used large marsh buggies to maneuver the soft wetlands. *Courtesy of Louisiana Department of Wildlife and Fisheries, 1937.*

exploiting Louisiana's oil reserves was gaining access. The easiest way to gain access was via dredged canals. These canals were the only practical way to access the oil. The soil was much too soft to lay train tracks, and roads were only possible to a certain extent.[250]

Eventually, the search for oil would take people into the marshes, thus necessitating the dredging and digging up of marshlands to create the most direct (and, therefore, most cost efficient) route to oil. This extensive network of canals certainly made drilling for and transporting oil more cheap and efficient, but it has also caused immeasurable harm to the wetlands. These canals not only affected natural drainage patterns but have also altered salinity levels in the marshes, which has had profound effects on both the flora and fauna of the region.[251] Land loss has been the most basic and obvious of these effects. Canal dredging accounts for 45 to 90 percent of the land loss experienced in the 1930s.[252]

As with the fishermen and trappers, the oil industry workers became another type of marsh dweller. Between 1901 and 1940, more than fifty

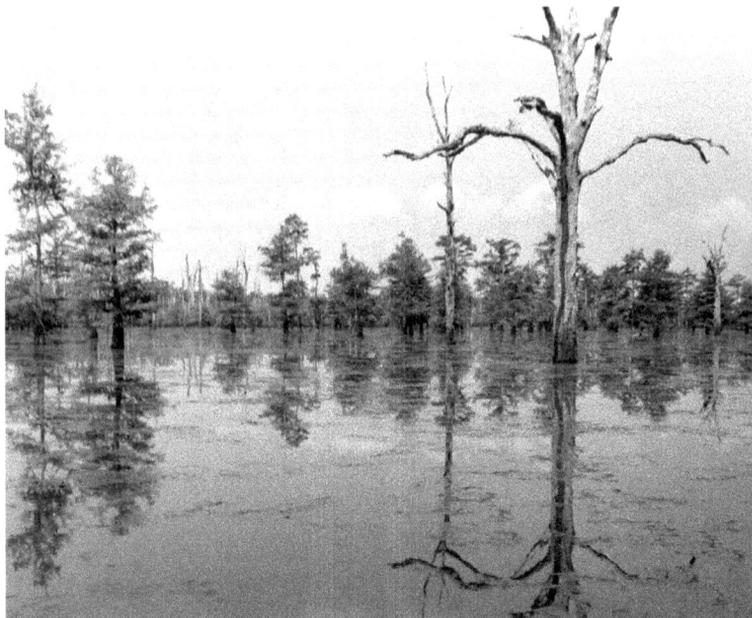

Dredging canals for oil exploration had significant negative impact on freshwater marshes located just north of the saltwater line, reducing many to mere marsh grass. *Courtesy of Louisiana Department of Wildlife and Fisheries.*

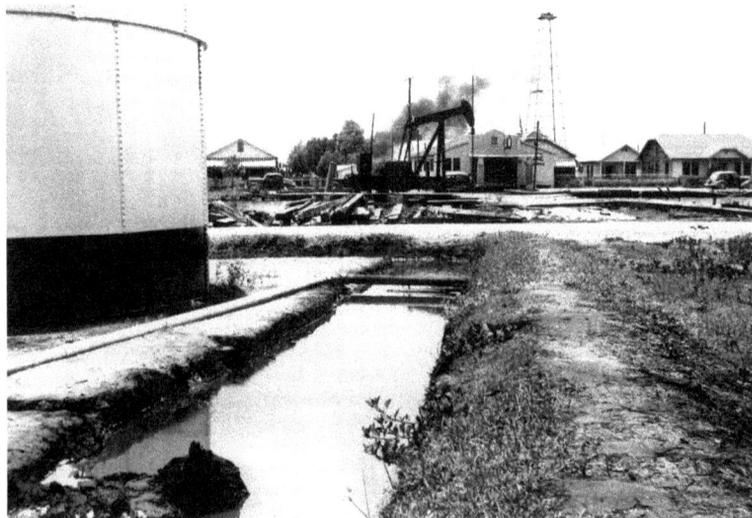

Starting in the 1930s, many coastal towns like Golden Meadow saw evidence of the oil field in their daily lives. *Courtesy of Louisiana Department of Wildlife and Fisheries, 1947.*

oil fields were established in the marshes of South Louisiana.[253] Each oil field had its own corresponding work crew and subsequent transient settlement. These settlements became a way to monetize the marsh on a wage basis as well as provide an opportunity to build out real towns and communities like Port Sulphur.[254] Scientific research conducted between the 1950s and 1970s shed new light on the value of the wetlands. People realized that the wetlands were not wastelands, as some had thought, but instead, they were some of the most prolific waters on earth.[255] Finally, the formerly "not valuable" marsh and swamps were realizing some monetary value thanks to the corporate invasion by oil companies. It's not that the marsh itself was given much value. The real value came in assessing what was under the surface—whether or not the marshland stood atop oil reserves.[256] What this still didn't take into account was the value of the land to the people.

Further, due to the influx and takeover by the oil industry, trappers and oystermen suddenly found themselves run off of land that they'd hunted and fished on for generations. The state had never before required ownership of these lands for people to use them for the various animals they hunted and fished. However, when the focus of the conversation shifted to mineral rights and people started figuring out how valuable those were, these fishermen found themselves out of their ancestral hunting and picking grounds. In nearly all cases, they were not given the opportunity to purchase land or have a say in how these lands were treated or what became of them. Between the state and the oil companies, everything was hashed out behind closed doors in office buildings far away from the marshlands.

The oil and gas industry was a huge push in helping to modernize Southeast Louisiana and helped to usher Cajuns into the more mainstream American society.[257] As the oil and gas industry grew in the twentieth century, Southeast Louisiana saw more and more non-Cajuns come into the area and dilute the culture even further. The money made in the oil and gas industry introduced Cajuns to a higher standard of life. More money meant more possessions, more extravagance. The simplicity was getting lost in all of it. The original Cajun way of life had to fight to be seen. Yet through the modernization and the money, some refused to relent and still held on to the beliefs in the customs of the traditional Cajun lifestyle.[258] While modernization happened at break-neck pace, a few people—namely the marsh dwellers—worked behind the scenes to try to preserve the culture.

Marsh dwellers were often misunderstood but played a huge role in the interworking of the marshes and wetlands. The marshlands were seen as the fringe. At the time, the conventional thinking was that no proper or sane person would try to live or make a living on those lands. Since it wasn't considered valuable or to be a place that could be "mastered" or "wrangled," it was just written off as worthless. Since the government didn't value the wetlands, they found it easy to enable the sell-off of them to oil and gas companies. The people who actually owned much of this land cared more about the money than preserving the way of life for coastal Louisiana. What many people living far away from the coast didn't understand was that the marshlands held plenty of life and a rich culture. Further, much could be learned from and studied in the marshlands. The old adage of "things aren't always as they appear" is highly applicable to the marshes and wetlands of Southeast Louisiana. Truly, one man's discarded wasteland was another's treasure-trove of fishing, seafood, trapping and freedom. The wetlands and marsh offered these transient people something that the government or anyone else couldn't—freedom. That's what they wanted, and that's what was most valuable to them.[259]

The oil industry is not the only way that the marshlands finally got some valuation. The fur industry also made people realize that these large swaths of worthless real estate were, in fact, veritable gold mines. In the early twentieth century, muskrat fur, marketed as several different types of animals, became widely popular globally for coats and accessories. At this time, it was common for a trapper to earn in the neighborhood of $4,000 during one seventy-five-day trapping season.[260] That was real money at that time (and still is), and this was another way that Cajuns moved from subsistence to cash-based living. It was nothing compared to the oil-land rush. Because so much money was now at stake, wealthy men started contacting the state regarding leasing this now-valuable property. Fishermen who had fished for generations found themselves thrown off their ancestral hunting and fishing lands. This, of course, caused problems with the local fishermen and the wealthy land leasers and sub-leasers, but these spats weren't new. They had been taking place in the timber industry for decades.[261]

Don Davis points out eloquently in his book *Washed Away* that it's truly a shame that the Cajuns and marsh dwellers were rushed off this land so quickly in many cases. It's ironic that they were the first people of European descent to realize the value of the marsh and wetlands, yet

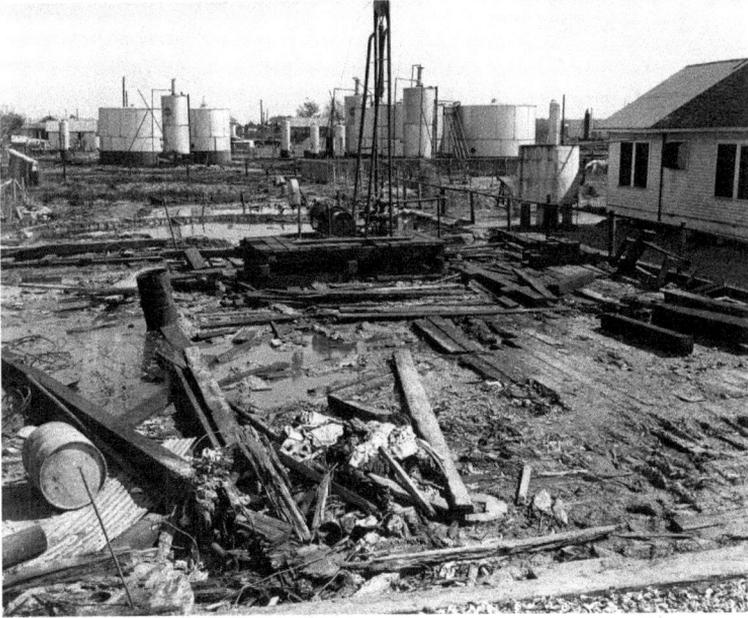

Oil companies were quick to buy up the mineral rights of any place they could in oil-rich towns like Golden Meadow in Lafourche Parish. *Courtesy of Louisiana Department of Wildlife and Fisheries.*

At one time, trapping was so prevalent that the industry even held a yearly ball in the mid-twentieth century. *Courtesy of Louisiana Department of Wildlife and Fisheries.*

they were kicked out and marginalized like they didn't even matter or like they never should have been on those lands in the first place.[262] As a sort of peace offering back in the early 1950s, oil giant Texaco would give the residents of the small coastal town of Leeville, located in southern Lafourche Parish, free gas for their homes. The homeowners would have to run their own pipes, but Texaco would supply the pipe at no charge. Mr. George Terrebonne, who grew up in Leeville, told us that Texaco started doing that so that the people would stop stealing the boards off the wharves that they'd built so they could access their pipelines. That was the exchange: stop stealing our boards, and we'll give you free gas.[263] Now that's a good arrangement!

During the 1950s, offshore oil exploration and drilling started, which allowed the industry to flourish even further. Coupling this industry expansion with the newly found American affluence that followed out of World War II, the availability and demand for oil increased greatly. With this expansion of the oil industry came many jobs for Cajun men and women (mostly men). Jobs in the oil field paid well and offered benefits. People from Bayou Lafourche and surrounding areas had never had jobs like those. Those who could and wanted to leave the fisheries did. Others stayed in but generally respected those who were able to work for the oil companies. Mr. George recalled when he was a child how his father had a deep respect for his friend Luke Cheramie, who worked in one of Texaco's offices. Mr. George's father's outlook on it was that if a person could work hard and grow up to work for a company like Texaco, that person was "really something." As in, that was the pinnacle of what people could do with their lives—have a good job in an air-conditioned office that paid well.[264] What more could a person ask for?

While the Cajuns actively pursued jobs in the oil field, and the oil money did start to flow through Southeast Louisiana communities, the outcome of the oil industry's presence was not always positive. The dredging that took place in the marsh and waste dumping polluted many of the area's traditional fishing, trapping and hunting lands. Equally as disastrous to the culture, the influx of men and capital with the oil industry

Opposite, top: Oil fields like this one dotted the landscape in and around the small town of Golden Meadow as early as the 1930s. *Courtesy of Louisiana Department of Wildlife and Fisheries.*

Opposite, bottom: An active piece of machinery for an oil company in the marsh on the east side of Golden Meadow. *From the authors' collection, 2014.*

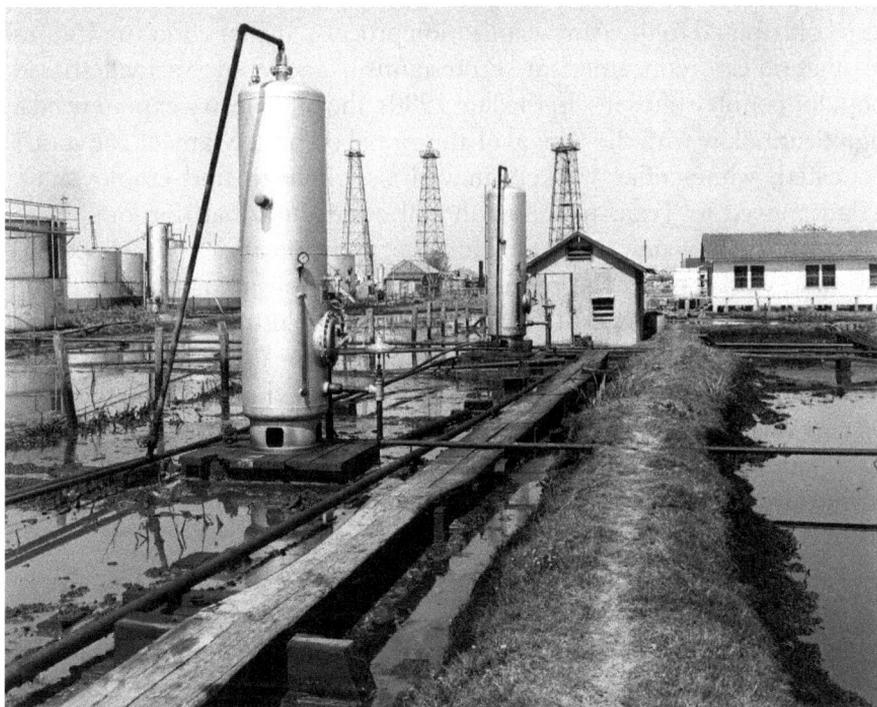

also contributed to the Americanization process, further exposing Cajuns to materialism, consumerism, Protestantism and even Nashville-based popular country music.[265] In the late 1980s, the oil industry experienced a significant blow with the arrival of the global oil bust. Many of the state's educated, white-collar workers moved elsewhere to find employment. Many moved to Texas to follow the oil companies that uprooted from Louisiana to lay new roots in Houston and other areas. The exodus of these workers and the profit centers of the oil industry have made the state even more reliant on tourism as an industry.[266] Cajun life—its cuisine, music and people—is, no doubt, a critical part of the tourist draw. The tourism craze began in South Louisiana as the state highway system was vastly improved in the 1920s and 1930s during the Huey P. Long administration. Growing widespread adoption of motor vehicles worked in tandem with the newly improved roads to allow people to visit the more rural parts of South Louisiana for the first time.

The Epic Impact of World War II

World War II ushered in the last comprehensive set of modern changes for most Cajuns. Many young Cajun men left home for the first time to serve in the war. Upon their return, many began to adopt the Anglo lifestyle and values.[267] They'd had serious contact with and influence from the outside world, and that stuck with them. Being off in the war helped to Americanize many young men, instilling a newly found love of America.[268] The experiences that many soldiers had in their deployments helped to shape and change their traditional Cajun values and beliefs. Back home, Cajuns actively participated in war efforts alongside their fellow Americans.[269] They recycled scrap metal, planted victory gardens and rolled bandages for soldiers. This cooperation with a larger community outside of Southeast Louisiana helped to increase their sense of being American. As Americans moved into Southeast Louisiana to live on military bases and to work in the ever-expanding oil fields, the Cajuns, many for the first time, began to see themselves as American.[270] Prior to this time period, most Cajuns had remained isolated and in relative poverty—many still didn't even own radios until that time. This also coincided with many more Cajuns starting to see themselves and their native culture as "inferior."[271] Ultimately, the Americanization process led to the further abandoning of French culture and traditions. Before

The postwar era was a prosperous time for many Southeast Louisianians. *Courtesy of Louisiana Department of Wildlife and Fisheries, 1965.*

the war, many people in South Louisiana were still flying the tri-colored French flag. Postwar, it was replaced with the American flag.[272]

World War II and Korean War GIs used the GI Bill of Rights benefits to purchase homes, start businesses and complete schooling. With education and a secure place to live, the returning soldiers flourished in an economy hungry for production. With this production came increased income, and with increased income came financial security. For the first time, Cajuns had money to burn. Once Cajuns had money, they cast aside the anti-materialism of their ancestors and proceeded to try to keep up with other Americans.[273] Like everyone else, they wanted the American dream that was being sold on TV, radio and in newspaper advertisements. Television and the messages it transmitted to a hungry audience served as the ultimate Americanizing tool. While the arrival of the oil industry helped move the people of Southeast Louisiana beyond the subsistence way of life, it also removed the last vestiges of European sensibility—backyard

In the 1960s, smaller communities like Bayou Benoit in St. Martin Parish installed boat launches to allow for public access to waterways. *Louisiana Department of Wildlife and Fisheries, 1966.*

gardens, for instance—replacing them instead with canned and frozen foods. But it gave people more money in their pockets for extravagances like RVs for Louisiana State University (LSU) football tailgating.[274]

All the while, the state government was still actively crushing use of the French language. Children were punished, sometimes severely, for speaking French in schools. Punishments ranged from swats on the hand with rulers to the more severe noose around a child's neck—placed symbolically, of course.[275] People also had fewer practical reasons to continue to use French and teach it to their children. The World War II era was the last breath of life for the traditional French language of the Cajuns. It was around this time that parents stopped teaching French to

their children altogether.[276] Seeing it as a dead-end language, they made sure to teach their children the more economically advantageous English first. For the first time, Cajuns were speaking English more than they were speaking French.[277] Mr. George Terrebonne was a child in the late 1940s and early 1950s and spoke French before he ever spoke English. Both his parents spoke French, so he spoke French at home. However, when it was time to go to school, young George faced hardships due to his lack of ability to speak English. When he first started school, he wasn't able to speak English at all. He remembers being punished harshly for being caught speaking French at school. He recalls being put on his knees and spanked as punishments. He recalls that he even urinated on himself several times because he couldn't ask the teacher how to use the bathroom in English. That seems to be more a failing on the part of the teacher for not imparting that knowledge on him, but those times were different than now, and people didn't necessarily view the situation with as much compassion as hindsight offers. Being from Leeville, young George was looked down upon by the "higher-class" kids from farther up Bayou Lafourche. He said, "I always felt inferior when I lived in Leeville." But from all the stories he told us, he loved his childhood and growing up in Leeville. From what we learned of his life, assimilating to the Anglo way of life in school was the biggest hardship he faced.[278]

The rural electrification program—from the late 1940s to the early 1950s—finally breached some of the last traditional Cajun holdouts. Modernization, mechanization and urbanization coalesced to diminish the need for many of the old traditional ways of the Cajuns. Supermarkets and the wider availability of food made communal cooking no longer a necessity. Clothes and toys and other household items now could be bought instead of having to be handmade. This time period also saw a proliferation of televisions in homes, thus diminishing the need for people to turn to one another for entertainment. Historian Shane K. Bernard posits that television helped to Americanize the Cajuns more than any other technological advancement, including the railroads and paved highways.[279] This modernization that followed after World War II left Cajuns with much less social time for friends and family. It had become more common for women to work outside the home, and people started feeling like they had "less time" in the day. Traditions like the *veillée*, once enhanced by family structure, which tended toward extended kinship and multiple generations living and working together, became less commonplace. With the advent of TV and radio, people no longer relied on each other for their primary

In the post–World War II era, families could spend an afternoon fishing from their new boats as a leisure activity. *Courtesy of Louisiana Department of Wildlife and Fisheries.*

sources of entertainment and information. However, the *veillée* tradition actually ended up evolving into something different—something seen as better and more modern. In time, the *veillée* took on a more grand scale. Gatherings became more formal events where food and entertainment were offered.[280] Radios and modern technology changed the dynamics of these events, and people went from reading to each other out of the almanac to listening to shows like the *Grand Ole Opry*.[281]

Some traditional ways of life still held out and prevailed, especially in the more geographically isolated areas. When Cajun cuisine expert Marcelle Bienvenu was a child, her family had camps on the Atchafalaya Spillway as well as Vermilion Bay. Camps are essentially modest homes built in remote areas. They're meant to provide shelter and a place to cook, sleep and spend time. She recalled fondly how a weekend wasn't a proper weekend if she wasn't able to spend it at the camp. Life at the camp, even in present time, mirrors the old subsistence way of life. In the summer, they caught,

A young woman fishes in what appears to be her Sunday best. *Courtesy of Louisiana Department of Wildlife and Fisheries.*

boiled and ate crabs. When the fish were biting, they'd have fish for dinner. Part of each day was spent foraging for what would become the night's meal. Living life outdoors, being on the water and spending time with family are what Bienvenu equates with her youth. Bienvenu's father was a master storyteller and would regale the family with stories for hours on end. Bienvenu now proudly carries on that tradition with her nieces and nephews, an integral part of a vibrant culture.[282]

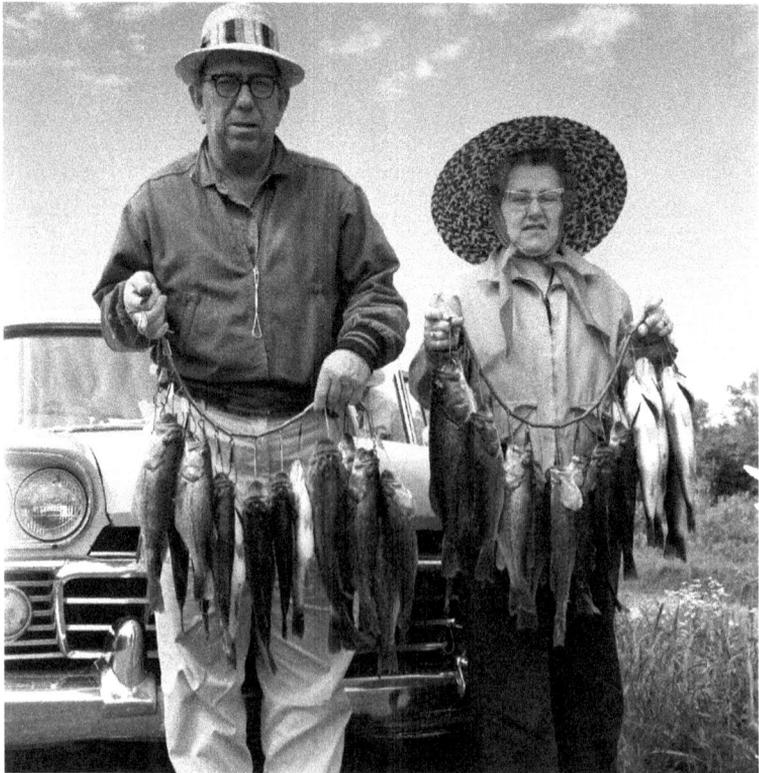

In the more rural coastal areas, away from the railroads and interstates, life stayed relatively quiet and unencumbered by much of the modernization, especially among the fishermen. Family ties were still important, and the sense of community that had pervaded for nearly two centuries was still intact. Mr. George Terrebonne, who grew up assisting his father on various trawl boats, shared a story that illustrated this well. Back in the mid-twentieth century, the trawlers in southern Lafourche Parish, mainly around Golden Meadow, pretty much all knew each other and were friends. They'd each have their places where they would trawl. During the day, a young George, who was around ten years old at the time, would point out each boat to his father on the horizon and ask who was who, and his father could tell him each and every one. The men would trawl on their own boats all day, then at night, they'd all gather close by and drop anchors. Back then people wouldn't trawl at night, so when the sun set, work ceased. After dropping anchor, they'd tie the boats together, typically five or so. Everyone would clean their decks and ice their shrimp. As each trawler finished his boat's work, he'd help the others until they were all done for the day. Young George, especially, would scurry from boat to boat assisting as needed. After the decks were clean and the shrimp was iced, the trawlers would retreat to tiny boat kitchens and cook something for a communal dinner. All of the men were great cooks, recalled Mr. George, and they'd proceed to feast on one of the boats. They'd eat dishes like *routi* chicken, *routi* shrimp, spaghetti and, always, plenty of seafood. After that story, Mr. George said sentimentally, "To me, that's a precious memory...Every night was like that."[283]

Since the country as a whole was more affluent in the post–World War II period, people began traveling in their cars for vacations. As a result, tourism to the state of Louisiana began in earnest during this time, thus exposing Cajuns to even more outsiders. This decreased the insular nature of the Cajuns' existence and began the commercialization of their culture. Tourism began to rise rapidly nationwide in the postwar period.[284] By the end of the 1950s, tourism was ranked as Louisiana's largest industry.[285] But

Opposite, top: A small fleet of shrimp boats. It was common for fishermen to spend time together in the evenings after the day's work was done. *Courtesy of Louisiana Department of Wildlife and Fisheries.*

Opposite, bottom: This scene is reminiscent of a Southeast Louisiana version of Grant Wood's iconic *American Gothic* painting. *Courtesy of Louisiana Department of Wildlife and Fisheries.*

the economy was becoming more diverse and offered better opportunity than Cajuns had been accustomed to, especially in the cities. The postwar period saw many people leave the rural areas to find better-paying jobs in more urban areas. Historian Shane K. Bernard notes that many who were formerly fishermen, loggers and moss pickers were more commonly becoming electricians, grocers and oil-field workers.[286]

Birth of Modern Cajun Cuisine

Newspapers, as they're prone to, heralded the codification of Cajun cuisine. As far back as 1877, Acadiana newspapers had published New Orleans–style recipes, derived from the local New Orleans newspapers. These recipes were quite popular with the rural Cajun housewives who set about cooking these new but still somewhat familiar dishes. These dishes, while not from the traditional Cajun culinary canon, quickly became staples of the people of rural Southeast Louisiana, who modified them and made the New Orleans–influenced dishes from other southern cities into true Cajun traditions. Further, in the 1920s and 1930s, local newspapers, in an effort to expand readership, began to publish cookbooks featuring those same New Orleans recipes. Local Cajun cooks flocked to these cookbooks, which heavily featured seafood dish recipes. Additionally, those who could afford to do so subscribed to the New Orleans *Times-Picayune*, which was and still is famous for its recipes. These newly discovered recipes and advances in home electricity availability, refrigeration and transportation paved the way for the Cajun housewife to start incorporating more seafood into her family's diet. These New Orleans recipes had a profound effect on shaping modern Cajun cuisine.[287] All this was possible because English literacy rates among Cajuns climbed as the 1940s progressed, which was a direct result of the increased focus on schooling pushed by the state government. The main reason for this push was to assist those living in the oil regions of the state so they could be better qualified for those jobs—many jobs in the bourgeoning oil fields required at least basic literacy. Another consequence of this was a huge development for food culture as it meant that recipes, once firmly in the domain of an oral and apprenticeship-taught practice, could now be written down and passed on in a more concrete manner.

In the post–World War II time period, as seafood was becoming more widely available and affordable for upwardly mobile Cajuns, traditional dishes like *court-bouillon*, which is primarily made of freshwater fish, began to be replaced with dishes like *étouffée*, which features more desirable ingredients like crab, crawfish and shrimp.[288] The ready availability and ease of use for processed seafood allowed the Cajun home cook quite easy access to all of these formerly hard-to-come-by delicacies. The Cajun palate quickly grew to love and become dependent on the delicious flavors of the bounties of the sea. Restaurants also cashed in on the Cajuns' newfound love for seafood. While many began to serve the dishes like *étouffée* and *court-bouillon*, it was in the fried seafood arena where restaurants flourished.[289] Since people generally didn't like frying seafood at home because it was a messy and time-consuming endeavor, it was easier and neater for them to dine on delicacies like fried oysters, fish and shrimp at restaurants. While the home diet for many Cajuns still consisted of the traditional dishes like *étouffée*, *fricassée* and brown gravies, the restaurant meals often focused on fried seafood.[290]

Catholicism, the traditional religion of the Cajuns, has always had significant influence over their way of life, including the development of the modern Cajun cuisine. Before the Second Vatican Council (1962–66), Catholics were never allowed to eat red meat on Friday. The holy Lenten season (the six weeks between Ash Wednesday and Easter Sunday) also had fasting and additional meatless days on its calendar. To this day, Catholics still observe meatless Fridays during Lent as well as several meatless holy days such as Saint Joseph's Day (March 19). The practice of abstaining from red meat consumption eventually pushed Cajuns toward developing a repertoire of seafood dishes like the crawfish *étouffée*, fried fish, redfish *court-bouillon*, oyster po' boys and shrimp *fricassée* for which they are so famous. This of course was only able to come about because many of the Cajuns were more financially well-to-do and had better access to seafood. Contrast that with the nineteenth and earlier parts of the twentieth century, when many Cajuns were still quite poor and living in poverty. Going "meatless" at that time typically meant using eggs as a protein source.[291] It's noted in the book *Stir the Pot* that Norris and Evon Melancon of Acadia Parish remember eating dishes like a roux-based egg and potato stew over rice or tomato gravy and rice with sides of smothered potatoes and scrambled eggs.[292] Further, author, historian and culinary instructor Marcelle Bienvenu recalled in the film *No One Ever Went Hungry* that her mother used to make a gumbo with potatoes and boiled

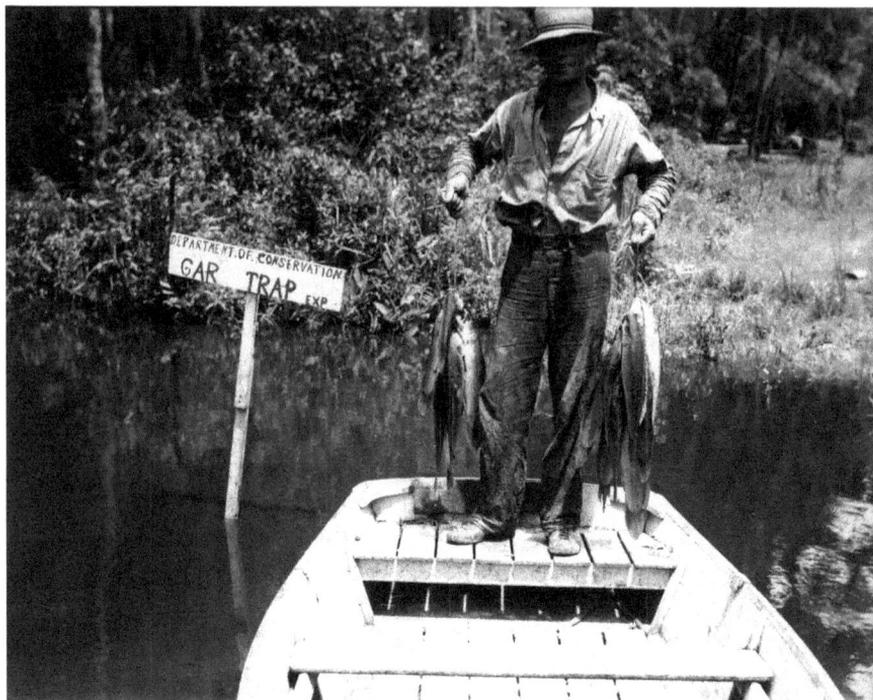

Prior to the 1950s, garfish was a popular freshwater fish choice on many southern Louisiana tables. *Courtesy of Louisiana Department of Wildlife and Fisheries.*

eggs as the main ingredients.[293] In the 1950s, large fish fries emerged as a way for people to pool resources and add variety to their Lenten diets.[294] To this day, this tradition persists in local Catholic churches and schools as a way to raise money and build community. However, interestingly, back in the 1950s, Cajuns still ate garfish.[295] Nowadays, garfish has fallen out of fashion and is not a fish most people would consider eating. People much prefer the taste of fried redfish, speckled trout or black drum. Back before crawfish became widely popular and available, fish fries were how most Catholics ate on Good Friday.[296]

The advent of women working outside the home also had significant influence on modern Cajun cuisine and how it's practiced in the home. Since the post–World War II era, many more Cajun women have been working outside the home. As a result, home cooking has suffered somewhat, and that's led to a decrease in the amount of traditional Cajun cooking being done in South Louisiana homes. What was once the norm

has now become more of a luxury, considering the time and effort it takes to cook most traditional Cajun dishes.[297] Before the days of grocery stores and restaurants, people cooked and ate at home. They typically grew or raised any food they consumed, supplemented by what they could barter for or cheaply pay for with what little money they had. As time passed and food became easier to come by, tastes, customs and practices related to food evolved as well.

Instead of producing one's own food, a person could turn to those grocery stores and restaurants for easy and convenient access to food. Kevin McCaffrey noted that his grandparents' generation was the last to garden because it was needed. Also, that was a time when more people in this country were still thought of as immigrants. Many of them still carried those European sensibilities around with them. People McCaffrey's parents' age grew up with those gardens, but by they time they were adults, it was the post–World War II boon time. The thinking by that point had gotten to, "Why do I need to garden when I have all these canned goods and frozen foods?" McCaffrey laughed a little when he lovingly said, "You know, I call my mother the 'Cheez Whiz' generation."[298] By this point, having a garden became more of a luxury and hobby than a requirement for surviving. That hobby of gardening has stuck with many Cajuns, partially due to their well-known preference for fresh foods and ingredients. The natural palate desire is for fresh, complex flavors. *Stir the Pot* authors recorded a sentiment from historian Nicole Fontenot about how even when Cajuns got to the point where they could buy produce at the grocery store, they still opted for fresh tomatoes and corn for dishes like *maque choux*.[299] Farmers' markets and roadside produce stands are increasingly present in the Southeast Louisiana landscape in modern times. Though not always plentiful, they have begun to make their mark in the produce market.

However, through all the modernization and changes of the mid-twentieth century, some cooking and food-based traditions thrived. Marcelle Bienvenu recalls fondly that it was both her father and her mother who taught her how to cook. Which dishes she learned from each parent falls directly in line with the traditional Cajun division of labor when it came to such matters. From her mother, Bienvenu learned how to make dishes cooked on the stove indoors like roux and gumbo. In Cajun households, women were the masters of the indoor kitchen. Outdoor cooking, on the other hand, was (and still mostly is) dominated by the men in the family. In addition to managing the *boucherie* for the family,

Cajun males learned to cook on their hunting and fishing expeditions. It is also tradition that the males cook all the wild game for the family as well as boil the seafood and man the barbecue pit in the summertime.[300] Bienvenu recalled watching her father cooking outdoors on an open-hearth fire. She remembers being amazed at all the wonderful meals he produced. She recalled how her father and the other men in the family would start roasting the Easter Sunday pig on Saturday night. To maximize the pig's flavor, her father would borrow a syringe from a local veterinarian to inject the brine into the animal prior to cooking. Bienvenu summed it up this way: for her mother, cooking was a chore, something that had to be done; but for her father, cooking was an occasion, an event. He loved to cook for large groups, and her mother loved that entertaining aspect—setting the table and fussing over the guests' needs.[301]

When most people think of Cajuns, they think of food—gumbo, *étouffée* and the like—all based on the bounty of the sea, but it hasn't always been this way. Like Cajun culture, Cajun cuisine evolved over time with flexibility and yet a cohesiveness that have allowed both to thrive. Viewed through this lens, it is no accident that Cajuns are most closely associated with gumbo: nothing explains the experience of Cajun history better than a dish made with anything and everything on hand. Based around a loose family recipe, gumbo absorbs whatever is thrown into it while maintaining its own identity as a dish. A gumbo is recognizable in any region, any place in the world by its base preparation, yet it may vary from person to person and town to town. Cajun culture is much the same—shaped by centuries of outside influences, foreign ingredients and ideas and even foreign blood. Cajun culture has absorbed it all, while maintaining an identifiable base, anywhere it is in the world. It is unique because of its colorful history, and it is made special by the land that Cajuns have come to call home, a land unlike any other on earth. The Cajun culture is worth studying and worth preserving. It is worth immersion and it is worth the time it takes to understand where the culture was, where it is and where it is going.

THE PRESENT TO THE FUTURE: WRITING THE NEXT CHAPTER

5

A GLIMPSE AT MODERN TIMES

It's about 10:30 in the morning on Good Friday as we're hosing the mud off of fragrant sacks of crawfish that the sun first breaks through the clouds and begins to turn the night's rain on the driveway into a blanket of steam. We have about sixty pounds of crustaceans here, squirming and clicking in purple nylon bags, bought from a refrigerated trailer marooned on the side of the highway. The plan is to get them boiled for noon when the family shows up, so the giant pot is already growing turbulent over the roar of the burner in the backyard, and the coolers lined up next to the house leak into the mud puddle along the side of the house. First, we purge the crawfish in the cooler's bath of salt water—an effort to cleanse the last remains of the swamp from the crevices of their shells and the depths of their guts. The first beers of the day are cracked open as the dirty water drains out of the bottom of the cooler into the little stagnant ditch that sits by the road—the ditch that's quickly lined with the cars of aunts and uncles and grandparents. The yard slowly comes alive with the sounds of children playing, getting reacquainted in that quick and open childlike way as they splash in the still-squishy grass. Clumps of people form like planets orbiting the heat of the pot, now filled with secret blends of spices and oils such that the steam burns the nose and makes the eyes water.

The men gather close around the pot and stare into the roiling red liquid, one of them stirring complicated vortexes through it with a miniature pirogue paddle. They discuss sports—baseball at the

Drawing by Frederick Stivers, 2014.

moment—but always with an eye toward football's approaching autumn. Sports is the great neutral ground for families otherwise frequently divided, or at least set at odds, over politics and religion. The women sit in the shade of the house talking food—what was eaten for breakfast, what's coming for lunch, what will be done with the leftovers for dinner. The kids are already covered with loose grass and splotches of mud. They've over-excited the dog, of course, and he has to be kenneled. Everyone is waiting—killing time while the water comes up to temperature.

When a font of steam bubbles up from the pot like a scene from some distant national park, the crawfish are slid in carefully, every guy around the pot either having heard stories of horrific splash burns or having experienced them himself. The chatter in the yard becomes more focused around preparations. Garbage bags are stretched into cans, and a winter's worth of newspaper is laid across folding tables in the concrete-cooled air of the garage. Music appears suddenly in the air when the roar of the pot cuts off. The crawfish are mostly cooked, and it's time to let them soak and allow them to stew in the spices to absorb the flavors. The impatient guests use the paddle to pick meaty-looking specimens out of the wet, bright red pile of crawfish, and they burn their fingers picking

them apart. Opinions are immediately rendered to the cook on spice levels and soak times.

Most everyone is already standing or sitting at a table when two men lug the inner sieve of crawfish splashing out of the pot and, leaving a trail of spicy broth on the ground, drag it over and in one spectacular movement hoist it up and pour its contents across the table, producing a view briefly concealed by a cloud of steam. Conversation drops to an almost inaudible level as fingers gingerly pick out boiled potatoes and corn, asparagus, Brussels sprouts and garlic heads. They select crawfish with substantial claws before anyone else has a chance to steal them. As the crawfish cool, the eating accelerates, and around the table, people fall into a rhythm: pick up, twist and pull off the tail, suck the head, discard the head, grab the meat of the tail between the teeth and pinch the base of the tail, discard the tail shell, pick up again. Over and over, this procedure becomes one complicated but fluid motion repeated a hundred or more times by everyone positioned around the pile of crawfish as it progresses from one large mass in the center to a constellation of smaller refuse piles of shells and other detritus.

It takes about an hour and a couple of boilings to get through all the crawfish in the coolers. After we eat, little remains. What's left is mostly vegetables, which are bagged for leftovers. The crawfish that weren't eaten are peeled by the women and heaped into bowls for tonight's *étouffée*. The sound of the hose drowns out the music again as the men rinse the pots and coolers, and the kids go back to playing. Conversations sprout back up as the families gather and re-coalesce around stories and tall tales. They spent the time before eating just catching up, but after eating, time is just for enjoying the company. The sun begins to sink and cast that golden, afternoon light on the backyard—the kind of light that memories are made of that the children will grow up to feel fondly about and not know just quite why. It will have its roots in afternoons like this one, free from the tyrannies of childhood life, where the adults are occupied with telling stories about the way things used to be—the good old days—leaving the younger generation open to roam the yard, the street, the woods out back and form their own good old days, to fondly recall one day when they are sitting around the backyard with sated bellies full of crawfish.

The mouth of Bayou Lafourche where it empties into the Gulf of Mexico. *Courtesy of Mary Chailland.*

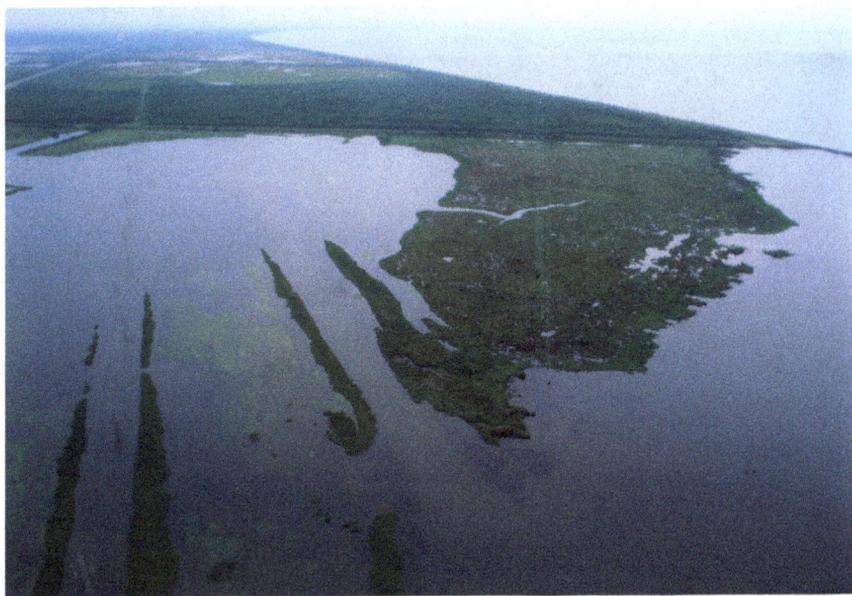

The marsh is an ephemeral boundary between water and land. *Courtesy of National Digital Library of the United States Fish and Wildlife Service, 2006.*

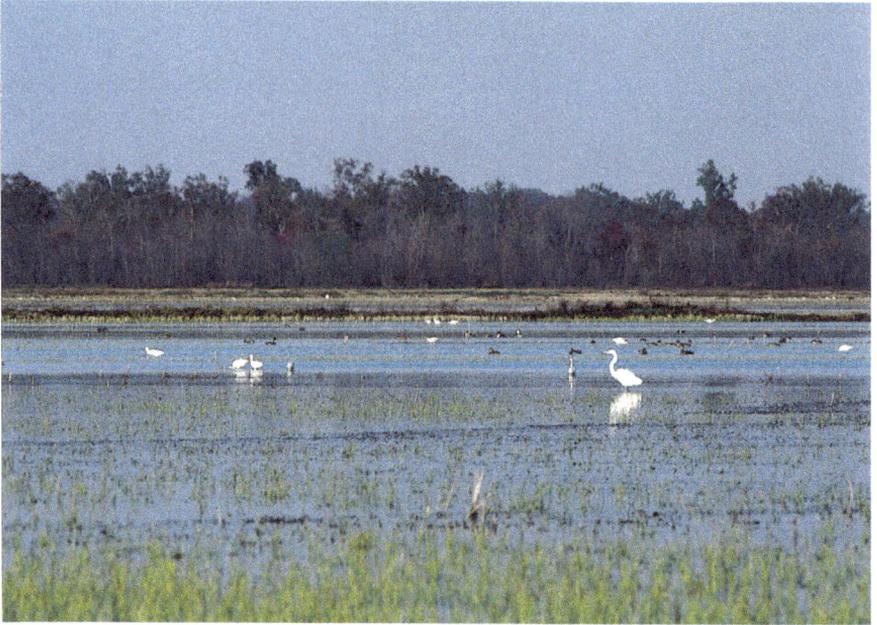

Rice ponds like this one dot Louisiana, also providing crawfish-farming opportunities outside of rice-growing season. *Courtesy of USDA Natural Resources Conservation Service, 2011.*

Often scorned for its harsh environment, the marsh undoubtedly holds a unique beauty. *Courtesy of J.C. Winkler, 2006.*

Swamps like this used to form most of the Louisiana coast. Today, they exist mostly inland. *Courtesy of Nick Shields, 2012.*

An aerial view of camps situated along A.O. Rappelet Road in Port Fourchon. *Courtesy of Mary Chailland.*

The Chandeleur Islands are a distant barrier island chain, home to diverse wildlife. *Courtesy of Jeffrey Warren, Grass Roots Mapping project, 2010.*

The official logo for the Louisiana Wild Seafood Certification Program. *Courtesy of Louisiana Department of Wildlife and Fisheries.*

The official packaging logo for Vermilion Bay Sweet White Shrimp. *Courtesy of the Port of Delcambre and Louisiana Sea Grant College Program Louisiana State University.*

Fried shrimp can be found and enjoyed at any seafood restaurant in Southeast Louisiana. *Courtesy of Louisiana Sea Grant College Program Louisiana State University, 2011.*

Boiled crabs are a delicious staple of the boiled seafood diet. *From the authors' collection, 2014.*

This wild-caught blue crab is destined for the boiling pot. *From the authors' collection, 2014.*

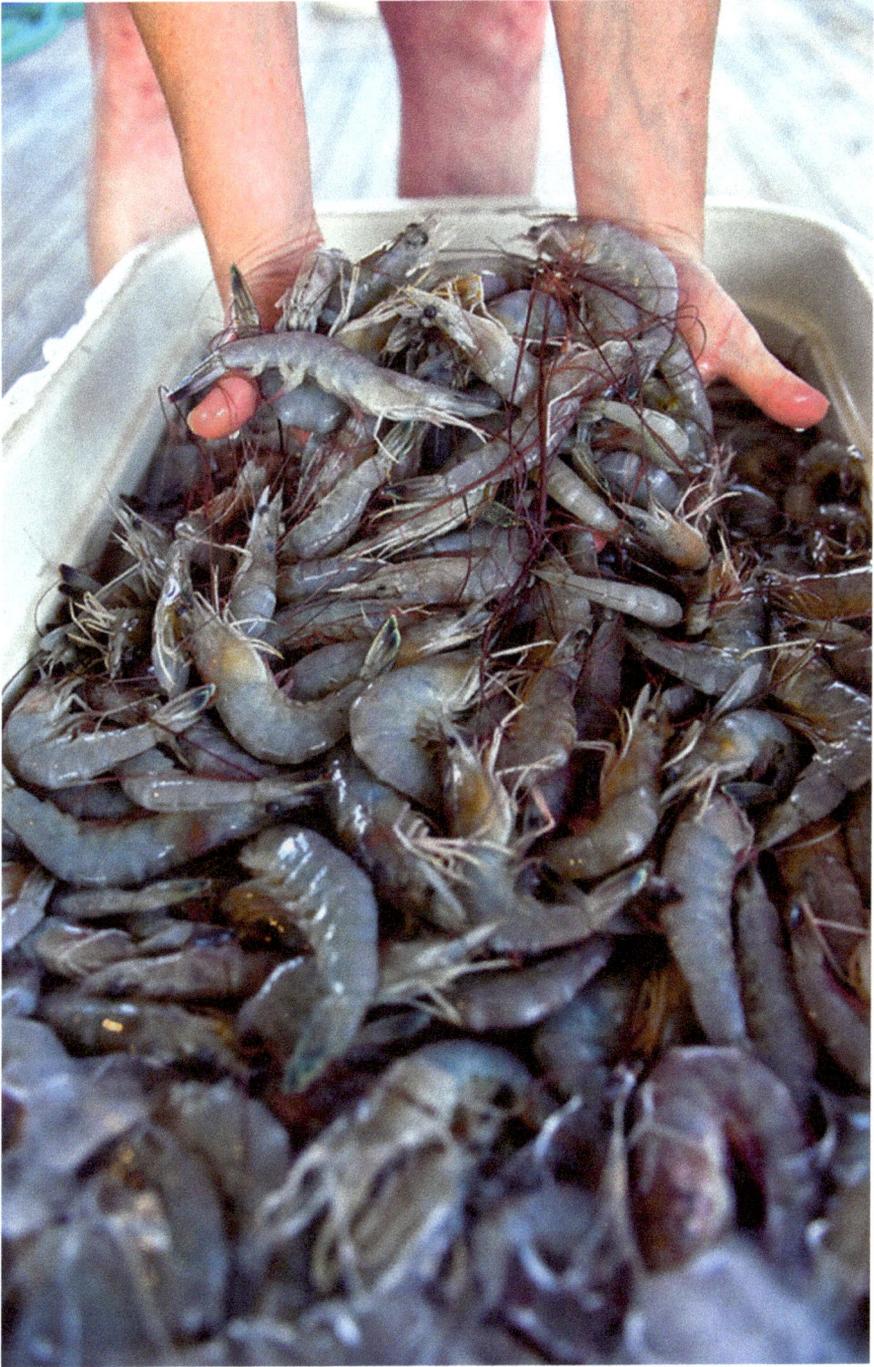

Shrimp are plentiful in Southeast Louisiana. *Courtesy of United States Environmental Protection Agency, 2011.*

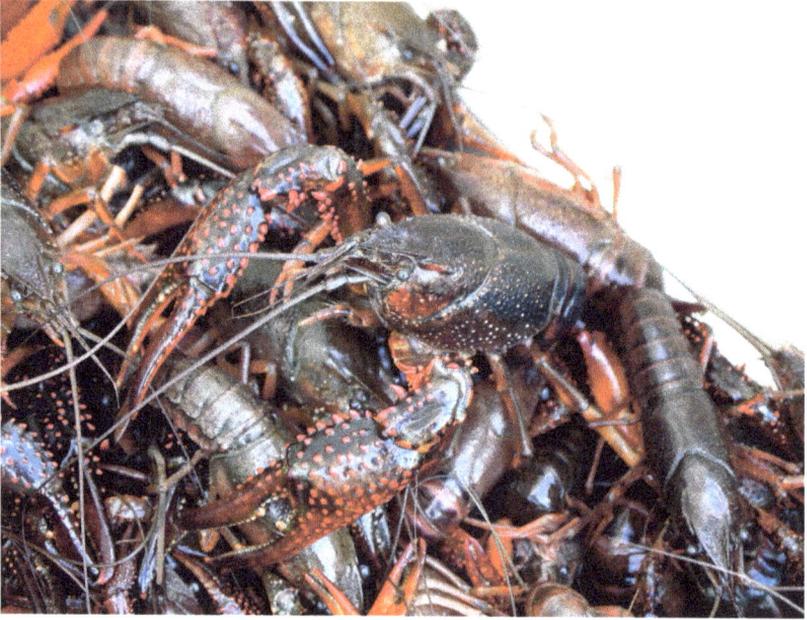

Crawfish aren't much to look at, but they are certainly delicious once boiled in a spicy broth. *From the authors' collection, 2013.*

Seafood isn't the only thing that's boiled—a variety of vegetables can also be delicious when added to the pot. *From the authors' collection, 2013.*

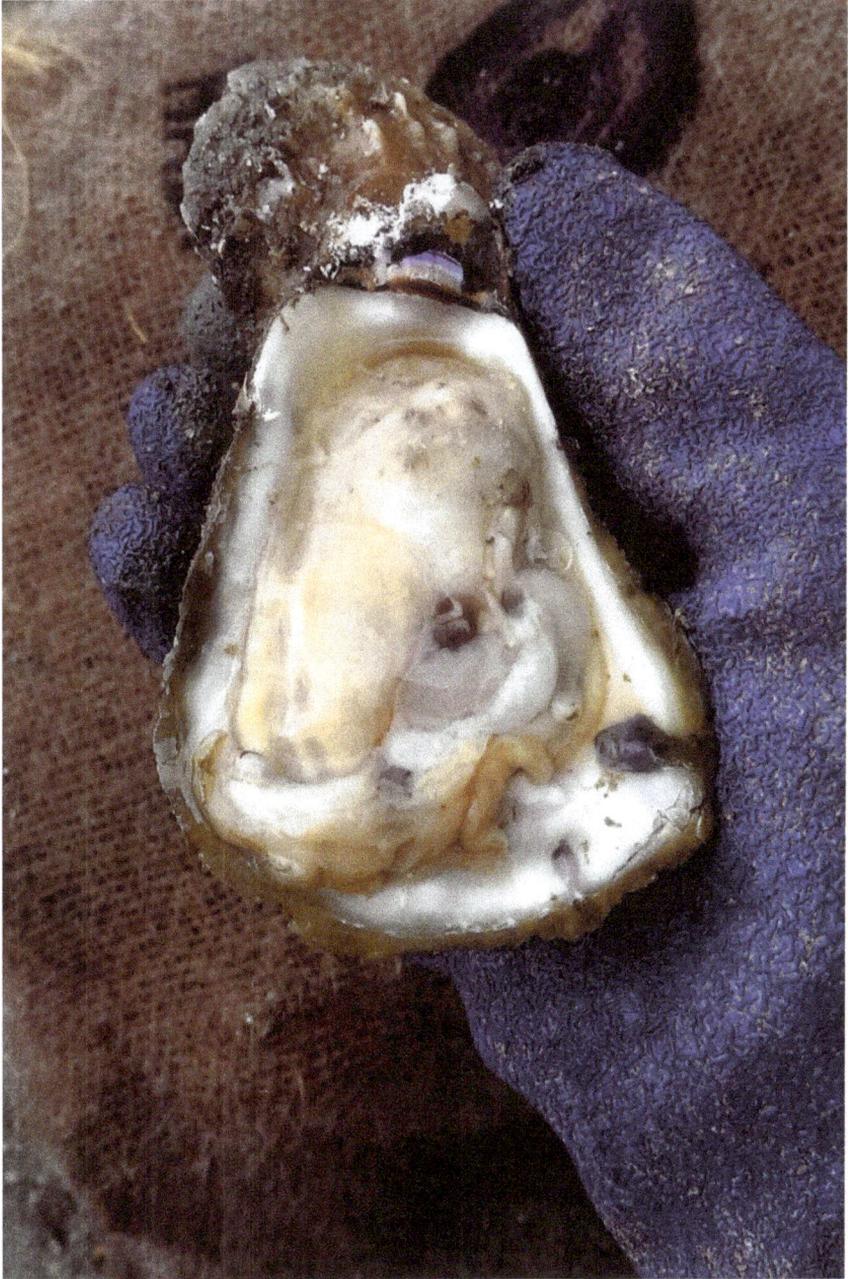

Few foods in Southeast Louisiana are as highly prized as a freshly shucked oyster. *From the authors' collection, 2014.*

Speckled trout are a highly prized catch among today's recreational anglers. *From the authors' collection, 2014.*

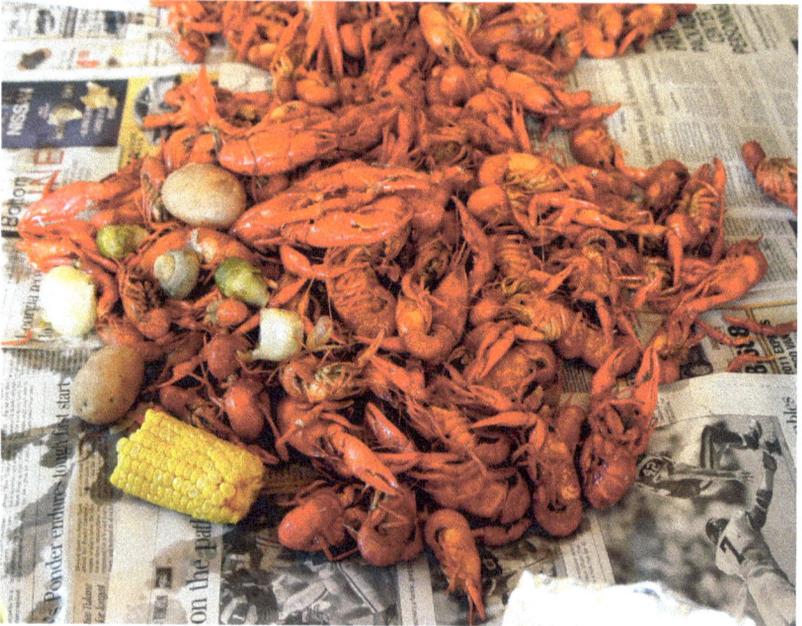

This scene of bounty is repeated across Southeast Louisiana for the duration of crawfish season. *From the authors' collection, 2014.*

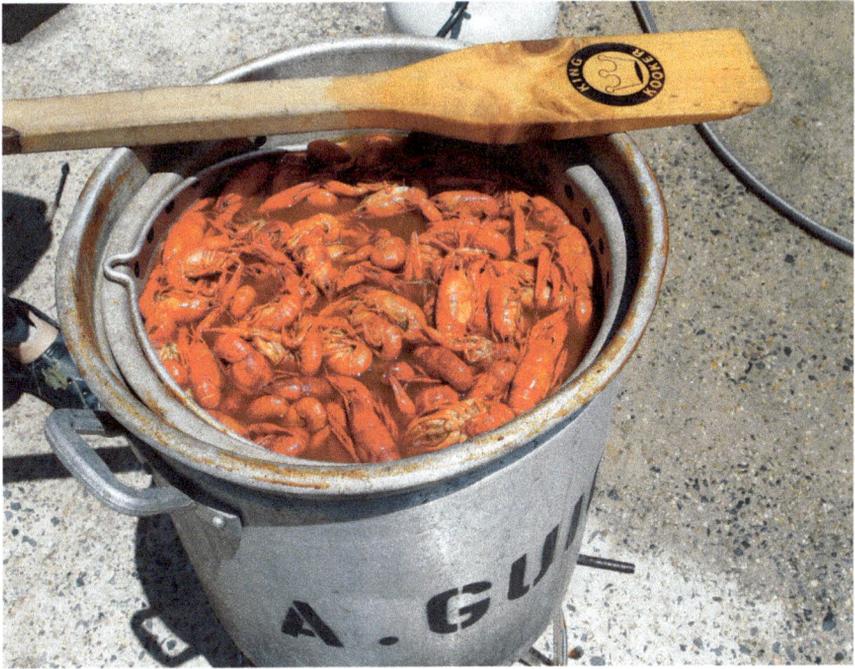

Boiling crawfish is as much a tradition as a culinary process. *From the authors' collection, 2014.*

Oil rigs dot the Louisiana coastline in the Gulf of Mexico. *Courtesy of Mary Chailland.*

This boat was part of a Blessing of the Fleet celebration in the late 1990s. *Courtesy of Mary Chailland.*

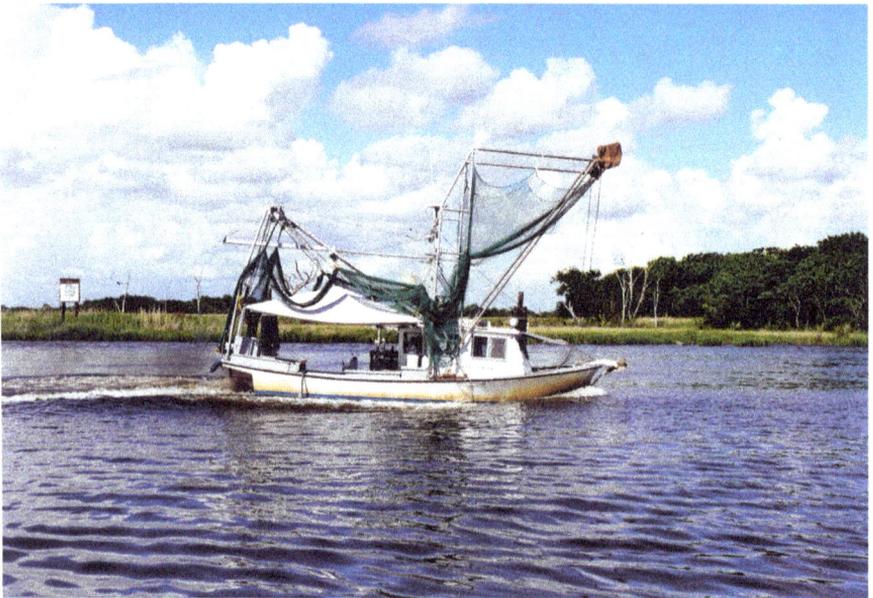

Small and large boats alike head out to catch their share of shrimp during the annual May and August shrimping seasons. *Courtesy of Mary Chailland.*

Most modern oyster luggers have a low, flat top over the deck to protect oyster harvests from the sun and other natural elements. *Courtesy of Louisiana Department of Wildlife and Fisheries.*

The Blessing of the Fleet is still popular in small coastal fishing communities like Golden Meadow. *Courtesy of Mary Chailland.*

The Blessing of the Fleet is a colorful affair. *Courtesy of Mary Chailland.*

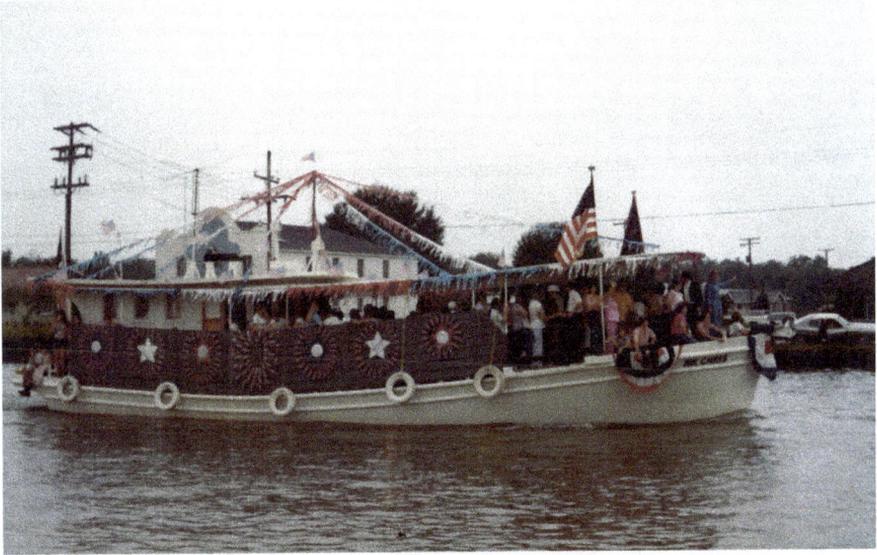

The Blessing of the Fleet has roots back in France as a way of protecting the fishermen and asking for a good harvest. *Courtesy of Louisiana Department of Wildlife and Fisheries.*

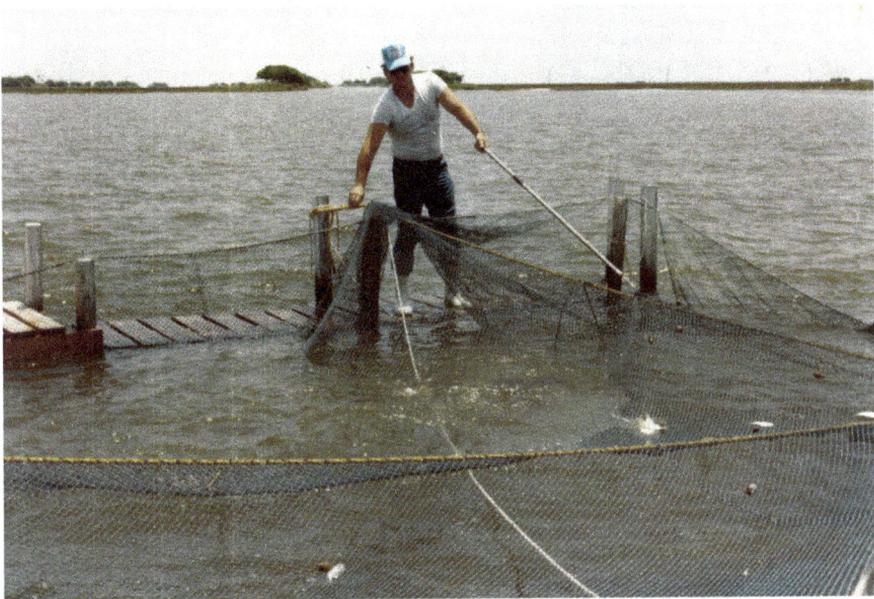

Seines are hand-controlled nets that allow for catching shrimp and fish. *Courtesy of Louisiana Department of Wildlife and Fisheries.*

A family eats crabs and crawfish on Good Friday on Grand Isle. *From the authors' collection, circa 1986.*

6

SETTING THE STAGE FOR MODERN TIMES

The United States has seen exponential growth throughout its short history, rocketing from a colonial backwater in the unexplored wilderness of North America to a world industrial and political power, all in the course of only three hundred years. The continent that is now largely dominated by the United States was once home to thousands of indigenous cultures and later hundreds of immigrant cultures, all settled in little enclaves across the vast and varied land. Over the course of American development, political and economic choices made by the government of Tocqueville's aptly described "Great American Experiment," a democracy shaped the culture and the course of modernization. False starts and setbacks occurred, but the pace of American development was always relentlessly forward facing.

Southeast Louisiana, though exceptional on so many levels, has been no exception to this relentless march of modernity. Sacrifices have been made in the name of progress: tradition, culture and even food have fallen by the wayside in the rush to provide better jobs and a higher standard of living. Nowadays, on the surface, Southeast Louisiana largely appears much like any other rural, small-town region in America. The improved infrastructure spurred by the oil industry not only brought development to the region but also brought middle-class jobs and the consumption-based lifestyle that accompanied the post–World War II economic boom. Paying well and providing benefits to workers without the need for higher education, oil-field work became the desired jobs in

the region at the expense of the customary family businesses. A higher standard of living often supplants the rich traditions and cultures borne of simple necessity. Improved communications technology like radio, telephone and television piped a coalescing American culture into the bayous and managed to change the product of over 250 years of slow adaptation in less than half a century.

The slow fading of community traditions was a symptom of a larger change as the communities of Southeast Louisiana retooled themselves, like the rest of postwar America retooled itself, around the pursuit of individual happiness rather than community well-being. While it is easy to look back fondly at the time before these changes, it is important to realize that the refocusing of economies around the individual rather than the community is a natural outgrowth of better incomes. As breadwinners in Southeast Louisiana took home more than just what was required to survive, luxuries came within reach, and the direct need for one's community to survive and live comfortably faded. Southeast Louisiana took on that trait of modern America as well: individuality.

Although outside forces like modernization and globalization threaten the traditional Cajun ways of life, they're almost equally threatened from within. Nowadays, parents don't seem to be imparting traditions and folkways knowledge on their children as past tradition had dictated. Less often, families take part in and practice the traditional Cajun ways of life. Further, today's parents don't seem to be instilling a spirit of curiosity in their children. Granted, this is not confined to Southeast Louisiana or this particular way of life. Sadly, it's all too common around the United States these days. Many of today's youngsters and teens aren't even curious about their roots or their heritage. It doesn't dawn on many of them to ask many "whys" or how particular traditions came to be. They simply accept it as a way of life without thinking about the deeper meaning.[302]

It seems that the children of the baby boomer generation are not as actively passing on traditions and folkways as was done in past generations. Life has become so busy, connected and fast paced that it seems like stopping to ask questions and thinking about their history and origin aren't what people make time for anymore. The days of Sunday family dinners where everyone gathered at "Maw Maw's house" are largely relics of the past. For these traditions to survive, they must be taught to the future generations and continue to be practiced. The survival of these traditions doesn't rest solely with the practitioners of the traditions. A much larger system is at work in Southeast Louisiana.

Cultural traditions like Sunday family dinners, *boucheries* and "making the *veillée*" cannot survive on good intentions alone. By studying culture, we can only see the past; we cannot predict the future course of culture or the future course of a cuisine; it's all too wrapped up in the vagaries of the moment—the little chances and random occurrences that make up human existence. What we can predict and to a certain extent control, given that food culture pivots on the raw materials of the traditional foodways, are the future courses of the fisheries in Southeast Louisiana. The fisheries provide the traditional jobs, recreation, customs and foods of the region, and as the fisheries go, so goes the culture.

Accordingly, policies made at every level must take into account their potential effects on the fisheries and subsequent effects on the culture. If the unique food culture of Southeast Louisiana is to thrive, environmental, energy, social and developmental policies all must allow the culture itself to thrive. When Southeast Louisiana is approached as a system in which food culture is dependent on cultural traditions, cultural traditions on the economy, the economy on the fisheries, the fisheries on the environment and, increasingly, the environment on culture, it becomes clear that the only way to ensure that the ingredients that make up the gumbo of Southeast Louisiana culture thrive is to make sure the fisheries are always functioning, economically and environmentally viable to supply the food, and thus the culture.

After all, Southeast Louisiana has a long history of cultural change, adaptation and building something new and successful from former swamp. This change always begins with people and their families. Every success story is based on a family. Families are the most intimate way through which we connect with history. Therefore, every person in Southeast Louisiana is connected to the history of the region via family. Our own family's course mirrors the course of the region as a whole. This family story begins with one of Addie's paternal great-grandfathers, named Claiborne Simon Boudreaux.[303]

Claiborne Simon Boudreaux was born on March 12, 1905, and originally hailed from the Houma area. He was named after Louisiana's first post-colonial governor, William C.C. Claiborne. Claiborne Boudreaux's nickname was "Casno Verre," which is Cajun French. It's derived from the phrase *casse no verre*, which translates to "break no glass." Claiborne was known to be a rowdy fellow with quite a temper, so when he'd get riled up in a barroom, the bartender would shout, "*Casse no verre! Casse no verre!*" reminding him to watch his temper and not break any of

Claiborne and Niese Boudreaux with their family in Grand Isle. *Courtesy of Brent Constransitch.*

the bar's glassware in the process. In time it came to be spelled Casno Verre, but most people just called him Casno for short. Since that's the name he was most recognized for, that's what we'll use in this account.

Casno was a man of ambition and high achievement. He started out as a trawler and worked in tandem with his older brother Ludovic, known as "Dovic." Dovic was the oldest brother, and Casno was one of the younger brothers. They all worked together loosely, and Casno's job was to work out in the field with the men trawling in the boats, while Dovic took care of the business side of the operation. The shrimp that Casno's fleet caught were then sold to Dovic's seafood distribution enterprise, Pelican Seafood Company. At one time, a dozen or so of these "shrimp sheds" lined Bayou Lafourche in Golden Meadow. Dovic's company was one of many. A shrimp shed is a wholesaler to which trawlers sell their catches so that they can be sold further to processing plants, canneries or the public at large. It was helpful for Dovic to have a fleet of trawl boats that he knew would sell directly to him, as it was likewise beneficial for Casno to have a trusted place to offload his shrimp.

Casno wasn't just a single-boat trawler. He directed and was responsible for a whole fleet of boats. While he didn't own them

directly, he organized an affiliation of trawlers and their boats that would operate under the Claiborne Boudreaux company. At one time, a dozen or so of these companies operated in the southern Bayou Lafourche region, each with its own flag. Back in those days, pre–World War II, boats didn't have radios or any kind of communication. All they had to communicate with were binoculars and flags. In one fleet, they might have had as many as twenty boats trawling. To be able to identify each other and pass supplies and shrimp to one another, they would look for those flags. Claiborne's flag had three thick stripes. The top and bottom were green, while the center stripe was white. Centered on the white stripe was a red diamond, which was the same height as the white stripe on which it was placed.

Claiborne was illiterate, but he was a shrewd businessman, nonetheless. With the help of his wife, Niese, who was able to read and write, they were able to be successful in their business endeavors. The two of them were a team whose skills were complementary and set them ahead in life. Addie's father, Rudy, Casno and Niese's grandson, remembers when he was young how Niese was a great cook, a good grandmother and very patient. He recalled in particular that when he was learning to trawl during the summers as a young man, she would remain patient when he was trying to learn a new trawling-related task. Casno, on the other hand, would get frustrated with him for not getting it right the first time. This trait was typical among Cajun men apparently, and that's a great example of how the Boudreauxs worked well together as a team. In the days when Casno was a trawler, Niese was always out trawling with him, which worked well for them.

In the 1950s, Casno moved on from trawling to owning a seafood distribution company like his brother had done but on a smaller scale. He sold to the public instead of focusing on the wholesale business like Dovic had. Casno had two businesses and would sell whatever seafood he could get. The first business was located in the middle of Grand Isle, but the second was on the north end of the island, situated on a plot of land that he purchased that stretched from the highway to Caminada Bay. His business faced the bay side, and he had a harbor where boats would come in and unload. Interestingly, he didn't deal much with commercial fishermen, but instead, he focused on buying from sport fishermen. In his later years, Casno followed his customers to become a sport fisherman rather than a commercial fisherman. He and Niese loved to sport fish, especially looking to angle large redfish. They actually

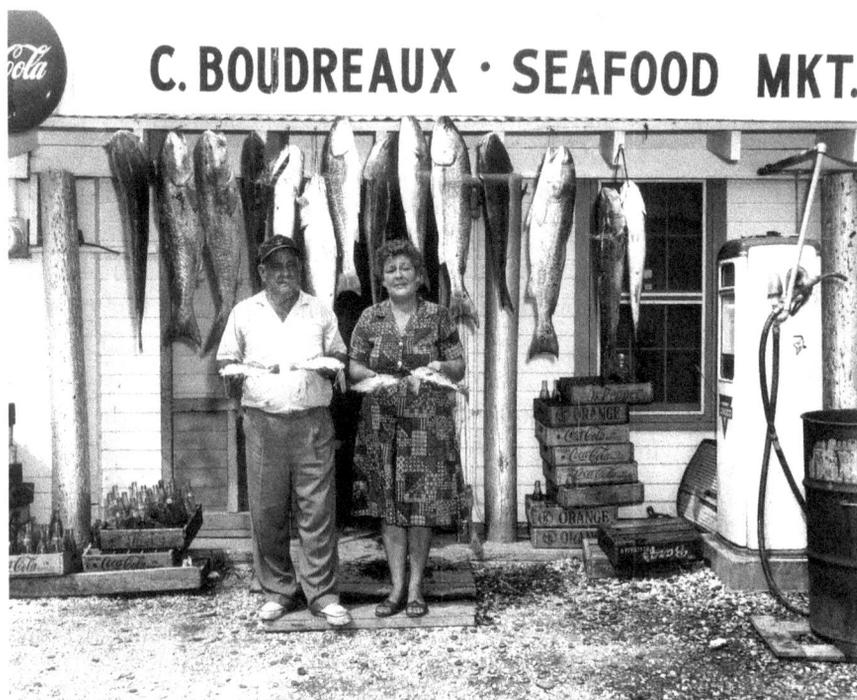

Niese and Claiborne Boudreaux started out as trawlers but grew into prosperous retailers on Grand Isle. *Courtesy of Rudy King and Dr. Patricia Bollinger, 1961.*

founded the Caminada Redfish Rodeo because they loved fishing for sport competitively.

While Casno and Niese grew up with little, they worked hard in their adult years to make a good living and ultimately a good life for themselves. Working up from trawler to celebrated sport fisherman, Casno is a true embodiment of how life changed in Southeast Louisiana during the twentieth century. Once Casno made his money trawling, he decided to level up in life, moving on to operating his business on land and fishing as a hobby instead of a way to make a living. Many people followed similar paths, although many others moved on to working in the oil field instead. Casno also embodied the American dream that became so wildly popular in his lifetime—work hard, get ahead, thrive and reap the benefits of success. It doesn't get any better than that.

ALLOWING THE CULTURE
TO THRIVE

Between land loss, hurricanes, varying environmental policies and political whims, Southeast Louisiana culture has faced more than its fair share of setbacks. However, it is still alive and well, especially as seen in the rural and coastal areas. It has a more American flair than it used to, but that's the nature of culture—it evolves and grows into something larger over time. Indeed, culture either evolves or dies out completely. The Cajun culture has been around for 250 years, in some form or another, so it stands to reason it will continue on, growing and changing with the times and people who practice it. It is tempting to view the stronger, more independent culture of the past as an idyll, but that culture, like it or not, is history now, though to the careful ear, whispers of that culture can still be heard in the din of modern life, and because of the whispers, Southeast Louisiana remains a place like no other.

It's not so much that the region looks all that different from anywhere else in America: we have highways and strip malls, chain restaurants and top-forty radio stations. What makes this place different is that it maintains a separate identity of itself and its people. Southeast Louisiana is understood by even the least culturally engaged people to be populated by Cajuns, who, it is understood, maintain their own traditions. This lends to the area a sense of blood-based, ethnic community that's rare these days, particularly in regions that have been populated for as long as the bayous. Usually over time, incoming blood dilutes ethnic communities,

but the Cajun culture has mostly engulfed this incoming blood and maintained a sense of "us."

For the longest time, the ties that bind the "us" of Cajun culture were forged on porches and in kitchens. These days, those ties are strengthened in less formal ways, by chance encounters between trucks on the front road, exchanging greetings and family news through open windows, snarling traffic—but nobody honks. Encounters in the grocery, in the marsh and at the boat launch all work to cement the identity of Cajuns as a community: it is still, after all, a region of small towns, and people see each other often in small towns. Frequent encounters out and about—running errands or running trout—lead to friendships, and friendships lead to invitations to seafood boils or weekends at the camp. Neighbors fish together, and their families join each other to cook the catch. Though it seems almost perverse to outsiders, the region's predilection for hurricanes also creates a sense of community. Disasters are best weathered together, sharing shelter, food and fuel when all are scarce. They can even become an excuse for a party—affectionately known as "hurricane parties." Community is vital and inevitable in Cajun culture.

Mr. George Terrebonne shared a touching example of just how deep the sense of community among Cajuns can be, particularly in times of trouble. When he was a child, George would often go out shrimping with his dad. He would go to school during the school year, but since much of trawling season happened during the late spring and summer months, he'd have ample time to help out his father on the family's boat, the *Miss Winnie*. One day, they were out trawling in shallow water, and his father noticed some smoke pouring out of the boat's cabin. His father instructed young George to jump off the boat while he tried to throw what he could into the water to save it. They attempted to wave down other passing boats, but no one saw them. Eventually, the boat was destroyed. A fellow trawler friend of theirs, a Mr. Guidry, noticed the smoke on the horizon and came over and rescued them. The community rallied and came to the aid of the Terrebonnes. Later that evening, Mr. Guidry gathered up a group of men to go back to the site where the boat caught fire and sank to see if they could salvage anything. Then Mr. Guidry took it a step further, making Mr. George choke up, even today, at the mention of the story, nearly sixty years later. Mr. Guidry showed up at their house the next day with a check. He'd sold the previous day's catch and wanted to give George's father the money since he'd just lost his boat and his livelihood. Mr. Terrebonne refused the money, so Mr. Guidry threatened

to throw the check in the bayou. What eventually happened to that check is probably known only to Mr. Guidry, but the gesture was what counted. Had Mr. Terrebonne needed a hand, his fellow trawlers, who saw him as a compatriot rather than a competitor, stood ready to help him. Cajuns have always kept this sense of community near and dear to their hearts and take pride in their willingness to help each other in times of need.[304]

If Cajun culture is to continue to exist in any form at all, it is vital that the people who call themselves Cajuns continue to see themselves as part of a community. It is vital that they maintain an identity as a separate, resilient and self-sufficient people. These community traits are something to be revered, and the notion that being Cajun is something to be proud of has strengthened in modern times. The days of the backward Cajun, of a sort of universal cultural inferiority, have passed. It all began in the mid-twentieth century when movements began to appear to save French and Cajun heritage in the state. In the 1960s, the concept of "social history" began to pop up around the United States. Social history can be described as history from the people's point of view, not from an authoritarian point of view.[305] This field doesn't focus on the subjects of "standard history" but instead focuses on impacts on real people and places, especially women, minorities and other overlooked groups who have contributed significantly to culture.

By 1966, this revitalization of individual cultures was on its way.[306] Ironically, around the same time as the African American civil rights movement, other ethnic groups (many of whom had been instrumental in discrimination against African Americans) were realizing that they, too, had been forced away from their ethnic heritage and were ready to reclaim it, just as the African Americans demanded to be recognized and accepted.[307] The whole "Age of Ethnicity" trend, as historian Shane K. Bernard best phrased it, began as an outgrowth of the black power, civil rights and counterculture movements in which people decided to rebel and cry out against the traditional attitudes placed on them by the Anglos.[308] In fact, many minorities began to despise the whole melting pot notion due to the homogenous nature of the idea—they preferred to cling to their historical ties and traditions.

In the early 1970s, the Cajun pride movement began to surface along with many other ethnic-pride movements inspired by widespread rebellion against Anglo-Americanism, and they started to embrace their own native roots once again.[309] The federal government, which was even encouraging "ethnic cultural pluralism" at the time, was a part

The Cajun lifestyle, especially when it comes to fishing, is alive and well. *From the authors' collection, 2013.*

of the ethnic-pride trend as well, abandoning many of its long-held discriminatory and culturally destructive practices. While it has not been easy and without flaws, the appreciation for and recognition of Cajun and French cultures in Louisiana has improved in modern times. Just as a broader acceptance for more cultures has become a societal norm in recent years, the appreciation for traditional Cajun culture has been ever increasing since the 1970s and 1980s.[310] A sign of the level of widespread pride in Cajun heritage came in 1974 when Cajun legislators in Louisiana helped to push through legislation that adopted an official Acadian flag for the state's Cajun population.[311]

Much like lost parts of the Cajun language were found encoded in Cajun indigenous music, disappearing parts of Cajun culture can still be found encoded in the indigenous food.[312] After weathering an all-out assault on their culture that destroyed many precious aspects of their history, Cajuns are rebuilding. Ingeniously, after a century of persecution of their way of life and language, the Cajuns hid their culture in their food where it could not be touched, and it is with their food that they begin to rebuild their culture. Foodways are the greatest extant remnant of what it means to be Cajun, and Cajun foodways are thriving.

8

ALLOWING THE FOODWAYS
TO THRIVE

Many of the traditional Cajun characteristics and cultural practices are still evident today, particularly in the food. Tradition runs deep, and Cajuns are still, by and large, rather traditional people. Cajuns continue their tradition of hospitality to friends and family alike, and hospitality still revolves around eating. Guests are welcomed as family, and family eats together with each member doing his or her part to make the mealtime enjoyable. Young and old commune over ice chests full of food, steaming pots, steaming coffee and steaming plates. The women cook inside; the men cook outside. Oysterman Nick Collins recalls how back when he was young, his family would live and work at their camp in Chenier, right outside Grand Isle. When it wasn't oyster season, his family would trawl for shrimp to make money. Collins remembers that the men basically lived on the boats—they spent the days working, either trawling or taking care of the boats. The women would stay at the camp and tend to the house and the meals. At night, everyone would sleep in the camp together, but during working hours, the men and the women had their clearly defined roles.[313]

The kitchen table is typically where most gatherings and feasts occur. Food—the preparation, consumption and enjoyment thereof—remains the key to understanding the Cajun way of life. Although the tradition of the large Sunday dinner has largely fallen by the wayside in modern times, people still talk about those days lovingly and with a sense of nostalgia in their voices. Mr. George and Mrs. Carol Terrebonne, owners

of the Seafood Shed in Golden Meadow, long for the good old days when they used to have family dinners on Sundays. They both recall their childhoods when it was the norm every Sunday for the family to get together for the noontime meal. Mrs. Carol described how her mother would cook, and everyone would sit around the table and eat together. She explains that it's not like today where her grandchildren are much more likely to want to watch TV while having their meal. They look back on those memories fondly but realize that times have changed, and it's just not like that anymore. Mr. George said, with a tinge of sadness in his voice, "We live too fast."[314]

However, that's not to say Cajuns don't still gather in large numbers quite often. While the weekly, "set in stone" dinner on Sunday has all but disappeared, Cajuns still get together with close family and friends often. Bound close together by the isolated geography, families often still live close by, generation next to generation, and typically gather more frequently than families in other parts of the state or country. The hospitality Cajuns are famous for is most evident in the practice of these home-based social gatherings, which are almost always taken as an excuse for a meal. These gatherings typically come in the form of outdoor cooking, a grand Cajun tradition that usually takes the form of a seafood boil of some sort, a large barbecue or sometimes even a *boucherie*, now more of a bittersweet nod to days gone by than the essential food preparation it once was. Outdoor cooking is usually done by the men, who are often more adventurous in their culinary pursuits. This adventurousness is likely a result of generations of men learning to cook from their fathers in less-than-ideal, more improvisational settings like boats and camps.[315] While the meal serves as the focus of the gathering, the group can range in size from just a few close friends and family to groups large enough to consume a roasted young hog. These gatherings are just as much about the preparation as they are about sitting down and eating together. With a seafood boil, it takes time and effort to prepare the pot and its ingredients. Vegetables need to be cleaned and sorted. Seasonings and spices for the boil must be measured. The seafood is rinsed, purged and prepared for its plunge into the salty, spicy boil. In the case of the *boucherie*, it takes several sets of hands to prepare the fire and set up the pig to roast. It's a multi-hour affair: it takes time to roast a whole pig. Roasters sit vigilantly turning the pig as needed, tending to coals and talking not only about what delicious dishes will be made from the final product but also about

Land-locked camps at Port Fourchon. They're built high off the ground in hopes of escaping rising water from hurricanes. *From the authors' collection, 2014.*

happenings in town, scandal and triumph among friends and family and, in more adventurous families, politics.

Nowadays, the grandest scale on which the people of Southeast Louisiana celebrate their foodways and practice their legendary hospitality for family, friends and strangers alike is with annual fairs and festivals. These celebrations honor not only the dishes and ingredients but also the men and women who work tirelessly in the industries. Modern festivals owe their existence to the hard work and dedication of civic-minded people from the late nineteenth and early twentieth centuries. They were initially designed to be fundraisers and social awareness-drivers for the plight of the area's poor, interestingly enough. Churches quickly became involved with festivals as a fundraising tool as well. As time passed, however, these older types of festivals gave way to the more promotional and "good-times" versions of festivals still seen today. Many of these modern festivals were established during the Depression era as a way to promote local agricultural industries.[316]

Each year, over four hundred festivals take place in Louisiana honoring a vast array of food products and other significant cultural symbols.[317] Most festivals promote or support the main agricultural or maritime industries that are prevalent in the area. They are also a time for people to sample many of the culinary delicacies that are part of the historical cuisine base. With so many festivals, it's difficult to choose which to attend. Most people have a favorite local festival and perhaps another favorite festival based around a fond delicacy. Festival attendance is usually a repeat occurrence, a tradition shared in the community. Some festivals grow to statewide renown, while others remain decidedly local.

The Shrimp and Petroleum Festival (a festival whose name itself is a microcosm of Southeast Louisiana) held in Morgan City on Labor Day weekend is approaching such statewide renown. Visitors find shrimp cooked several dozen ways in several dozen unique but regionally familiar dishes such as shrimp *étouffée*, boiled shrimp, gumbo and jambalaya.[318] Each dish is lovingly crafted by a local nonprofit or business and based on a historical recipe that undoubtedly stirs up memories of past meals for the taster. By combining two of the region's most significant industries, the festival manages to capture the intrinsic spirit of why these festivals exist.

Of course, since this is South Louisiana, several crawfish festivals take place each year, most notably in Breaux Bridge in early May and in Chalmette in late March. Both festivals celebrate the highly prized crustacean with multi-day events that include food, music, crafts and loads of fun for people of all ages. At both festivals, the food is mostly crawfish centered with items like *étouffée*, crawfish pies, crawfish po' boys and much more. As with most festivals these days, they also include carnival aspects with rides and games for kids and adults alike. For example, kids (and the young at heart) love watching crawfish scuttle to the outside of a target-shaped racecourse. Though the state's official position on betting on these events is best not explored, the "owner" of the winning crawfish receives a prize. The festival in Breaux Bridge takes it a step further by holding two food-related contests: a crawfish *étouffée* cook-off as well as a crawfish boil cook-off. What could be more delicious?[319]

Finally, one of our personal favorite festivals is the French Food Festival that takes place in late October in Larose, just steps from the Intracoastal Canal. This festival is one that's near and dear to our hearts because it happens near Addie's hometown. From the live Cajun music that fills the main tent to the seemingly endless Cajun delicacies that can be sampled

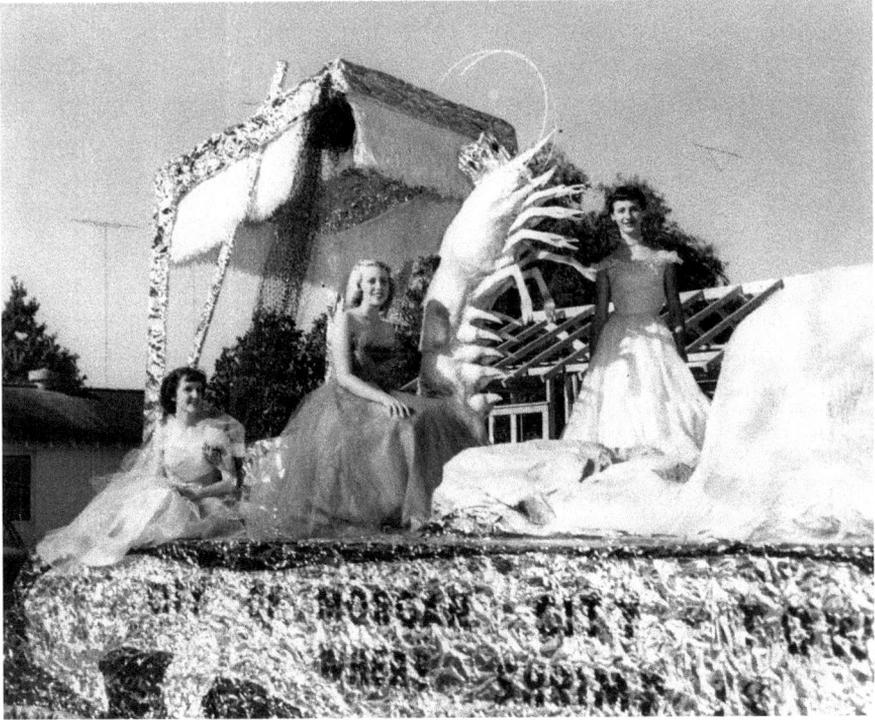

The queen of the Shrimp and Petroleum Festival with her maids, date unknown. *Courtesy of Louisiana Department of Wildlife and Fisheries.*

liberally, this quaint yet well-attended festival stays true to the spirit of festivals past. Each year, the French Food Festival also has a great Cajun arts and crafts market and a live auction with an auctioneer who speaks so fast it can leave you dizzy. Of course, this festival also includes the carnival rides and games that have become so prevalent these days. The French Food Festival is also a great place to watch the old folks dance the two-step and the Cajun waltz to classic Cajun tunes.

The food served at festivals mirrors and preserves the food served in Cajun kitchens across Southeast Louisiana. Today's Cajun cuisine is the epitome of simplicity, based on fresh ingredients, careful preparation and layers of deep flavor and centuries of tradition and memory. While Cajuns do use some pepper in their cooking, it is not done to the extent that outsiders would have people believe. Instead of relying only on cayenne or black pepper to do the work of flavoring, Cajuns prefer to lean on onion, bell pepper, celery, garlic and parsley as their flavoring

agents. Of course, salt and pepper are used to achieve the depth of flavor for which Cajun cuisine is so well loved, but those are typically used with moderation and a conservative hand.[320] As Darrel Rivere, owner of Rivere's Foods in Pierre Part, said in Kevin McCaffrey's film *No One Ever Went Hungry*, "It's all about flavor and not so much about spice."[321]

Modern Cajun cuisine as we think of it today actually had humble beginnings. Since Cajuns were primarily a cash-poor people, they often made do with little protein and lots of starch. Even in the twentieth century, pasta was used as a means to stretch out proteins. For instance, around Donaldsonville and farther south along Bayou Lafourche, people often ate (and some still do) "baked spaghetti." It's essentially macaroni and cheese, but the Cajuns, especially those of Italian heritage, liked to make it with spaghetti noodles instead of elbow macaroni, as is commonly used these days. Also, the Cajun baked spaghetti tended to have eggs in it as a binder, so it was a firm version of macaroni and cheese. It could be sliced with a knife into squares.[322]

Another famous Cajun protein stretcher is something affectionately called "weenie spaghetti." This is simply a red sauce served over pasta that uses hot dogs as the protein. Nowadays, many Cajun homes still make this dish, especially in the southern Bayou Lafourche area. The red sauce is typically rather plain—no herbs or much seasoning—but does utilize lots of onions. The flavor for the dish primarily comes from the flavor imparted by the hot dogs when they're combined with and stewed in the tomato sauce.[323] Mr. George Terrebonne from Golden Meadow recalls eating lots of gravies (sauces) and rice when he was a child. He also recalled that his mother used to deep fry everything—eggs, pork chops, number seven beef steaks—in oil, and his grandfather would cover everything in black pepper.[324]

Although eating seafood gained popularity in the 1930s, it remained beyond reach for many of the region's poor, especially those not living near the coast. Only when those folks moved upward into working in the oil fields did such delicacies become widely available to them. Interestingly, many men first tasted seafood in the mess halls of the offshore oil rigs where they lived while they worked. Workers would catch fish like red snapper directly off the rigs, and galley cooks would prepare the catch, much to the delight of workers. Inevitably, the oil workers brought their newly found love for seafood home to their wives and asked if they could start preparing dishes for them. From the 1950s to 1980s, the Cajun housewife's culinary repertoire expanded to include many seafood recipes.[325]

Cajun cuisine is in a near-constant state of evolution not only out of nutritional necessity but because Cajuns are open minded about changes to their cuisine when they're in line with core values.[326] For example, many people use pre-peeled crawfish tails in their *étouffée* or boxed jambalaya mixes when they don't have time to make one from scratch. The core ingredients tend to stay the same, but the method by which these ingredients are procured and prepared changes as technology and convenience converge. The future of Southeast Louisiana regional foodways lays somewhere in how successfully these changes can be integrated into the cultures of the food and of the fisheries that provide the raw ingredients for those foods. Cajuns always seem to be ready to use a better (or tastier) way, and the future of Cajun foodways, while remaining true to the core traditions, will look much different than those of the past.

The Vietnamese population in Southeast Louisiana has played a part in creating the future of Cajun cooking. Despite having only been a part of the region since the mid-twentieth century, they have contributed to the evolution of Cajun food culture. Their traditional *banh mi* sandwich (itself a fusion of Vietnamese and colonial French influences) has now become common in the pantheon of po' boys. Liz Williams, president of the SoFAB Foundation, gave a relevant example about the Vietnamese coming into the fishing industry in Louisiana. Surely, they had their own techniques and customs, but it wouldn't be right for someone to come to them and say, "No, you can't do it that way." Their techniques and customs are important, valuable and relevant.[327]

Vietnamese customs have actually led to innovations here in Southeast Louisiana. The Cajun microwave, a sort of double-wall convection oven, was actually first observed on Vietnamese fishing boats. It was advantageous on boats as it was self-contained, used hot coals rather than flame and didn't need to be minded. It is based on a cooking apparatus typically found on Vietnamese fishing vessels that was used to have food cooking while the people on board fished during the day. The device cooked dishes in layers, starting from the top down. One day, someone struck by its ingenuity brought this item to the LSU AgCenter, and they helped develop it into a commercially viable product. It has since garnered a substantial following of backyard chefs in the area.[328]

These days, Cajun cuisine is widely known and largely loved; it would be hard to argue that Cajun cuisine is in danger. Cajun cooking and "Cajun" flavors are seemingly everywhere across the country.

It has somewhat incorrectly become shorthand for spicy or, perhaps more accurately, flavorful. Chef Paul Prudhomme is credited with the mainstream popularity of Cajun cuisine. His style of Cajun cooking was heavily influenced by the cooking he did at home in rural St. Landry Parish. He's known for using fresh ingredients not only because they make better products but also because his family was so poor when he was a kid that they had no refrigeration for storage. He had no choice but to cook fresh. Chef Paul burst on the scene from the kitchen of the famed New Orleans restaurant Commander's Palace in the mid-1970s and opened his own restaurant in the French Quarter—K-Paul's Louisiana Kitchen—just a few short years later in 1979.[329]

Chef Paul's influence on the rise of Cajun cuisine as an ethnic food category cannot be overstated. He invented the dish blackened redfish and made it so popular that commercial fishing of redfish is now banned to protect the species from overfishing. Chef Paul paved the way for other chefs like Chef John Folse to come in and spread the word about authentic Cajun cuisine. Inevitably, the Cajun craze spread like wildfire, and soon, national chains started co-opting the term "Cajun" for all types of various and not-quite-appropriate uses. Posh "Cajun" restaurants also popped up in major metropolises like Los Angeles, New York, Houston and Washington, D.C.[330]

But all hope is not lost—not by a long shot. Through the quagmire of Cajun pizza, burgers and, yes, even sushi, many local chefs and Cajun cuisine enthusiasts are seeking to preserve the traditional cuisine in addition to evolving it in appropriate, meaningful ways. Several nonnative-born chefs who have a love for the Cajun cuisine create interesting ways to fuse the traditional dishes with influences from their own backgrounds. Dishes like crawfish fettuccine, Cajun enchiladas and even Cajun-style corn bread seek to remain true to the roots of Cajun cuisine, as opposed to the co-opting of spicy flavors associated with some Cajun dishes to suit the creator's own needs. Some see this development as a threat, but Cajun historians like Marcelle Bienvenu and Carl Brasseaux take it all in stride. They're confident that the Cajuns and their cuisine can absorb these changes just like they've absorbed ingredients, techniques and dishes from other cultures for over two centuries.[331]

Overall, we've seen clearly that Southeast Louisiana is adept at adopting other cultures. It starts with absorbing different Cajun food cultures: gumbo from one bayou differs from another, and when the two bayous meet, they forge a new "recipe"—which is in reality an altered form of the

oral tradition of cooking. Cajuns are also good at adapting and adopting from the outside. Foreign ingredients and cooking techniques are made Cajun by cultural osmosis, adapted because they are cheap, convenient or just plain delicious. This is an earmark of a healthy food culture—a flexible, dynamic scene, always open to new ideas while adhering to basic principles. In Cajun cooking, those principles are simple: the food is based on flavor, simplicity and the surrounding land and water. The surrounding environment is the greatest influence on Cajun cuisine these days, to the point that it seems impossible to imagine Cajun cuisine and even Cajun culture without Southeast Louisiana. While the Cajuns are themselves the product of exile, it's hard to imagine that exiled Cajuns today could be the same without the products of the fisheries of their homeland. To protect the gem of Cajun culture is to protect the fisheries.

9

ALLOWING THE FISHERIES TO THRIVE

The fisheries industries have faced setbacks and hardships in the last fifty years, but they seem to be rebounding in ways not even imagined ten or fifteen years ago. While over time fewer people have chosen to work gathering and harvesting seafood, improved methods and technology have made up for the loss of labor. After all, the bounty of the delta is still sought from both inside and outside the region. In fact, it can be said that the changes in eating habits and food distribution across the country have actually increased the demand of seafood, just as the same changes that brought foreign foodways to the bayou brought bayou foods to the rest of America. This national-level demand solidified the consolidation of the many fishing industries under larger industrial interests. Catches that had previously been controlled and distributed on a largely local scale were now sold to distributors with national reach. After all, the product goes where the market is, and the American appetite for seafood was just beginning to be awakened. Fishermen sold where the consumers were, and getting to these consumers required larger capital than they could raise. The balance of power in the fisheries shifted closer to the packing interests. These interests were buying caught product on such a scale that they were able to set (to a certain extent) the price of the product each season. This system worked to provide for many Southeast Louisiana fishing families as long as Louisiana was able to compete on price. Unfortunately, especially in the case of shrimp, as the market expanded beyond America's shores, imported and often

farm-raised Asian shrimp appeared and dropped the bottom out of the shrimp market. With the market flooded with cheap product, Southeast Louisiana could not afford to operate, and the number of boats in the fishery began to decline. The American appetite for shrimp was as strong as ever, but when the markets are concerned primarily with price, those that cannot compete are eliminated from the consideration set.

The arrival of imported shrimp in the 1970s changed the whole Louisiana shrimping industry paradigm. Fishermen used to get good prices for their shrimp. When imports began flooding the market, those prices dropped significantly while costs continued to rise. People realized that they could not compete with imports on price. Instead, they had to deal with rising costs and dwindling income and profits. The shrimping industry underwent a huge metamorphosis in this time period. Many shrimpers had to sell their boats or lost them due to inability to pay bills. Communities like Delcambre became shells of their former selves. The economies of these areas just shriveled before everyone's eyes. This continued, and for many years, the shrimpers struggled to maintain their foothold and market share. The situation seemed bleak. Besides the imports, the shrimpers and other fishermen had a whole host of issues to deal with in the early 2000s. Several huge hurricanes hit the area— Katrina, Rita, Gustav, Ike, Isaac—and the BP oil spill also took place during that time. The number of hurdles to overcome appeared to be insurmountable.[332]

Of course, it isn't only the shrimping industry that has rubbed up against the fickle support of the markets: the same general boom and decline can be seen across the Louisiana fisheries. What's left remains in a precarious balance between competing industries in a sinking, dying land. Some of the industries, once prolific, even brought about their own demise by operating without concern for the sustainability of their industry. A great example of the need to operate in a sustainable fashion lay outside the fisheries but at the heart of Southeast Louisiana in the timber industry. The region was once blanketed by vast cypress forest, but the timber industry, which had long been logging at an unsustainable pace, reduced the soil-retaining vegetation of the swamps into canals and open marsh, which, when combined with the leveeing of most major waterways, permitted the infiltration of salt water far into the heart of the wetlands. The timber industry died out in the late nineteenth century, of course, not due to saltwater intrusion but because the timber was harvested too fast. Long-term sustainability was simply not a concept

This bridge and elevated roadway connect the town of Leeville directly to Port Fourchon. It is raised due to continuing land loss. *From the authors' collection, 2014.*

in those days, as people looked at the available resources as infinite. In the case of timber, Southeast Louisiana plain ran out and left behind a legacy of denuded swampland, an ecological nightmare exacerbated by shortsighted oil prospecting. A proper balance between the competing interests of the economy and the environment was never made. A proper balance in the fisheries is of utmost importance.

Nowadays, the economy of Southeast Louisiana is a study in contradicting interests of vital industries with culture in the crosshairs. As industry vies for space with the environment, a growing economy butts up against disappearing land, and as the national culture seeps further and further into the bayous, one of the last bulwarks against the loss of Southeast Louisiana culture is the food. It hasn't always been that way, of course, but increasingly, the people of the region find that their strength lies in their togetherness and their communities. Their cultural traditions and identities already contain many solutions to problems they face today. At the heart of their identity is their food and its ingredients, eating being the

most fulfilling, necessary and universal component of existence. The value to Southeast Louisiana culture is not limited to food but is perhaps best expressed through its food, which draws from the history and topography of the place these people call home. Being Cajun is more than a label; it is a way of living and a way of eating. Nowadays, thanks to the tireless efforts of cultural champions inspired by what they found among the bayous, being Cajun and living the Cajun way of life is something to be proud of and worthy of working to preserve and grow. The best way to preserve the Cajun culture—the Cajun way of life—is to preserve the fisheries that once served as the lifeblood of the coastal communities.

Ultimately, all the goodwill and pride in the world cannot support Cajun food culture if it is not economically feasible. This is the chief battle today: finding a way for the food industries of Southeast Louisiana to not just survive but thrive as viable, living aspects of a greater culture. The culture, it seems, holds the key to the future of the fisheries. Older ways of doing business are lying dormant along the bayous, existing just below the surface of modern commerce. For the longest time, the food producer and the consumer were intimately linked in Southeast Louisiana. A family, if they didn't catch seafood themselves, had another family they'd depend on to sell them their supply. This created a positive relationship, a sense of community and a healthy, tightknit, sustainable economic model. Consumers would stock up on catch in the high season, much like the producers themselves would stock up on cash in the high season. The bounty of the season would sustain both through the off-season. Income, though unsteady, was sufficient because the producers could count on the demand from consumers—consumers whose appetites they knew from meeting them around town. Sometimes all it takes is a question, an answer and a handshake to do business, to use the black ink in the ledger.

Life in Southeast Louisiana can be described as a culture of relationships—long term, short term and extended, it runs the gamut. Personal connections are what matter most here. It's the type of place where everyone knows everyone in town. It's not uncommon in some of these smaller communities for a company head to call an applicant's grandmother to get her personal recommendation for said applicant. If Granny's going to vouch for a young man or woman, the company head can rest assured that they're making a good decision by hiring the prospective candidate.[333] This well-connected culture of relationships helps breed resilience into this vast network of people. A culture of

community-wide self-reliance is cultivated; the individual benefits, and the community at large benefits.[334] George and Carol Terrebonne know about the importance of relationships as well. Whether it's with their regular roster of trawlers or the one processor that they mainly sell to these days, the Terrebonnes are thankful for and value the people with whom they do business. They realize that relationships are what allow people to succeed in business, especially a business like trawling, where so much of it is done face-to-face, without any middlemen.[335]

The current trend in the food-consumer market of wanting to connect with the farmer, fisherman or butcher who made their meal possible ties directly into this culture of relationships. Nowadays, people who are passionate about food and sourcing often want to know not only where and how the food was raised but also who was responsible for it. People value being able to put a face to a name or product; they want a relationship to be formed over the food they consume. This makes the whole experience of purchasing what is really a life-sustaining commodity more personal and enjoyable for everyone. It allows the consumer to be better connected to their food source, and it gives the farmer, fisherman or butcher greater visibility in the marketplace. Jim Gossen, founder and chairman of Sysco Louisiana Seafood, LLC and a highly respected member of the seafood industry community, believes firmly in promoting the people doing the extraordinary. People want to feel connected to the source of what they enjoy.[336]

In keeping with this trend, point-of-origin information has risen to the forefront of eaters' minds. People want to connect with their food and be familiar with its orgins. Chef Brian Landry of the restaurant Borgne in New Orleans is thrilled to be able to work with knowledgeable local fishermen from various coastal areas of Southeast Louisiana so that he can pass that information on to his customers. To him, all of this dovetails nicely into getting more fish products to market. The more people know about Gulf fish and what's available, the more they can ask for, which prompts chefs to start that whole cycle over again—a modern-day circle of economic life. Chef Brian sums it up nicely: "The more people talk about it, the better it is for everybody." Creating an emotional connection between people and their food is key not only to good food but also to economic sustainability.[337]

To illustrate the power of personal connections, Tom Hymel, the seafood industry development director for the LSU AgCenter and Louisiana Sea Grant, recounted in a lecture he gave at the 2014 Louisiana Fisheries

Summit a story about a fisherman who showed up at the Delcambre docks with eight thousand pounds of shrimp that needed to be sold immediately. The rapid response from the community at large helped this fisherman sell his catch in a matter of hours. Between an e-mail blast, a few phone calls and some social media shares, the job was easily completed. When technology and community converge, it can be a boon for fishermen. This is a wonderful example of a mutually beneficial relationship where the consumers are getting the freshest possible product and a fisherman is receiving the best possible price for his catch. Fishermen are figuring out that it boils down to establishing and maintaining great relationships with their customers. Truly, this is a win-win situation, and it's all based on marketing directly to consumers through personal connection and informal social networks.[338]

James Beard–nominated filmmaker Kevin McCaffrey spoke with us in an interview about the importance of these informal social networks—how these networks of people often exist to the mutual benefit of everyone involved. A prime example of this is the shrimpers who sell directly to their customers at the docks. They're receiving top dollar for truly high-quality seafood. A significant part of getting a good price depends on when the shrimper hits the docks. Traditionally, it would be best if done when few others were shrimping, but these days full-time shrimping is done seasonally rather than on an as-needed basis, which means the price fluctuates downward when the season is high and upward when the season is lower. Ultimately, it's all about knowing a trawler will have customers waiting to buy when he hits the docks. McCaffrey mused that few formal, organized social networks exist in the area. He commented on how farm to table is huge but that it's not as often making its way to the table when it comes to meat and seafood. He concluded that it's likely that regulations play a large part.[339]

What the fisheries industries are catching on to is that marketing is the key to success. We already have a superior product here in South Louisiana. It's now time to show people that by having the packaging and marketing match the product being sold. Tom Hymel and his teams at Louisiana Sea Grant and the LSU AgCenter know more than a little about branding and direct consumer marketing. For the past thirty years, Hymel has helped fishermen understand more about the fisheries industries, their role within those industries and how they can be more independent in the selling arena. It used to be that fishermen sold at the docks to the plants and processors pretty much exclusively. The selling

arrangement had been this way for a few decades. As the fishing industry grew throughout the twentieth century, the supply chain was more formalized and forceful toward fishermen and how they were required to sell their products. Hymel told us in no uncertain terms that at one time, the processors ruled. They decided who sold what where. If a fisherman fell out of the good graces of a processor, that processor could make that fisherman's life quite difficult by refusing to buy from him.[340]

Now the tides have slowly started to turn. Due to the hard work by Hymel and his teams, fishermen, especially shrimpers, have realized that they can sell directly to consumers. Many of them can make a good living without having to rely exclusively on the processors any longer. For many fishermen, this is a welcome and overdue change. By employing and utilizing education programs and demonstration projects, Hymel is able to teach the fishermen how to interact with and sell to the public in a successful manner. Furthermore, in 2010, Hymel and the LSU AgCenter started Delcambre Direct Seafood, which has since evolved into the Louisiana Direct Seafood program. It's an extensive online hub that allows fishermen and consumers to interact with one another directly—no middleman. Prices are also worked out between the customer and fisherman offline—no prices are posted on the website. The website simply serves as an information portal to connect buyers and sellers. However, Hymel did tell us that in the first year alone, some fishermen in the program were making up to $8,000 extra each week, just by selling product directly to the public. That's no small amount of money no matter how it's examined, and it's all from direct, personal connections, an almost revolutionary idea in this day and age.[341]

In our interview with Tom Hymel, he had several great stories of fishermen (and women) going out and breaking all the old rules and old ways of thinking. That's just what the shrimping industry needs—smart minds willing to think beyond the old way of operating. In order to prosper, Hymel believes strongly that a homeostasis needs to exist. The fishermen need to be able to make a living. The ecosystem, which is admittedly a bit challenged at this point, needs to be healthy and thriving to produce the products. Finally, the customers must be motivated to buy. Positioning Louisiana shrimp as the premium product it is helps this whole system to remain economically sustainable. When the ecosystem is healthy, it can produce high-quality seafood for which consumers will gladly pay the fishermen top dollar. When the natural resource is available and the fishermen can make a living from it, that's when the puzzle pieces fall together and situations unfold as planned.[342]

Hymel passionately believes that the fishermen need direct marketing to survive these turbulent times. At the 2014 Louisiana Fisheries Summit, he said, "Direct marketing is needed because the folks left in the industry are survivors."[343] Fishermen have seen so many changes and had so many setbacks in the last thirty years. Between natural disasters, man-made disasters and the encroachment of cheap, foreign imports, the remaining fishermen were in desperate need of some type of lifeline. The direct-marketing initiatives introduced by Hymel, via the LSU AgCenter and Louisiana Sea Grant, provide that lifeline and much more. He operates on the philosophy that these boats are floating small businesses. To the families that own them, these boats represent their livelihood and means of survival. He wisely noted, "Nothing here is trivial."[344]

Through their years of research and experience, Hymel and his teams have figured out much about a critical component of Louisiana's relationship market—the "ice chest" market, as he likes to call it. These are people who like to purchase one or several ice chests—often between fifty and one hundred pounds—of seafood to have on hand and put away in their freezers. These people love seafood, and they prefer the higher-quality products. The best part for fishermen is that they are willing to pay for pretty high-quality seafood. With the help and blessing of the Delcambre Port Commission, fishermen sell directly to these folks at the docks.[345] No longer are people forced to work through processors and brokers. Face-to-face, personal transactions are taking place. A smile and a handshake are now part of the sales equation again. In the end, both the fishermen and consumers benefit. Now that fishermen are selling directly to the public, they fetch better prices for their catches. Returning to this mode of direct selling also has benefits for the culture. It gives the fishermen more control over their catches and what they can charge for their seafood. It also gives people the opportunity to work together one-on-one. Fishermen are getting to know their neighbors and others in their community better because they're meeting face to face. They're transacting directly, and that's what matters.[346]

While the Delcambre Direct Seafood program has now expanded, the port city of Delcambre was the original testing ground for such a program. In fact, some would argue it was the perfect place for such a grand experiment. Tom Hymel describes the Delcambre Direct Seafood program as a true success story. Now in its fifth year, the program is still going strong and performing well. But Delcambre has come a long way in those years. Once a relatively large and bustling port town, from 1975 until just

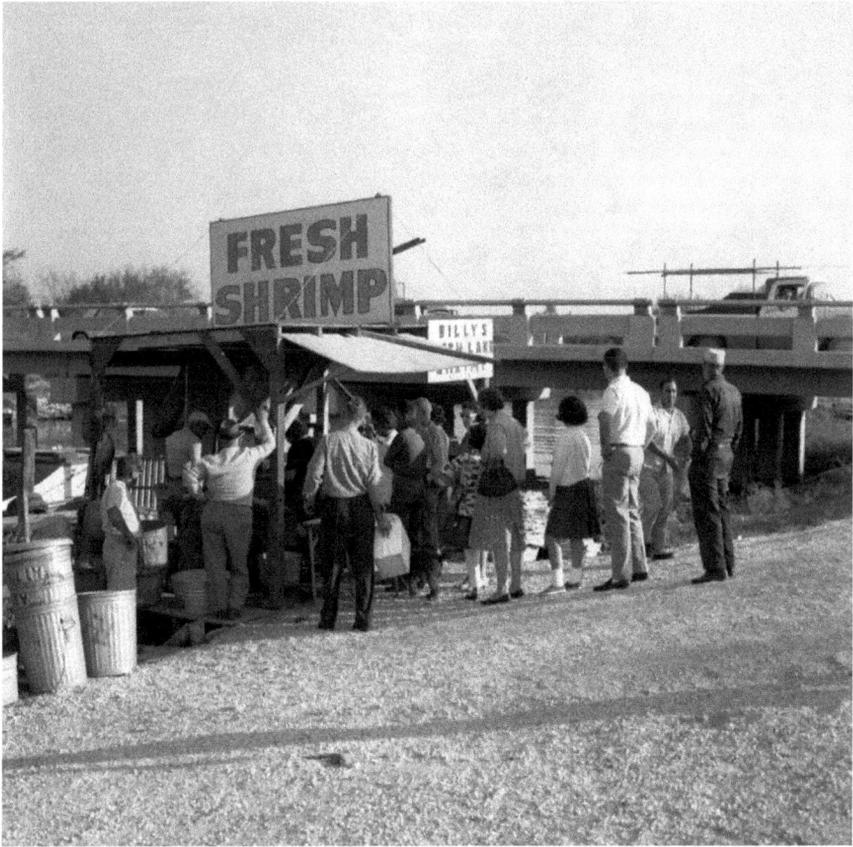

Customers purchasing fresh shrimp at a waterside stand. *Courtesy of Louisiana Department of Wildlife and Fisheries.*

about the present time, Delcambre shrank considerably in terms of both population and fisheries activity. The fishermen left in Delcambre were nearly desperate. They were not getting good prices from the processors and had lost touch with ways to reach their consumers directly. Sensing an opportunity, Hymel and his people worked to set up the website and marketplace to help facilitate sales directly to consumers.[347]

With direct selling, it seems that we're experiencing a return to the past. These fishermen are returning to a long-time gone way of selling to their customers directly from the docks and their fishing boats. Some had lost touch with how to connect with their friends and neighbors over business. Many had forgotten that having personal relationships with people is the

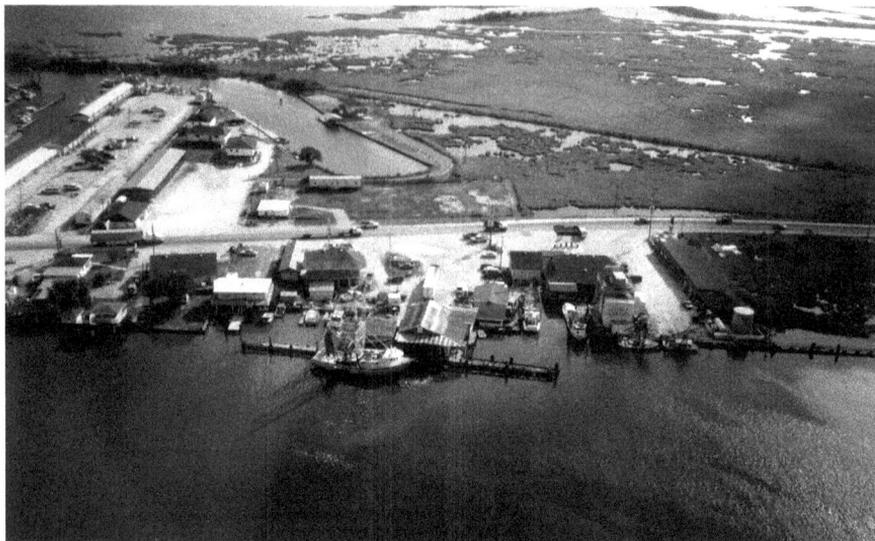

An aerial view of the town of Leeville in the late 1990s. Once a hub for shrimpers, Leeville is slowly disappearing. *Courtesy of Mary Chailland.*

best way to get business done, especially in a small town with a high-end, premium product like Louisiana shrimp. Fishermen had gotten caught up in the race-to-the-bottom price game, and many of them honestly thought that people wouldn't pay more than two dollars per pound for shrimp. They were wrong, and we're sure that they're glad they were wrong. Local fishermen are selling jumbo shrimp for four to five dollars per pound—over twice what they previously thought the market could bear. The quality of the product has begun to take precedence over the sheer nutritional quantity of the product.[348]

The emphasis on quality over quantity plays a central role in the price of Southeast Louisiana seafood and, in turn, a central role in the future of regional foodways. If the fisheries are healthy both economically and environmentally, they can support a thriving culture. But the success in the future of regional fisheries is dependent on the price that regional fishery production can fetch on what has become an international market for seafood. Recently, prices for seafood have been rising because even the Asian producers cannot keep up with worldwide demand. Along with the rising prices in shrimp have come increases in the cost of finfish, blue crabs and crawfish. Buying a few sacks of crawfish to boil for friends and family used to be no big deal. Ten years ago, crawfish was easily under

a dollar per pound after Good Friday, the traditional height of crawfish season. These days, the prices can be as much as five times higher for much of the season. The tradition of boiling seafood is slowly getting beyond the means of the average family in Southeast Louisiana. It's gone from being something people did often to something that's now a special-occasion treat. The tradition survives but in a different form. Interestingly, a higher price for seafood has positive consequences for the culture as well. More of the coastal Cajuns are returning to the bays and marshes to catch their own food rather than having someone catch it for them, simply because it is cheaper. The love of their food is driving these Cajuns back into the marsh, preserving nearly three centuries of tradition and wisdom in the process.

Not every person has the means or wherewithal to catch the food they love, however. These people, who live in Southeast Louisiana and beyond, mainly depend on grocery stores for food. Don Schwab, CEO of Barataria Foods in Houma, and many others believe that this realization represents a turning point for the shrimping industry—basically, a make-or-break scenario.[349] Local shrimpers obviously cannot compete with foreign imports on price. Quality is the key difference. While imported shrimp is a commodity, local shrimp is a luxury—a premium product. This has resulted in a trend toward branding and a deliberate differentiation of Louisiana shrimp from foreign imports. It is a matter of fact that wild-caught shrimp are superior in taste and quality to imported, farm-raised shrimp. That's just the nature of how the shrimp grow and age combined with factors like water freshness, diet and space to move and grow.

Jim Gossen, founder and chairman of Sysco Louisiana Seafood, LLC, firmly believes in the notion that people will pay more money for a product they perceive to be of higher value. This means people will gladly pay for better seafood as long as they're convinced it's of higher quality. This notion dovetails nicely into the idea of niche markets and using niche markets to capitalize on demand for smaller-market products. In this world of mass-produced, widely consumed products, a movement back toward craftsmanship and the specialist is emerging. People will pay more for something personally handcrafted or hand-caught. We are moving back to a place where the fisherman is seen as an artisan and specialist, focusing on a small niche with his work. The shrimper focuses solely on shrimping and aims to get the best quality shrimp to market so he can sell it to the public for a premium price. Consumers are infatuated with the trend because they realize that these items are worth paying

for and that they're getting a great value for their money. Quality and attention to detail can be the difference between being at the top of the industry or not.[350]

THE SHRIMP INDUSTRY

At the 2014 Fisheries Summit, several speakers talked to the fishermen and other attendees about the need to differentiate the shrimp supply from the farmed, imported competitors on the market. In his talk, Don Schwab likened the domestic shrimp supply to a fine wine. Louisiana's fishermen should be marketing and selling their shrimp as a luxury product because it is of a higher quality than the farm-raised imports. Another analogy used by Schwab was one touting Louisiana's shrimp as the "filet mignon" of the sea. Since Louisiana supplies only about 8 percent of the nation's shrimp, we're clearly in the minority of supply. However, this analogy implies that we are the top and most choice part of the supply. Filet mignon is rare and expensive, just like the high-quality Louisiana shrimp found in the Gulf of Mexico. Additionally, the global demand for larger shrimp is the reason that Schwab believes the state should consider pushing back the start of the shrimping season, maybe even by a couple of weeks. He believes fishermen could see a great increase in shrimp size, resulting in a corresponding increase in the price per pound for that shrimp. He provided a clear example at the summit. He said that even looking at something as small as seventy shrimp per pound versus one hundred shrimp per pound could make a big difference. The seventy shrimp per pound will fetch a higher price than the one hundred shrimp per pound. Education and information can help fishermen realize that waiting and being patient with the shrimp growth can pay off better in the end.[351]

THE OYSTER INDUSTRY

While branding efforts are taking off in both the finfish and shrimp industries, oystermen have been a bit more hesitant to adopt this way of thinking. Jim Gossen has been working for years, first via his own company

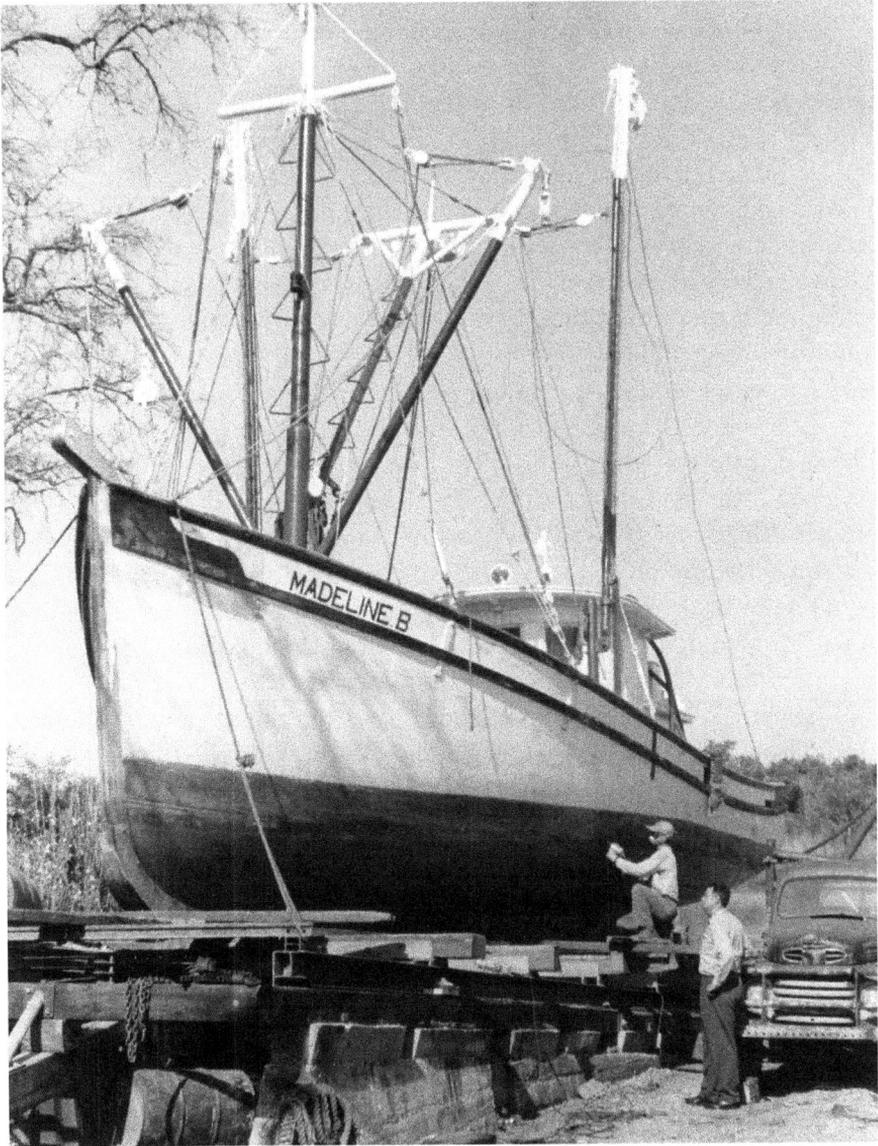

A large boat up on dry dock. In the off-season, fishermen prepare their boats for the busy times ahead. *Courtesy of Louisiana Department of Wildlife and Fisheries.*

and now as the founder and chairman of Sysco Louisiana Seafood, LLC, on winning over the hearts and minds of these fishermen, ultimately to make them more successful and profitable in their own businesses. To

illustrate, Gossen recounted a story of a time when he spoke to members of the Louisiana Oyster Dealers and Growers Association. At the time, besides Apalachicola oysters, no other Gulf oysters were branded. Gossen brought visual aids to illustrate his point: beautiful boxes of Beau Soleil and Island Creek brands of oysters. He then made a bold claim to further illustrate his point: "These oysters on the table are three times better than your oysters that you produce." Of course, this turned heads and started grumbled conversation among the attendees. Who was this guy telling these oystermen that their oysters were an inferior product? He continued to say, "They must be! They cost three times more. Why are they getting three times the money?" The point that Gossen was making is that branding elevates the status and, therefore, the price of products. Those Beau Soleil and Island Creek oysters have brand names, which means that their producers can charge more for them. People know they can trust Beau Soleil oysters because they know exactly where they came from and who produced them. The same can't be said for generic oysters from the Gulf of Mexico. They may well taste ten times better than any other branded oysters, but that doesn't matter if people have no status or reference point with which to associate the oysters.[352]

While the oystermen clearly understood his point, they're hesitant to undertake the task of branding their oysters. Gossen believes that it comes down to the fact that the oystermen don't yet see it as being worth the cost and effort. Gossen sees this as taking a short-term view to a long-term problem. He admits that at first, financially, it is a cost and something to bear, but he went on further to state that it's a longer-term investment. Even in five years, benefits could start to be realized. He feels it's a worthwhile endeavor, especially for those looking to leave their oyster businesses to future generations of their families. Brand affinity and recognition take time to develop. Investing in it now can help ensure success for a business's future.[353]

Gossen has also put his money where his mouth is with his own Aristocrat brand of oyster, developed with the input and assistance of several sources—the LSU AgCenter, Auburn University, Gossen's knowledge and experience with sales and marketing and, finally, with local fisherman Jules Melancon's oystering know-how. They're growing these oysters via off-bottom farming, which means the oysters are grown in cages instead of on reefs or on the soft ground. The farm, which is known as the Caminada Bay Oyster Company, is located on Grand Isle. While Gossen owns the company, Melancon handles the oystering part

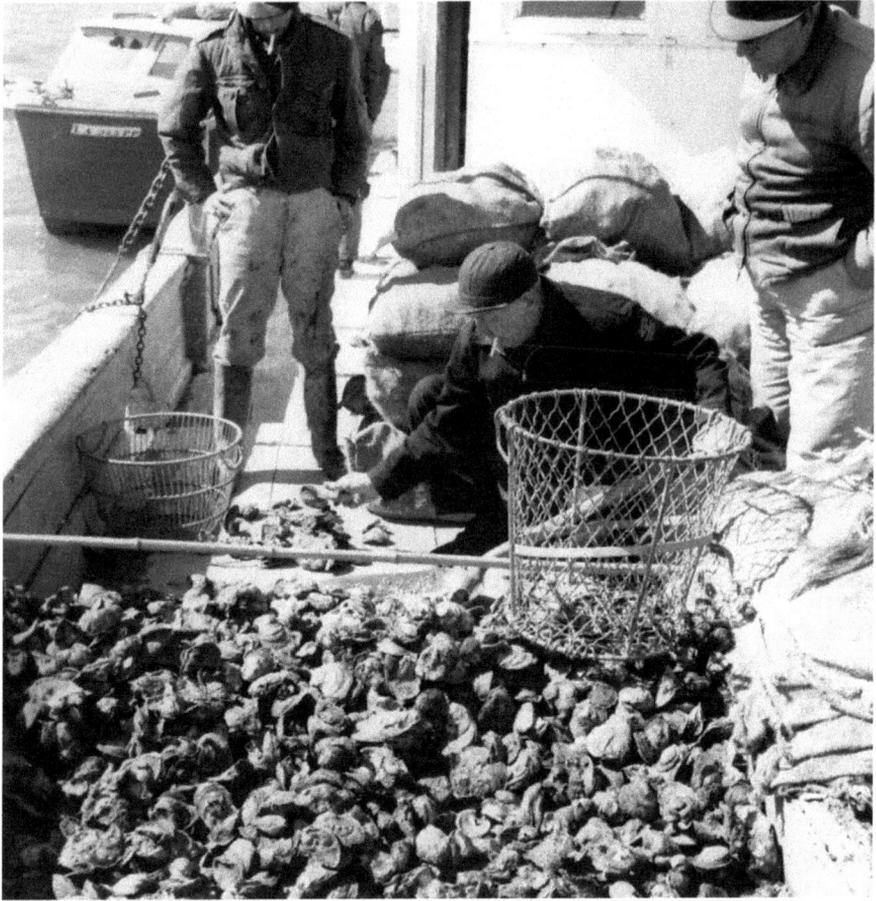

An oysterman sorts through his catch on Grand Pass, February 1963. *Courtesy of Louisiana Department of Wildlife and Fisheries.*

of the project—the maintenance and harvesting. Gossen also manages the funding and promotion. The process has been a little slow, but that doesn't seem to deter Gossen. "It's like anything else when you pioneer things," he said. "You're learning, and it costs money." Taking what he has learned in his forty-two years in the seafood industry and helping others apply that information and know-how is his great passion. Ultimately, what Gossen evangelizes is the need to create and maintain a better product—a better oyster. He speaks with oystermen at length about quality and consistency. "Your oyster's only going to be as good as what you put in that box today," reminds a wise, experienced Gossen.

Dr. John Supan checking on his work at the Grand Isle oyster hatchery. *Courtesy of Louisiana Sea Grant College Program Louisiana State University, 2007.*

By this he means that a brand or an oyster is only as good as what was harvested and shipped out today. Putting trash and low-quality oysters into branded boxes is never a good idea. For those who think they might be able to slip one past the customer, he has these words: "You're fooling yourself. You're not fooling the guy who's going to eat it." Quality is the bottom line in the world of branding and especially in the world of seafood branding.[354]

While branding seems like a novel idea for Louisiana's seafood industry, it's actually not. Back in the nineteenth century, companies like McIlhenney were branding their oysters with the word "Cove" in them. For example, they had one brand of oysters called "Cowboy Brand Cove Oysters." At that time, anything labeled "Cove" was synonymous with Baltimore oysters and the Chesapeake Bay, which were considered the most prized oysters in the world. Companies like McIlhenney used these brand names on their canned oysters that were sold to out-of-state markets, but they still marketed and sold fresh Gulf oysters to local customers. In out-of-state markets, they felt that having an association with the "Cove" brand name gave them legitimacy and

better recognition than if they labeled them as the Gulf of Mexico oysters that they were.[355]

The Crab Industry

Similar to what's happening in the shrimping industry, crab fishermen are being encouraged to see their catch as the premium product it is. Blue crabs from Louisiana are among the sweetest and most delicious crabs on the market. At the 2014 Louisiana Fisheries Summit, Kevin Voisin, founder of the Houma-based marketing consulting firm Ignite, spoke about how foreign, inferior swimmer crabs from China and other Asian markets are actually selling well and for a higher price than Louisiana's blue crabs. Why is that? He attributes it to the colorful and attractive packaging used in the East. He told the audience that well-marketed, inferior product can outsell a superior, better-tasting product just by being in a beautiful package. "Image sells more than anything" was a big part of his message. Voisin and other marketers are encouraging crabbers to better market and package their products. This should help crabbers begin to increase market share and asking price.[356]

Overall, the crab industry is faring well right now. The higher price of shrimp actually is a good thing for the crab market because crab is a higher-priced, premium item. When people are already paying more for shrimp, they also start considering crabs as an option. The good news is that crab consumption is actually trending upward. Voisin cited statistics that said annual per-capita crab consumption increased from 2008 to 2013, up from half a pound per person to three-fifths of a pound. That's a 10 percent increase in only five years. Considering how poorly the economy performed in that period, it is actually a little surprising to see the increase. The most interesting part about these annual consumption figures is that they're actually quite small, especially when compared to other meats like beef (56.5 pounds), chicken (83.7 pounds), shrimp (3.8 pounds) and even something like sugar (a whopping 156 pounds) for the same time period. Clearly, while the crab market is starting to perform better, it is still competing heavily for a place on the plate. High crab prices, says Voisin, means that people aren't deciding where to buy crabs; they're deciding whether or not to buy crabs at all.[357]

The Finfish Industry

Chef Brian Landry relies heavily on the local black drum and sheepshead varieties of finfish at his seafood restaurant, Borgne. He prefers them because they're cost effective, reliable in quality and consistent in flavor. In terms of specialty Gulf finfish, his favorites are pompano, triggerfish, tilefish and any of the groupers, especially barrel grouper. They're all mild in flavor and sell well among his patron base. He appreciates having access to such bounty and expressed that sentiment this way: "One of the great things about the Gulf is just the access to the variety of seafood we have is unprecedented."[358]

Chef Brian Landry appreciates the efforts of suppliers like Jim Gossen who encourage fishermen to keep the by-catch in order to start developing demand for seafood from the Gulf that don't necessarily have a dedicated fishery. Something Chef Brian wishes that fishermen would start keeping is their fresh squid. Fresh squid is a by-catch item for shrimpers. Chef Brian uses fresh squid—also known as calamari—in his restaurant and would much prefer to be using fresh Gulf squid than having to fly it in from the East Coast as he does now. He realizes that to do this, the conversation with and habits of the fishermen need to change. It starts with people like him asking for the product and suppliers like Gossen passing that on to the fishermen.[359]

Branding Case Study: Louisiana Wild Seafood Certification Program

The State of Louisiana, in addition to encouraging packaging branding, is instituting a voluntary seafood certification program. Seeing that Louisiana seafood was increasingly being placed into the same consideration set as farm-raised and imported seafood, the Louisiana Seafood Promotion Marketing Board (an offshoot of the state government) decided that action was needed to differentiate the state's seafood from its biggest competitors. Legislation in 2010 allowed the Louisiana Department of Wildlife and Fisheries to create a program called Louisiana Wild Seafood Certification Program (LWSCP), which certifies the origin of participating Louisiana seafood products. Ultimately, this means that consumers can buy what's labeled as Certified Authentic Louisiana Wild Seafood with confidence.[360]

As the requirements currently stand, the LWSCP ensures that a licensed Louisiana fisherman landed the seafood in Louisiana, originating either from the Gulf of Mexico or Gulf Coast state waters. It also ensures that the seafood was processed and packaged in Louisiana in accordance with strict program guidelines.[361] As mentioned, the LWSCP is a voluntary program. Fishermen are not required to participate but are highly encouraged to do so. Participation in this program validates the efforts of the fishermen and shows that they are indeed selling authentic Louisiana seafood. This also gives consumers a way to look for and ultimately ask for locally caught and processed seafood. The state also has an ongoing marketing campaign associated with this program encouraging consumers to demand local Louisiana seafood in restaurants and at grocery stores. In the end, this program is designed to help both the consumers and the fishermen. It puts everyone on a level playing field so that consumers can more easily make informed decisions about the seafood they're purchasing and consuming.[362]

BRANDING CASE STUDY: VERMILION BAY SWEET

In addition to the direct marketing efforts around the state, Tom Hymel and his staff at the LSU AgCenter and Louisiana Sea Grant have also developed the Vermilion Bay Sweet brand under which jumbo shrimp and black drum are sold directly to consumers via retail outlets like grocery stores and restaurants. This seafood is natural, wild and fresh from the waters of South Louisiana. The Port of Delcambre owns and manages the Vermilion Bay Sweet brand and collects a small fee from each package that fishermen sell. Shrimp was the flagship product, and they served as the inspiration for the brand name because of their sweet, tender, white flesh. At this point, the shrimp packed under the Vermilion Bay Sweet label are caught in the waters off of Intracoastal City by a Vietnamese-run boat group. The shrimp are brine frozen out at sea and transported back to shore to be packed and processed in the port city of Delcambre. The shrimp are sold headless and frozen in one-pound packages. In the beginning, the shrimp were hand-peeled and hand-deveined, but production costs have dictated a shift toward machine processing. Currently, the shrimp come in two different varieties: seventy to ninety count for gumbos and stews and the much larger twenty-one to

twenty-six count for dishes that prominently feature shrimp. In the spring of 2014, the twenty-one- to twenty-six-count packs commanded seventeen dollars per pound. That may seem costly to some, but considering that this is zero-waste, locally caught, premium jumbo shrimp, the price better comes into perspective.[363]

During the 2014 Fisheries Summit, Hymel gave a presentation on the subject of the Vermilion Bay Sweet brand. He told attendees that the target market for this product is what he likes to call the "Cajun gourmet." These are people who are looking for the best seafood they can get, and they're also willing to pay for it. They value quality, even when it means a higher price point. High-quality, good-tasting seafood is worth almost any cost to them. Often, they're busy folks who don't have the time to clean the shrimp they want to eat. They'd rather pay the seventeen dollars per pound for 100-percent-usable shrimp meat than spend hours peeling it themselves. In all, this new wave of branding for locally caught shrimp is a boon for shrimpers. Few ever thought that they could command north of fifteen dollars per pound for even their most choice product. The shrimpers are now discovering new markets and opportunities they never knew existed. This is something in which Hymel takes great pride. His life's work has been to help shrimpers and other fishermen to stay in the game to hopefully get ahead one day in this highly competitive seafood arena.[364]

Fin fishermen are also getting in on the action now. Fisherman Douglas "Big D" Olander is currently using the Vermilion Bay Sweet brand on black drum that he's catching out near Delcambre. Olander used to sell all of his fish to the big fish buyers in New Orleans. Hymel and his team worked with Olander to set up a system to consistently and efficiently process and bag the fish so that it could be distributed wholesale to restaurants and grocery stores. In the spring of 2014, Olander was asking ten dollars per pound at the wholesale level. The grocery stores are then able to ask thirteen dollars per pound at retail. This endeavor has been quite successful for Olander, to say the least. He's currently running at maximum capacity for the size of his operation, and the market demand shows no signs of slowing.[365]

Hymel firmly believes in the opportunity on the horizon for the Vermilion Bay Sweet brand. They're currently working on developing the programs for blue crabs and wild catfish. The wild catfish is currently in the testing phase. Traditionally, wild catfish retails for about $3.95 per pound wholesale. With the Vermilion Bay Sweet branding, they

were able to charge between $6.00 and $7.00 per pound in a test run conducted with a restaurant in Baton Rouge. Not surprisingly, "Big D" Olander was the fisherman for that project. The price commanded for high-quality wild catfish when it's properly packaged and labeled is truly amazing.[366] This is a great example of another phenomenon that an increasing number of fishermen are getting into—value-added products. These are products that go beyond the basic whole fish or shrimp: some processing has been done for the consumer. It could be as simple as filleted, packaged fish or as intricate as crab cakes or peeled shrimp with an accompanying sauce. Fishermen realized that they can make more money when they have a portion of their business coming from the value-added market. The Vermilion Bay Sweet brand is an excellent example of this phenomenon.[367]

GROWING DEMAND FOR LOUISIANA SEAFOOD

It's a simple fact that the people of Southeast Louisiana alone cannot support a large, healthy fishery economy, nor should that be expected of them. After all, 70 percent of all Gulf Coast seafood is landed through Louisiana, and Louisiana ranks number one in national production for shrimp, blue crab, oyster and crawfish.[368] While direct marketing is, by virtue of perishability, limited to the region, branding and marketing efforts in packaged seafood can be undertaken to grow markets across the globe. Interestingly, Don Schwab said at the 2014 Louisiana Fisheries Summit that domestic shrimpers should not wish the imported shrimp away. He stated correctly that the supply of foreign shrimp has helped to create a global market for shrimp. This benefits Louisiana fishermen as much as anyone else. This also presents our fishermen with the opportunity to differentiate their project from the pack and help people realize it's a different and better product than most of what's out on the market. Schwab believes that what Louisiana's shrimpers need to do is increase their market share. They need to have more people eating Louisiana shrimp, when they're eating shrimp at all. Schwab believes that just having people increase their consumption of Louisiana shrimp once per month would be huge. It's not about making grand impacts and market penetration all at once. The real way to grow the market share is to have numerous

consumers increase their consumption slightly. He believes it would do wonders for the industry. [369]

Further, Louisiana's shrimp is becoming more popular globally. As populations in China and India increasingly enter the middle class, the demand for high-quality shrimp in those markets will continue to increase. Schwab cited that in 2020, China is expected to have a middle-class population larger than the whole United States population combined. The demand is becoming evident. Schwab said that even in the past few years, we've seen more domestic shrimp make its way to China. The Chinese have a nearly insatiable taste for jumbo shrimp—the large brown and white shrimp on which the Gulf of Mexico garnered its reputation. Schwab said that most of the shrimp caught or produced in China are small, around the twenty-six- to thirty-per-pound size. The Chinese don't get jumbo shrimp domestically, but they want it and pay premium prices for it. Increased demand from these burgeoning markets will help Louisiana shrimpers combat the imported shrimp problem. The markets exist. Louisiana shrimpers simply need to get hooked into the action and capitalize on the demand. [370]

The same can be said for the crab market. According to Kevin Voisin, China's middle class also has a taste for crab—so much so that China's exports are starting to dwindle due to increased demand at home for their product. Decreased production due to overfishing is also a factor in exports dropping. The upper-middle class in China is especially keen on crab. They can afford to buy it, and serving and eating crab is actually considered a status symbol in China. As with anything expensive, it's trendy to be seen and associated with fresh crab. Voisin likened this to the diamond and steel shortages that increasingly affluent Chinese have helped initiate. He says that overall, the increased demand is a positive development, but that demand does have implications, like potential stock shortages. [371]

This phenomenon isn't limited to shrimp and crabs. Jim Gossen has a passion for discovering and capitalizing on the less-than-obvious opportunities that wait in the Gulf waters and its fisheries industries. Pushing the limits of what is traditionally thought of as Gulf seafood has been part of what's made Gossen and seafood industries leaders like him so successful. Gossen has a colleague living and working down on Anna-Maria Island in Florida who dries and cures mullet roe to ship to Spain as *bottarga*, a Mediterranean delicacy. Gossen's colleague fetches sixty dollars per pound for his product at the wholesale level, and just like that, Gulf

A trawler sifts through by-catch to ensure no shrimp are thrown back into the Gulf. *Courtesy of Louisiana Department of Wildlife and Fisheries.*

mullet roe is a valuable commodity. All this is possible because someone recognized a niche-market opportunity and proceeded to capitalize on it. Gossen firmly believes that as opportunities are unearthed and effectively monetized, younger men and women will be increasingly attracted to

working the Gulf's fisheries industries. Once they see hope for making a real living for themselves and their families, they may start to consider the fisheries as viable career options.[372]

FISHERMAN EDUCATION

Starting now and continuing into the future, education will be a huge component to ensuring the success of fishermen. All the branding and marketing in the world cannot take the place of good business practices. Tom Hymel recently oversaw the development of a Louisiana Seafood Professionalism program. Brought to life in partnership with the Louisiana Department of Wildlife and Fisheries, this three-year professionalism program seeks to increase the knowledge of fishermen to help them become smarter, savvier businessmen. Hymel said, "These guys live in a box. Their horizon is the back deck. They are working and busy and don't have time to go think and explore. They're too busy working *in* their business to work *on* their business." This is exactly where his program can be useful. The Seafood Academy seeks to streamline all the information these farmers of the sea need to know into a concise manual and training program. Shrimping, along with all fisheries work, is quite difficult, and the fishermen need to know what they're doing to be successful.[373]

While the program seeks to achieve many goals, some of the key tenets of the process are teaching fishermen about direct marketing and then teaching them the value of tight quality control on their products. When fishermen only sold to processing plants, it didn't necessarily matter how pretty the product was. The processor was paying what he was paying, and that's that. Nothing extra was paid for pretty shrimp—just extra cost and time and effort on the shrimper's part—so most people didn't bother taking those steps. The shrimp was safe to eat and delivered in a manner in which the processor could use them—that's all that mattered in the past. Now with direct marketing, an incentive exists to keep the shrimp looking nice and fresh. Retailers and direct-sell customers aren't going to buy shrimp that's not pristine—they do not have that option. Customers only want shrimp that looks, smells and is supremely fresh. The market has now made it worth the money for shrimpers to take extra-special care when transporting and storing their catches.[374]

In the end, Hymel believes that education is the key to the future. He said, "We're poised to train our people so that we can have a more educated workforce so that economic sustainability isn't nearly as risky as it is now." Yet all this tragedy and these turbulent times gave birth to many creative and ingenious ideas. Many of the fishermen still around today thrive amidst the adversity. This is possible because of the work of Hymel and his staff at the LSU AgCenter and Sea Grant. They are working with fishermen directly to educate them about what it is they need to do to be savvy businessmen. One of the tenets at the heart of the shrimp industry's comeback is the effort to distinguish Louisiana shrimp as a premium product. Hymel and his team are trying to get the fishermen out of the mindset that they're catching a commodity item and into the mindset that what they're trawling for is a premium, high-end product. Getting the shrimpers to buy into the notion that they are dealing in premium product is the first step to ensuring their success. Hymel believes wholeheartedly in this process, and it seems to be working out well. The proof is in the success that they've had with fishermen with this new approach. Hymel believes that capitalizing on the "buy local" phenomenon is at the heart of this and that being the antithesis of commodity-imported aquaculture shrimp is a critical factor in winning over the support of the local market. Hymel's optimism and enthusiasm for the future are palpable. Many of the fishermen he works with are savvy young businessmen who are eager to adopt these new ideas and approaches to managing the fisheries. He said, "There's a new group [of shrimpers] out there that's coming and making things happen."[375]

The workers of the fisheries are intelligent, driven people. They put long hours of hard labor into their businesses, often for very little profit. They fish because they love it and get satisfaction from knowing they bring the bounty of the Gulf to the tables of Southeast Louisiana and beyond. They do it because it's part of their heritage. Essentially, fishing runs in their blood.[376] Education can help these producers work more effectively and teach them that while the relative isolation of the Cajun community in the past has resulted in a self-reliant community, in modern times, this self-reliance can also be somewhat of a hindrance, especially if disaster strikes. Being able to take care of one's self and family is a great and essential asset, but it's also important that people be able to come together as a community to work together to solve problems and work through issues. For example, people can't solve a problem like fishery sustainability, marketing practices or the big one—coastal

Coastal erosion has taken its toll on the area south of Leeville. *From the authors' collection, 2014.*

erosion—individually. That takes a group effort and multiple points of input to put a plan into action.[377] At times, people have to consult with a group to advance and achieve individual objectives. That's at the heart of how the government and formal systems of today are set up and how they operate. It is vital that Cajuns begin to expand their definition of their community to include all of the stakeholders in the fisheries of the marshes and the Gulf of Mexico.

This brings us to the BP oil spill of 2010. Liz Williams, president of the SoFAB Foundation, worked as a consultant on several claims cases related to this because she is an expert on culture and how that plays out in the fisheries industries here. Many of the fishermen aren't in the habit of documenting everything or keeping overly meticulous records. It's just not how many of them operate. Therefore, when it came time to file claims for BP, they didn't have any of the documentation required to prove what their losses were. Part of it was that they just didn't keep the receipts or information necessary to prove financial outlays. Another part of it is that many fishermen still rely on the bartering system as a

way of living. For example, they may trade pounds of shrimp or sacks of oysters for baby-sitting services from a friend or family member. They also eat some of the catch themselves, which means they're not having to lay out cash for food at the grocery store. But without records, this is difficult, if not impossible, to quantify or prove. Therefore, when it comes time to show the loss, some fishermen have a hard time doing so.[378] The ultimate irony is that they're just trying to protect themselves by staying self-reliant, but those actions are what end up hurting them most because they can't actually prove what they lost.

A balance must be struck between education and preservation, and perhaps these are not mutually exclusive, but it seems that the way government systems work are antithetical to the way Cajuns work. Rules, regulations and procedures all seem foreign in a land where community and a handshake are valued above all else. Accordingly, education should focus less on changing who Cajuns are and serve more as a way to help them interface with the foreign cultures of greater America and American governance. Education can increase profits and production, thus ensuring economic viability. When one stakeholder hits upon a success, that success should be shared among all stakeholders, improving the health of the entire fisheries economy. Through education, the fisheries can move forward together, as a community.

Utilizing Technology

George and Carol Terrebonne own and operate the Seafood Shed, just south of Golden Meadow. They've owned it since the 1990s, when they were taken on as a third partner in the business. Eventually, they bought out the other two partners and now own the business outright. The Terrebonnes have been around the shrimping industry all of their lives. Mr. George used to trawl with his father as a boy, then was a trawler himself for a while as an adult. He's seen every side of the business, and he's also seen it change over the years. In the nearly twenty-five years they've been operating the Seafood Shed, the Terrebonnes have seen the shrimping industry dwindle in size. Not only do fewer fishermen operate out of Bayou Lafourche, but also even fewer large, sea-faring vessels remain in operation. It's much more common now to see the smaller vessels that only go out for a day or two at a time. Rising costs are one

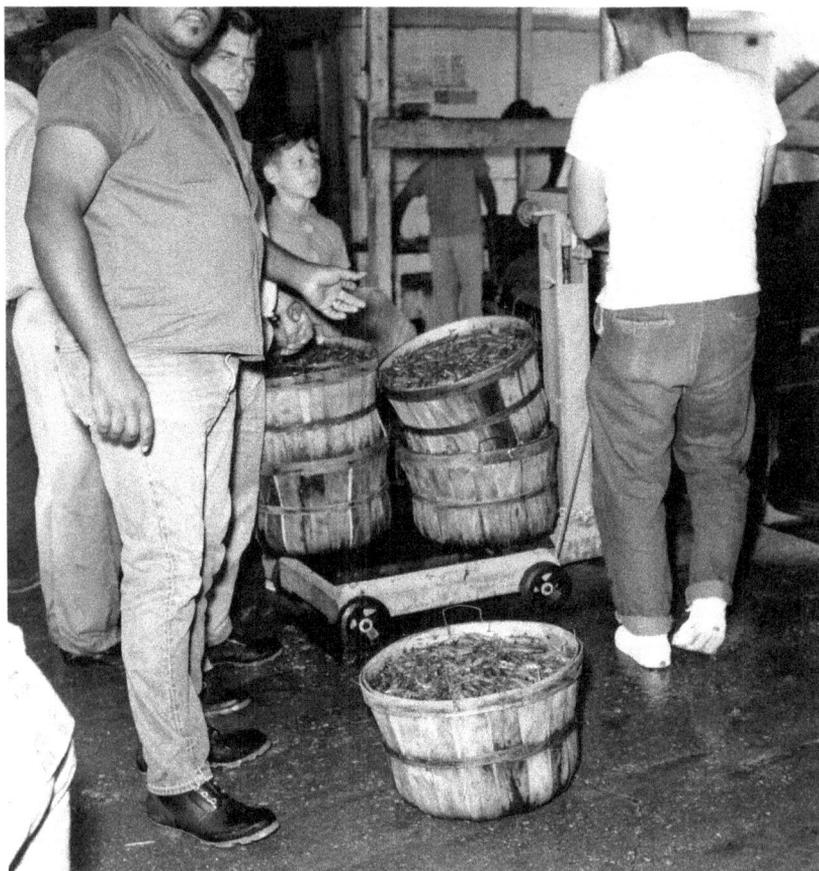

of the reasons fewer fishermen are around these days. It used to be that men would work in the oil field for seven days, and then on their seven days off, they'd do some trawling. Back then, the price they were getting for shrimp relative to the money it cost to go out and get it was tipped in a positive direction for trawlers. They'd work for the oil company and receive their benefits and full-time paychecks, then supplement that with whatever they could sell trawling.[379]

Like many docks, the Terrebonnes sell to both processors and the general public. While most of their shrimp is sold to the processors, the retail side is what keeps the business afloat. Without that, Mr. George said resolutely, "we'd close the doors." The retail business is key to their success and longevity. For many years, the price of shrimp was depressed, while costs rose exponentially. Recently, due to the shortage of imported shrimp,

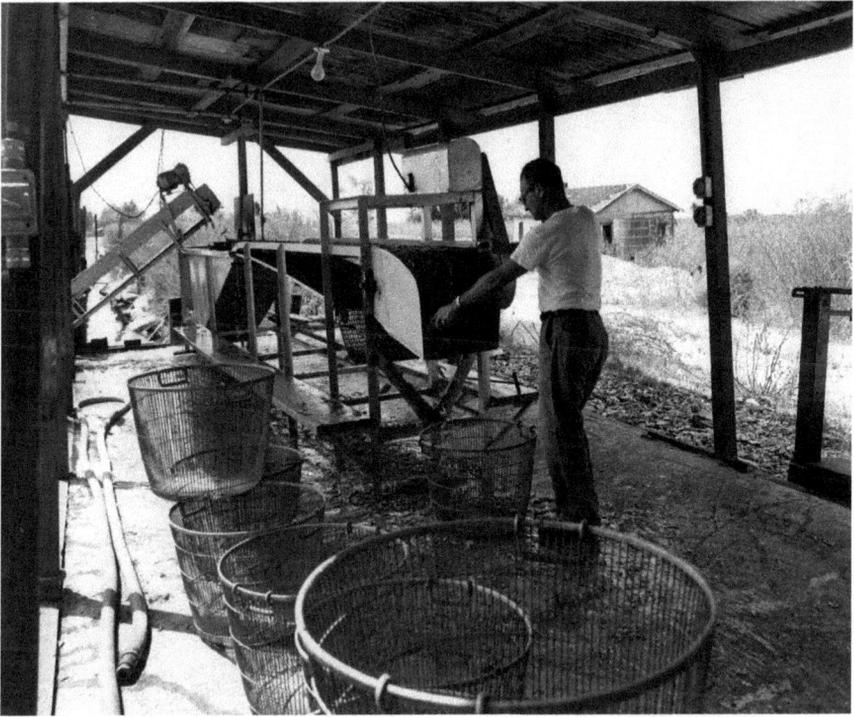

Shrimp docks would often have some parts of the process mechanized, but much of the work was done by hand. *Courtesy of Louisiana Department of Wildlife and Fisheries.*

Opposite: Prior to mechanization, shrimp baskets were hauled by hand on small carts. *Courtesy of Louisiana Department of Wildlife and Fisheries.*

domestic demand rose. Suddenly Louisiana's shrimpers were able to get better prices for their catch, and that has benefited the Terrebonnes as well. Overall, times are good for the Terrebonnes. Everything considered, today their business is thriving, and they support three families with the money generated. Brimming with pride, Mr. George told us, "We make a good living for three families. That's what we do."[380]

In the nearly twenty-five years that the Terrebonnes have been operating the Seafood Shed, they've seen a steep slope of technological advances. When they started out, workers were still unloading shrimp from the boats by hand in wooden crates. They loaded trucks and iced shrimp, all by hand. The only machinery to be found was the truck that came to pick up the shrimp. As a result, Mr. George and even his son Wade, who is in his late forties, have bad backs. Mr. George said to us,

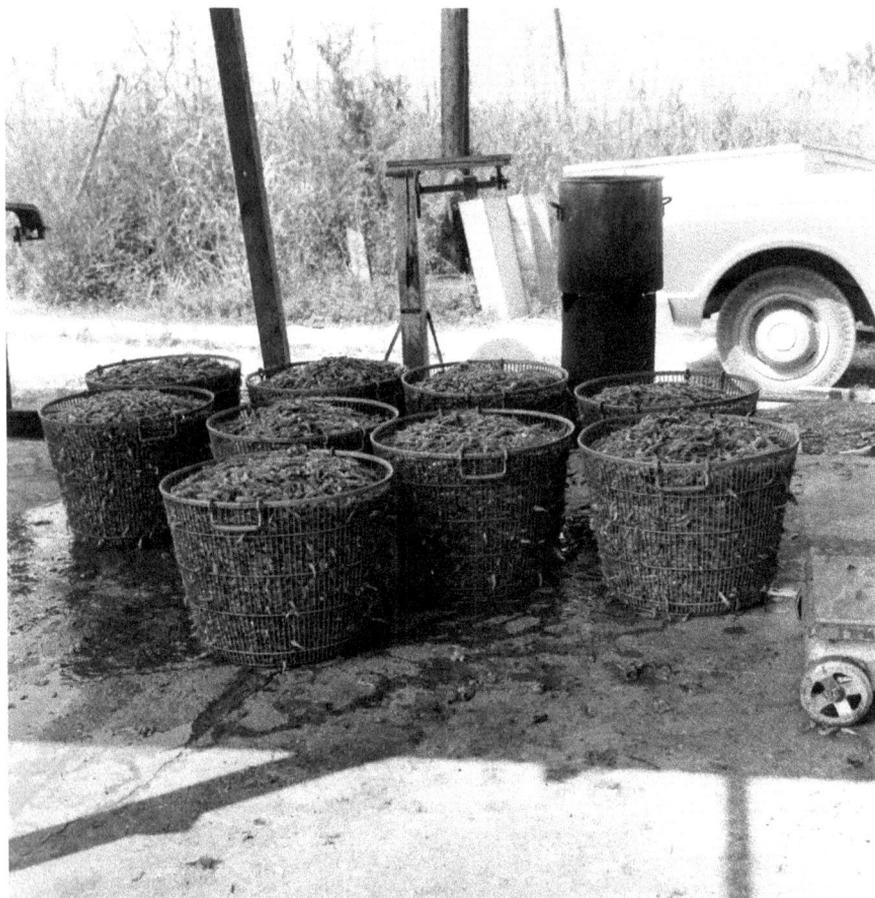

These open baskets of shrimp, manually hauled from the boat with back-breaking labor, are relics of the past. *Courtesy of Louisiana Department of Wildlife and Fisheries.*

"That's why I'm disabled." Contrast that to today, when the Seafood Shed has a vacuum system that removes shrimp from the boats. They have an automatic conveyor system that moves, weighs and dumps the shrimp. They now use a Bobcat front loader to ice the shrimp. Forklifts do all the heavy lifting now, moving the shrimp fairly effortlessly from cold storage to the transport trucks. What used to take a team of thirteen men is now done with two. Not only does it take less labor, but it also takes half the time for a trawler to drop off his catch and be on his way.[381]

Technology is also connecting people now more than ever. The world has, indeed, gotten smaller. Evidence of this exists in numerous places in

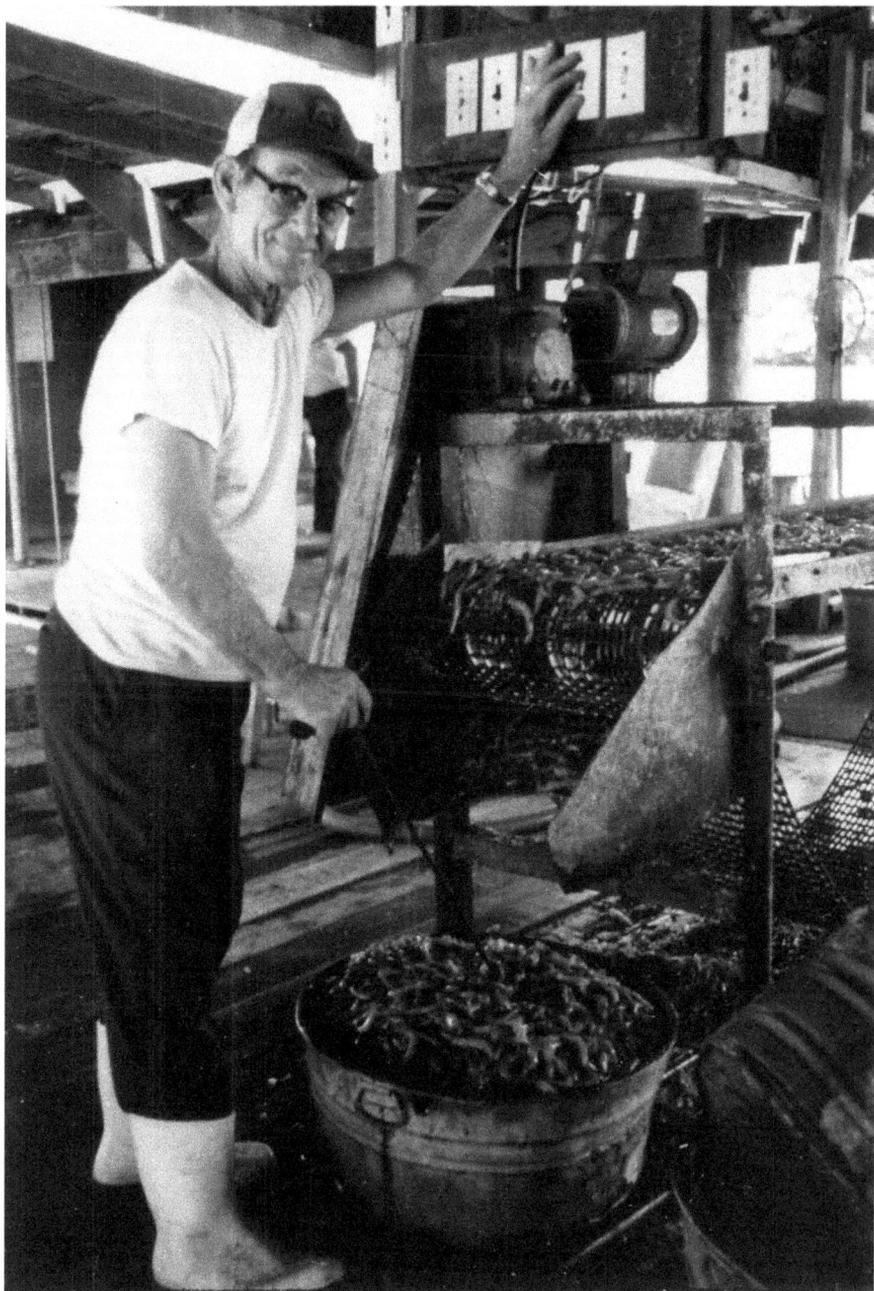

A dockworker offloads a shrimp boat with mechanical assistance. *Courtesy of Louisiana Department of Wildlife and Fisheries.*

most people's daily lives. Shrimpers and their livelihoods are impacted by that change as well. At the 2014 Louisiana Fisheries Summit, Don Schwab gave a great example of technology's impact. He said that instant communication has revolutionized shrimp pricing and sales. It's quite easy these days for shrimpers to know the specific prices factories in Japan and Thailand are paying for shrimp, for instance.[382] The information is readily available in real time, which allows prices to be more competitive globally. Shrimpers know what constitutes a fair price for shrimp and how that compares against the global market. Now more than ever, Louisiana's shrimpers are more informed and armed with information that allows them to stay competitive in the global market. Jim Gossen told us of the opportunities he sees in mobile apps, connecting commercial fishermen with markets but also connecting recreational fishermen with wildlife authorities, allowing for more efficient management of wildlife resources.[383]

When Nick Collins started oystering with his dad, Wilbert, in high school, they had no electronics on the boat aside from the motor. They used to travel across the Mississippi River at night to get loads of oysters with nothing guiding them but Mr. Wilbert's experience. He knew where he was going because he'd made the trip many times before in that same unguided manner. Nick laments on how spoiled he is today because he's dependent on his GPS and depth-finding equipment, but that's the nature of today's fishermen—they're using the technology they have available to them to make their businesses run better and be more profitable.[384]

Longtime fisheries businessman and expert Jim Gossen told us that nowadays, the fisheries industries are no longer dominated by a few large players but by numerous family-run businesses, all rather small in scale. Over the last thirty years, the size of the industry has shrunk considerably. Many processing plants, once vibrant trade houses, stand shuttered or have been demolished. Sons seeing their fathers struggling to make a living trawling for shrimp or harvesting oysters are leery to get into what they view as an ailing industry. However, while the fisheries industries are merely a fraction of the size they once were, Gossen believes that economic opportunities still exist, and even more possibility is on the horizon. Echoing the sentiments of Tom Hymel, Gossen stated that improving the way the fisheries are managed and fished is the key to the long-term viability of each industry.[385]

Potential solutions put forth by Gossen are that finfish fishermen need to focus on fishing smarter, more efficiently and in a manner that produces superior quality catch. Educating fishermen and teaching them

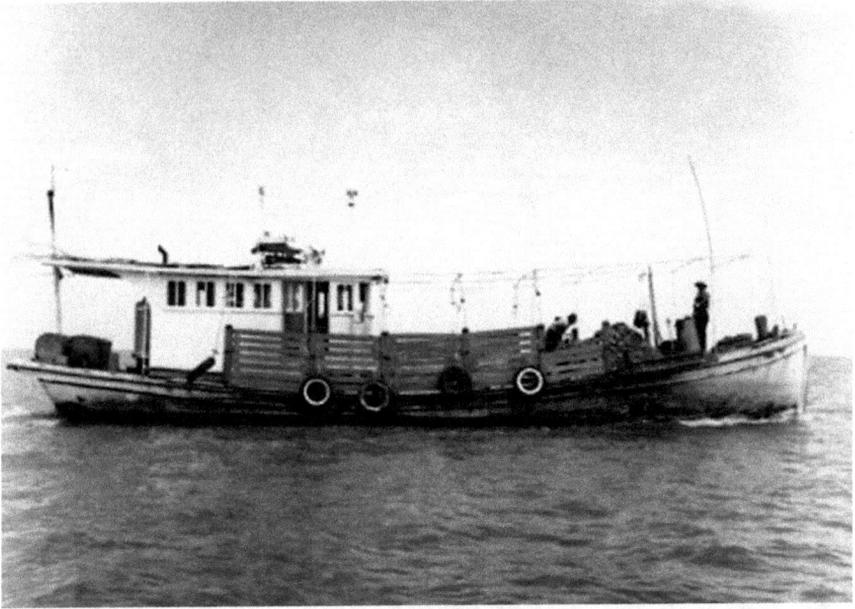

An oyster lugger out in open waters. These wide, shallow boats can carry thousands of sacks of oysters. *Courtesy of Louisiana Department of Wildlife and Fisheries.*

how to manage resources, time and temperature are key. A great example of this is the tracking system used by Gulf Wild, a 501c(5) nonprofit organization started by fishermen associated with the Gulf of Mexico Reef Fish Shareholders' Alliance.[386] They use a tagging and tracking system for the finfish species that fall within their purview such as red snapper, grouper and tilefish. To properly manage this quota system, they've implemented a tagging system for the fish whereby each fish is tagged with a number that can allow for tracing the fish back to the area where it was caught, who caught it on which boat and the dock name where it was landed. All this information is available when the number is entered into Gulf Wild's tracking system on their website.[387]

The key is accurately managing the annual finfish catches on both the commercial and recreational side. While the commercial side is well regulated with tracking and control points, the recreational industry goes largely unmeasured. Gossen suggested developing a smartphone application that allows anglers to report their own finfish catch numbers, weights and the general area where the fish were caught. Gossen told us that he strongly believes that "the key to the longevity and growth of

Recreational fishermen in the marsh grasses east of Golden Meadow. *From the authors' collection, 2014.*

Opposite: The brackish waters of the Southeast Louisiana marshes make excellent fishing grounds for recreational fishermen. *From the authors' collection, 2002.*

the industry is management."[388] The fish stocks must first be properly monitored to ensure that effective and correct quotas are established. A tracking mechanism for the recreational side would go a long way in aiding those efforts. In the end, Gossen feels that people would be eager to participate in a program like this, especially if the recreational fishermen could access and use the data themselves. The "gamification" of the recreational fishing industry could be a simple yet effective start toward reaching a solution.[389]

Gamification, resilience and competitiveness are more than buzzwords; these concepts hold the future of the fisheries. The survival of the fisheries, and of the culture that depends on them, hinges on the successful implementation of ideas that improve the economic viability of Southeast Louisiana's bounty. As global competition intensifies, any advantages producers eke out over competitors will help them survive. Cajuns seem

well suited for the impending battle. They have long been resilient and adaptable, and they have long taken ideas from other cultures, immigrants and the nation they call home. Armed with the best ideas they can find, the Southeast Louisiana fisheries industries seem well poised to compete on a global scale. However, despite all the progress made in keeping the fishery economies viable, trouble is brewing, and unfortunately, it's much larger than any one component of Southeast Louisiana life.

The Environment

The wetlands that line the coast of Southeast Louisiana are three types of resources in one—economic, environmental and cultural. This isn't a new idea: in the early twentieth century, fishermen worked more like conservationists, although that's not what they called it. They worked the fisheries and trapping seasonally, quitting each when the time was right. They simply did tasks when it was time to do them, and if the time wasn't right, they'd stop. It was instinctive—they knew what to do via communal, inherited knowledge. Mr. George Terrebonne's grandfather, who was an adult by 1920, lived and worked this way. Mr. George explained to us how he saw his grandfather work: "When it was trapping season, he knew it was trapping season. He'd start trapping. He knew when to quit crabbing. He knew when to quit shrimping...They knew when it was time to quit...They'd stop." It's not like it is today where a crabber will try to fish for crabs year-round. The men who worked on the water and in the marshes in the early twentieth century did it all; they crabbed, trapped, shrimped and even passed seines to catch finfish. Mr. George went further to say, "We did everything, and everything had its season. Everything had its place...Everything had time to grow."[390]

This approach came from an unspoken understanding of the value of the land—the value of home. Before modernity and the advent of consumer culture, the land and its fruits were all people had, and they treated it accordingly—with deference. This seems to be something forgotten in the midst of modern science and technology. Jim Gossen, however, thinks in ways similar to the Cajuns of old, considering the Gulf to be our most valuable renewable resource. The bounty that exists under water is astounding, and people need to do little for it to be this way. No planting, no working the fields and no watering need to be done. As long

A small boat tows a shrimping trawl. *Courtesy of Louisiana Department of Wildlife and Fisheries.*

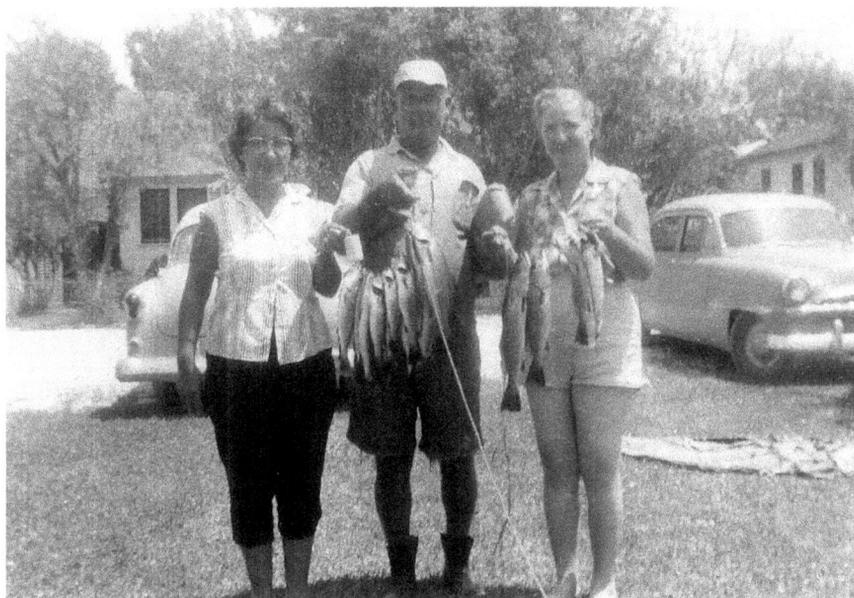

Recreational anglers proudly showing off their catch in the town of Galliano in 1958. *Courtesy of Mary Chailland.*

as the Gulf is taken care of, it can continue to renew. Even better is the fact that the fisheries must be worked and harvested to keep homeostasis in the stock levels. Fishing the waters actually makes them healthier and more abundant because it spurs the sea life to produce more offspring and, therefore, more creatures to harvest from the Gulf.[391]

Properly managing the fisheries is one of the keys to the longevity of these industries. Gossen believes that some of the money that's made from the oil industry should be invested back into creating better estuaries for the fisheries. Gossen stated wisely, "Think about it. There's not many things in the world that you don't have to do anything to it, and it just keeps reproducing." He's correct, and certainly not for anything as valuable as seafood. To help bring the situation into perspective, Gossen shared a fantastic metaphor with us during his interview. Since the fisheries are under water and basically "out of sight, out of mind," it's hard to get people—politicians and the general population alike—to focus on them and be concerned about depletion levels.[392] He astutely told us, "The Gulf is over twice the size of the state of Texas. If you had twice the landmass of Texas producing all kinds of strawberries, oranges, peaches, rice and sugarcane, and you didn't have to do anything to anything. You just went and harvested it. You'd be pretty concerned when it started depleting, huh?"[393]

Gossen's quote sums up the issue eloquently and fairly stresses the larger challenge of getting people to pay as much attention to the quality and state of the Gulf of Mexico as is needed. The state of the Gulf is the main influence on the quality and amount of seafood the Louisiana fisheries produce and thus factors in heavily on the quality of life in and vibrancy of the communities that depend on the Gulf.

Chef Brian Landry hails from the Gulf Coast. He's not only someone who cooks seafood from the Gulf, he's also someone who cares about and advocates for its overall health and wellness. He does this because he cares about the land and water he grew up on, the people he grew up with, but also because his livelihood, like that of the fishermen, depends on the overall health of the Gulf. His restaurant, Borgne, specializes in seafood delicacies primarily sourced from the Gulf. If he loses access to the products he depends on and that his customers come to him for, his business's viability is at risk. Not only is access a concern but affordability is also a factor. If he can't bring the seafood into the restaurant at a price that works for everyone involved—supplier, restaurant, diner—then the business isn't sustainable.[394]

Anglers fishing on a small but sturdy plot of marsh grass. *From the authors' collection, 2002.*

While he grew up on the recreational side of fishing, Chef Brian views the issues quite clearly from both sides because he takes part in both sides of the equation. Fishing out in Shell Beach and Venice, near the mouth of the river, is how Chef Brian was first exposed to the Gulf and its bounty. While he's from New Orleans, he spent a great deal of time on the coast while growing up. To this day, Chef Brian's family still owns a camp in that area. Over the years, he's witnessed massive change in the landscape and waterways. His family's camp in Venice was actually destroyed in Hurricane Katrina and was rebuilt soon thereafter so his family could continue their fishing traditions. One of his favorite outings each year is right before Thanksgiving when all the males in his family, ages thirteen and over, gather at that fishing camp for a weekend of fishing, cooking, communing and just plain having fun.[395]

In addition to taking care of the Gulf and its bounty, Chef Brian is also concerned for the fishermen. Without them, he loses his access to the Gulf's bounty. All the fish in the sea aren't of much use to him and his business if no one will retrieve them. The fishermen are the essential element in the equation. Sourcing product from local fishermen and suppliers is something to which Chef Brian is dedicated. His philosophy is this: "The more money we can spend

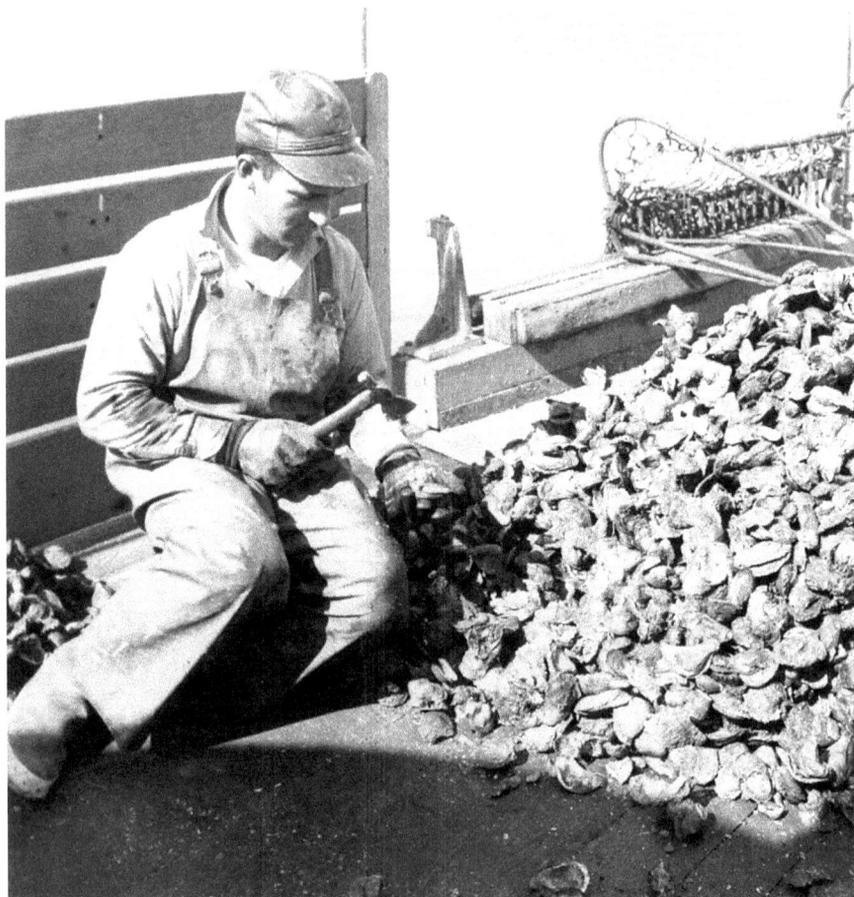

An oysterman uses a hammer to break apart oysters to prepare them for sale in February 1961. *Courtesy of Louisiana Department of Wildlife and Fisheries.*

in our backyard, the better." He realizes that when he supports local fishermen, he's supporting local families as part of that package. He notes poignantly, "When you see that it's families, just like I have, relying on people to buy the oysters or the shrimp or the crabs or the fish they catch, it becomes more personal."[396]

What Can Government Do?

Right now the idea of rebuilding the coast and the wetlands is a white-hot topic. State officials in Louisiana are finally discussing how to go about rebuilding and some practical ways to make it happen, but they often discuss it in cold, impersonal terms as if the decisions made will not directly affect the lives of tens of thousands of people living along the coast. Chef Brian wisely realizes that it's not as easy as stating, "Let's just go rebuild the coast." His philosophy on the matter is that each time man interferes with nature, he rarely is able to imagine the long-term consequences to both nature and man. A great example he used was how the Mississippi River is confined along its entire length by a levee system so that people were able to build towns and grow the area. An unforeseen consequence of that move is that the swamps in the area are no longer getting fresh water when the river rises annually, because it no longer floods as it did previously. To combat this, the state wants to undertake freshwater diversion projects, but each time people make a move, nature has a countermove. Freshwater diversions change the hydrology of the already-fragile wetlands in unforeseeable ways. Diversions can push out brackish species, shift oyster beds and kill some kinds of grasses, all with the hope that they'll just be replaced with others. Chef Brian astutely observed that the conversation is complicated and many different factors must be considered. Getting input from all parties and making difficult decisions is something with which the state government is tasked. The hope is that effective action and smart thinking can prevail, but optimism can be hard to come by with government matters these days, especially when it comes to a project of the scope (and cost) of saving Louisiana's coast.[397]

The wetlands of the coast have long been considered a no-man's land. Regular people (government officials, city residents, inland farmers, etc.) couldn't ever quite understand how people wanted to live in this "vast wasteland." What they fail to see is the residents of the coastal swamps and marshes know that a complex, vibrant system exists here. Kevin McCaffrey interviewed a man named E.J. Daigle from Franklin for his documentary *No One Ever Went Hungry*. Mr. E.J. is an old man who fishes for crawfish in the wild. He traps in secret locations in the Atchafalaya Basin. McCaffrey proceeded to interview Mr. E.J. for the documentary, out in the basin among the wild irises and wetlands. While a good bit of the interview made it into the final film, McCaffrey told us in our

interview with him about how he and Mr. E.J. had a long discussion about the hydrology of the basin. See, Mr. E.J. was born on a houseboat and grew up in that basin—long before the state outlawed houseboats in the basin in the 1970s. They had a detailed discussion about rainfall and fish movement. Compared to what a geologist that McCaffrey later interviewed said, Mr. E.J. was able to explain the hydrology to Kevin in the very same terms. He grew up with it. Mr. E.J. has valuable, traditional environmental knowledge. That's something that many fishermen have because they live and breathe the water and wetlands and swamps. It's their life's work, what they do and what they know best.[398]

Situations aren't always what they appear to be in the wetlands. Sometimes land may not appear valuable, but it is. This is why local knowledge is indispensible. Asking the people who live on and work the lands what their thoughts and ideas are is critical, especially when it comes to something as mysterious as the wetlands. While the present may look bleak for some of our oldest ethnic groups, all is not lost for the future. Dr. Don Davis, director emeritus of oral histories at the Louisiana Sea Grant College Program, noted for the first time, with the master plan currently in progress in the legislature, that policy makers are taking culture into account when planning and making decisions. Legislators are talking to people, average citizens and fishermen alike, to try to understand the value of what is invaluable to so many. In its ephemerality, it has historically been difficult to assign a dollar value to Southeast Louisiana.[399] Historically, this collaboration and question asking hasn't been the norm. In many instances, fishermen were seen as unintelligent and not having any useful information to offer. Nothing could be further from the truth. The fishermen are the people who are out on the water and in the marshes on a daily basis. They make their living from the land. Most of them know their stomping grounds like the backs of their hands. If anything, they're some of the first people who should be consulted when it comes to on-the-ground decision making. One of the best examples of this took place in the 1970s. Dr. Davis interviewed fishermen who were telling him about the "bad water" in

Opposite, top: Boats and barges for the oil industry line Louisiana State Highway 1 just south of Leeville. *From the authors' collection, 2014.*

Opposite, bottom: The salt water has yet to drown this oak grove in the marsh. *From the authors' collection, 2014.*

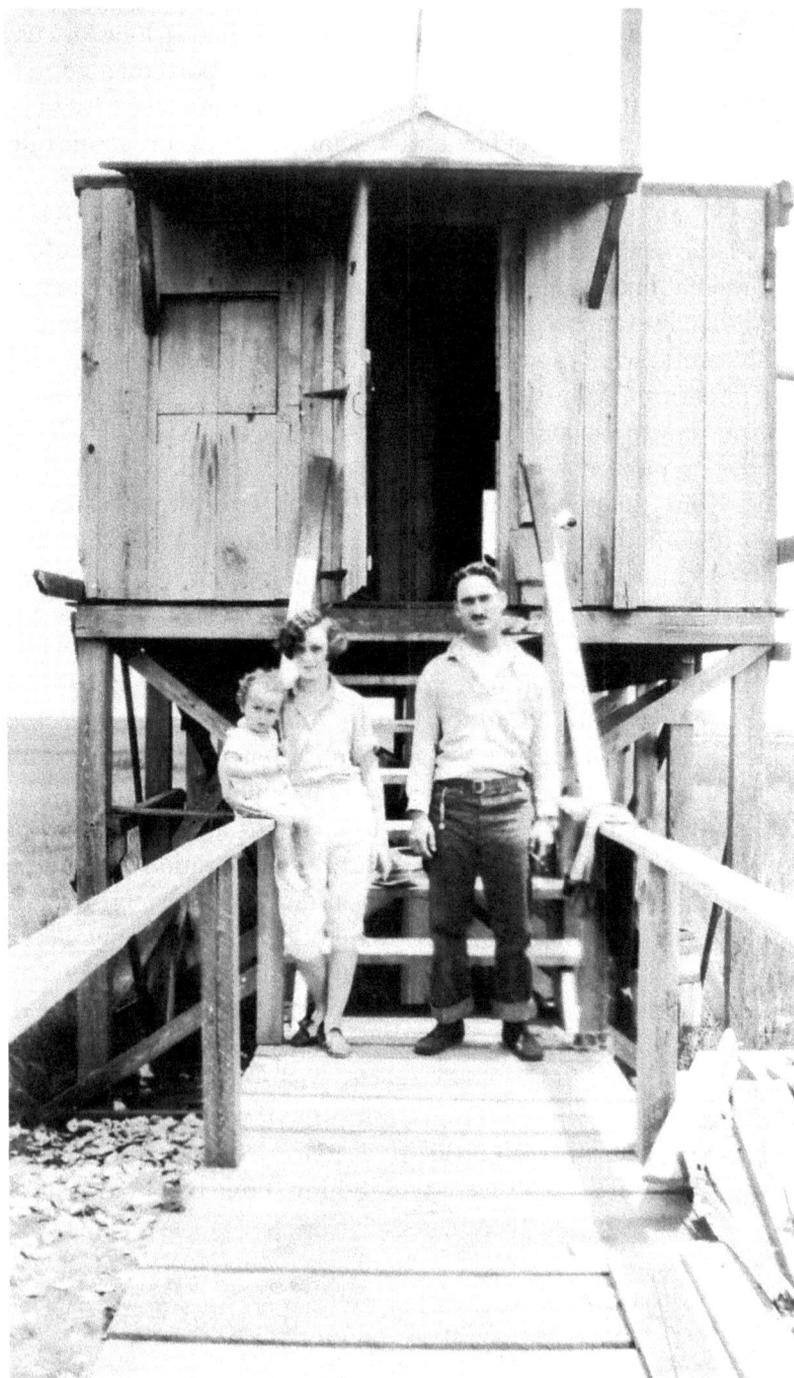

Bayou Lafourche at the town of Leeville. *From the authors' collection, 2014.*

Opposite: In the nineteenth century, oystermen and their families lived on their oyster reefs in makeshift homes, intimately connected with the environment. *Courtesy of Louisiana Department of Wildlife and Fisheries.*

the Gulf. Today it's called hypoxia—the Dead Zone. Even back then, the fishermen knew, but no one ever thought to ask.[400]

Dr. Davis went on to say that most people not from South Louisiana have difficulty understanding the heritage and long lineage lines and ties to this area. It has to be explained to them that it is not uncommon to have the ninth or tenth generation of people living within twenty-five miles of a family's nineteenth-century homestead. It takes a while for people not from here to understand how deep people's ties are to their ancestral homes. The family ties here are strong, and so is the desire of people to stay here in their homes on the property that their family may have owned for almost two hundred years. Dr. Davis summed it up best when he said, "It's often said that once you drink the water of Bayou Lafourche, you will always come home."[401]

It's not only that people are inextricably linked to their hometowns and cities, but they are loath to be separated from their actual homes. Dr. Davis recounted a particularly telling story in our interview: "I

A pathway to the Grand Isle beach on the coast of the Gulf of Mexico, Louisiana's first line of defense against the Gulf. *Courtesy of Mary Chailland.*

interviewed a fellow mid-part of last year who was asked to move next door. 'NO!' [he said.] Now wait, [that] wasn't [just] 'no.' That was [an] unequivocal 'NO!' And I asked why. He said, 'You see that oak tree? I woke every morning looking at that oak tree. I don't plan to wake up next door and not see my oak tree.' That tells you all you need to know."[402]

Indeed it does because the people of Southeast Louisiana, especially the older generations, are so firmly attached to their homes and their surroundings that they simply can't imagine living anywhere else. It's as if the thought never even occurred to them. The gentleman in the story above couldn't fathom waking up and not seeing his particular oak tree. With the rapid pace of land loss, someday he may have no choice. The coastline of Louisiana has always been a hazy, poorly defined boundary. It is not a cliff, and it is not a beach. The Louisiana coastline is a shifting map of grass and silt, changing slightly on a daily timescale, drastically on a geologic timescale. Mankind has only lived in this region for the blink of an eye on the geologic timescale, and now we're beginning to realize that we have built our homes upon shifting soil. As loath as many may be to move, they will be forced to—not by governments, for Cajuns have never been a people to listen to anyone but themselves.

No, eventually the Cajuns will be forced to move progressively up the bayous by nature. This process has already begun as communities right on the coast sink into the Gulf, swept away by subsidence from storm surge. The people move to the next town up. Well, the next town up is now probably in danger, and the difficult task ahead is deciding what to save and how much saving it is worth to the people of the region, the state and the nation.

CAN THE COAST BE SAVED?

Saving the coast is indeed a tricky endeavor. No panacea exists; after all, Louisiana has 7,721 miles of shoreline.[403] What works well to save one thing will inevitably cause harm in another area. The current rate of coastal land loss is 20 to 35 square miles per year, yet some of the freshwater diversion projects meant to address this loss are forcing shrimp farther back into the salty Gulf water while making former oyster habitats useless.[404] The problem is also people. Few want to sacrifice what they have in order to help the greater good; the sense of community among Cajuns seems to have broken down somewhat in that regard. "Community" seems limited to their literal towns, the people they know and the lifestyle to which they have become accustomed. As difficult as it is to admit, that's the case. This is where the true intricacies and seemingly insurmountable hurdles spring up. People are fighting tooth and nail to prevent projects that could help this area last longer because it hurts their short-term interests in some way or another. What this approach lacks is the understanding that eventually the river and Gulf will swallow up Southeast Louisiana. No one knows when. It's just a matter of time. Estimates range from fifty years to several hundred years. It's an area that is dying at the hands of man. Man intervened to first tame the Mississippi for humans to live here, and that was the beginning of the end of the wetlands in the region. The damage caused by the oil and gas fields was basically fuel on the fire and helped speed up the inevitable collapse and destruction of one of the country's most fertile wetlands and estuaries. Of course, since we are here in the United States and people have property and rights that need to be considered and contended with, the marshlands will get caught up in the crossfire. Inevitably, the needs and wants of man will take precedence over the

The new bypass bridge connecting the town of Leeville to Port Fourchon resulted in the old Louisiana Highway 1 being abandoned at the water's edge. *From the authors' collection, 2014.*

long-term health and viability of this area. Nature will get caught in the crosshairs, and suffering will be widespread because of it. Man's general lack of long-term vision and thinking outside of his own survival has been the bane and ruin of many ventures. It is looking as though it could ultimately be the destruction of these once-bountiful wetlands as well.[405]

Dr. Don Davis prefers to describe the wetlands as ephemeral. It seems to him that they can't decide whether they want to be land or water. In the wetlands, change happens rapidly. Land moves or sinks while water rises and flows. During our interview, Dr. Davis shared a favorite story of his concerning the wetlands. Back in the 1970s when he was a professor at Nicholls State University, he had a Japanese immigrant student who asked him to see the wetlands. Dr. Davis happily obliged by driving him out and showing this young man what he wanted to see. While they were out looking at the wetlands, Dr. Davis suggested to the young student that he stand on top of his car so that he could get the widest view of the vast area. The student took him up on that offer, and as he stood on top of the car, he slowly

A small cemetery in the town of Leeville, once located on high, solid land, is now only accessible by boat. *Courtesy of Louisiana Department of Wildlife and Fisheries.*

gazed all around him, looking at the Gulf and then back at the wetlands. All the student could say of it was, "It's so big." Dr. Davis thought that summarized the whole wetlands experience well—the expansiveness and all-encompassing nature of it all.[406] Besides being fertile fishing grounds and nesting areas, the wetlands are the area's first line of defense for hurricanes and tropical storms. They also act as a defense barrier by absorbing some of the nitrogen and phosphorous that comes down the river. Otherwise these unabsorbed minerals contribute to enlarging the Dead Zone (hypoxia).[407]

The Dead Zone is a familiar topic to Jim Gossen, who sits on several nonprofit boards, some of which are concerned with conservation in the

Gulf of Mexico, especially as it relates to the fisheries. It is understood by Gossen, and by most who deal with the Gulf of Mexico fisheries, that the fisheries aren't the only priority of all the Gulf stakeholders. Industries like oil and gas are a critical component of the local economies of the Gulf states, and the local citizenry needs the jobs they provide to make a living. However, the fisheries also contribute sizably to the economy of Louisiana, providing $2.4 billion in economic impact.[408] Therefore, conservation is both environmentally and economically important. In his experience, Gossen feels that relatively simple efforts could be undertaken to help further conservation efforts to ensure the longevity of the fisheries, Louisiana's one and only natural, self-renewing resource.[409]

One great example Gossen used to illustrate his point concerned the vast array of canals no longer actively used. He believes firmly that the companies that dredge those canals should have to fill them back in once they are no longer in use. Doing that would help to lessen the effects of coastal erosion and reduce the number of canals that eventually widen into bays due to the erosion process. Since the canals are long, straight throughways, recreational boat traffic tends to use them as well, many boats speeding through the wide-open waterway. Over time, this has a detrimental effect on the overall landscape and marshlands surrounding the canal. As long as those canals are needed for industrial purposes, Gossen has no problem with them, but once they're no longer in use, he rightly believes that the company should have to cover the cost and do the work to fill in the canals. Gossen stated rather plainly that he's not an environmentalist but simply someone who advocates doing "what makes sense and needs to be done to conserve the resource." Gossen also advocates studying the effects of water diversion projects before they're put into place.[410]

Out of economic sustainability comes community sustainability. Preserving the culture behind the fisheries and their bountiful seafood is another key to success. If communities aren't healthy, then they can't sustain the industry for long. One of the reasons that Tom Hymel and his teams were so focused on helping the Delcambre port come back is that they wanted to help preserve and maintain the heritage and culture of the area. Bringing Delcambre back as a fishing port not only helps the fisheries directly but also helps the community at large by increasing tourism to the area. People travel to meet these fishermen to see how they operate. People are interested to see where their seafood comes from and how that process unfolds. Connecting with the source is an important

Today, much of Louisiana's remaining marshlands looks similar to this with low grasses and wide, dredged canals. *Courtesy of Louisiana Department of Wildlife and Fisheries.*

cultural phenomenon right now, and having a formal system in place, like the Louisiana Direct Seafood program, is essential to the success of the fisheries and the town. We live in an experience-based society today, and people's ability to visit these boats and meet the fishermen goes a long way toward helping those people pay higher prices for their shrimp.[411]

For culture to survive, Liz Williams strongly believes that it needs to be able to change with changing times. Culture needs to evolve so that it can remain relevant to people. Everything changes over time, and a culture that seeks to survive is no different. When groups try to cling to

culture too tightly and refuse to let it grow, evolve or change, that's when Williams believes the culture and its associated traditions are most at risk of being killed off or becoming irrelevant. Some people fear change. They see it as a threat. However, that very change is what will allow customs and traditions to thrive. Culture is rooted in the past, but it must be practiced in the context of the present. A dynamic culture is a healthy culture. Williams takes it a step further when she asserts that culture is a social invention. It takes the input of many people to actually become a custom or part of the culture. It's not an individual's invention. Therefore, when enough people in the social group decide what can and should change, they do it. Individuals can choose to keep alive particular parts of a tradition or not, and that's ultimately how culture and traditions survive—when enough people deem something worthy of practicing.[412]

10

A GLIMPSE AHEAD

We talk at length while we drive since we have nothing else to do; the iPod is busted, and we only have one CD to listen to these days. We talk about the future, our future, but also the future of the region, our home. We talk about the importance of the old traditions—how they are often all that people here have left after decades of land loss, economic hardship and hurricanes. The roads follow the curves of bayous—new paths built atop the patterns of ancient ridges. New traditions too should be built atop the patterns of the old, we decide.

From talking with people along bayous all over Southeast Louisiana, it is obvious that the key to the future success of the region lay somewhere in its past. Some of the traditions here have survived over 250 years for good reason: they're robust, meaningful and, most importantly, they work. At the heart of these traditions lays an emphasis on community, and it's in the political, economic and social bonds of the community that lays any hope of this region surviving.

The future could be a tale of the small becoming big again, a tale of leveraging large networks of people to aid the economic health of the individual enterprise, and it could be as simple as traveling to the docks to buy shrimp. Once sold indiscriminately by the pound, the bounty of the region is again becoming defined by quality rather than quantity. The fishermen and shrimpers who can deliver that quality to their loyal groups of consumers will be rewarded. As a society,

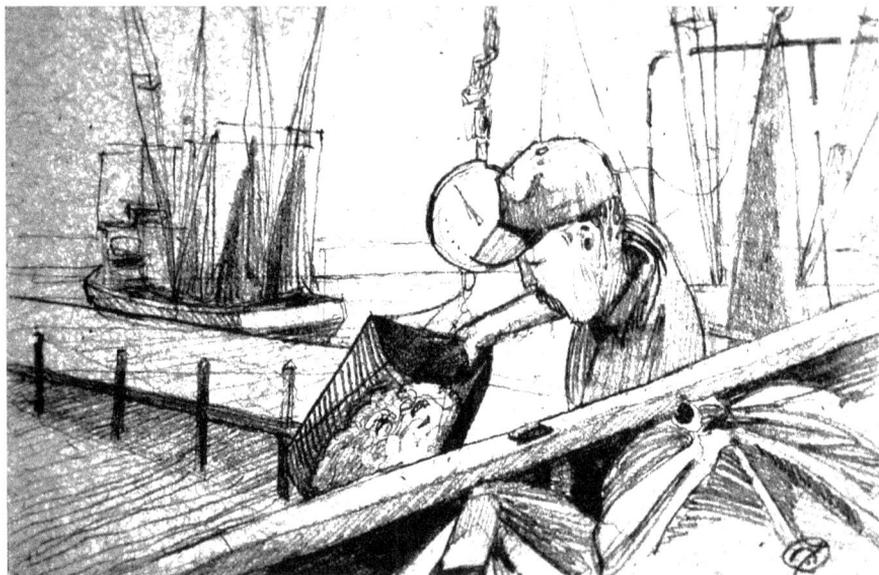

Drawing by Frederick Stivers, 2014.

we are slowly realizing that the commoditization of our traditions weakens them. When we don't have to do the work of building our traditions, we become lazy about them and more willing to outsource the tradition. The grocery store, with its ready, convenient access to prepared food (even pre-boiled crawfish!), serves a valuable purpose for busy people, yes, but when the grocery stores provide the foraging and cooking, and individual families are not, a link in the community between food producers and consumers is severed.

So where did the region go? It went backward in time, back to a time when people bought their food directly from producers. We openly fantasize in the car about a culture where Saturday is spent in line at the docks, waiting for the morning catch to arrive. In those lines, the community would meet and talk about food, about their gatherings and traditions. When the boats came in, money would change hands, directly from shrimp eater to shrimp trawler in exchange for fat, meaty, wild-caught Gulf shrimp. Perhaps friendships would be made, links forged between otherwise disparate groups of people. The seasons would regain importance—shrimp, crawfish, oysters, crabs, all in abundance in the proper time. An industry could be reestablished around a new and

vibrant culture of traditional, local eating. A culture of, for and by food producers in a region flush with food.

Sure, it sounds a bit like a utopia or some anti-corporate propaganda, but in reality it's neither. It's just the Southeast Louisiana way of life. It's a way of life founded centuries ago by simple, poor people around what was readily available. It's a way of life based around people and what those people do to survive and to help each other survive. Everyone lives on the same land, drinks the same water and eats the same food from the same bays. At one time, this was an openly recognized fact, and that time is returning. The sense of Southeast Louisiana as a unique and self-reliant region is growing, and a growing network of people—from university programs to grassroots efforts—is helping the region along on the path to self-reliance.

Ultimately, self-reliance is the key. The culture of Southeast Louisiana can only be preserved from within. While outside parties certainly can do well by documenting the fragile and disappearing customs of the region, they cannot, by definition, rebuild them. The only people who can create Southeast Louisiana traditions, new or resurrected, are the people of Southeast Louisiana, and if they are to succeed—and they will—it will be together, as a community. It's in the swamps and along waterways wide and narrow, accepting the heat of the sun through the golden filters of grass and moss, that we find optimism for Southeast Louisiana. The answer to the myriad problems that face the people here will not come from some great discovery. It will not come from the government or from outside at all; it will come from within, where the answer has always been. Armed with a long history of successes and failures, a great store of communal knowledge, the people of Southeast Louisiana will soldier on, and more, they will prosper as a community, together.

APPENDIX
RECIPES

S ince no book on Cajun food culture would be complete without recipes, we've included instructions for ten of our favorite Southeast Louisiana meals. These recipes mostly come from Addie's family, passed down mainly through her maternal lineage. Most of these are seafood based featuring delicacies like crabs, crawfish, oysters, finfish and shrimp, but we've also got a couple of non-seafood recipes. Enjoy!

SEAFOOD AND SAUSAGE GUMBO

Recipe by Addie K. Martin

Serves 6 to 8

Seafood gumbo is the apex of Cajun delicacy. Use this recipe as a base, and customize it endlessly with whatever meats and seafood you can find.

INGREDIENTS:
1 cup canola oil
1 cup all-purpose flour
4 cups sliced okra (fresh or frozen)

Kosher salt and cayenne pepper to taste

3 cups diced onions (about 2 medium-sized onions)

1 cup diced celery

1 small green bell pepper, diced

¼ cup minced garlic

½ pound smoked sausage, cut into coins

1 pound fresh chicken and duck sausage, casings removed

4 cups shrimp or chicken stock

8 cups water

1 pound shrimp, peeled and deveined

1 cup oysters with liquor

Garnish: 2 cups sliced green onion

METHOD:

- In a large stockpot, heat the oil over medium-high heat. Once the oil is hot, add the flour using a wire whisk.
- Stir the roux constantly for 20 minutes until rich dark brown—do not scorch; if you see black specks, discard and start again. Get the roux as dark as possible before adding in anything else because it's going to come out much lighter than it looks in the pot. As long as you don't have black specks, it is not burnt. You can keep going. It could take longer than 20 minutes depending on the flame you are using.
- Once the roux is at the desired level of darkness, add the okra and a little salt and sauté in the roux for about 15 minutes.
- Add onions, celery, bell pepper and garlic and sauté about 5 minutes or until veggies are sufficiently wilted.
- Add both sausages and blend well into veggies—cook about 2 minutes or so.
- Add in the stock and water slowly, stirring constantly as you add. Keep stirring until everything is mixed well. Adjust seasonings at this time—check salt and pepper.
- Bring the gumbo to a rolling boil then reduce to a simmer and continue to cook for 2 hours. Cover the pot. Stir every so often to make sure the gumbo doesn't stick to the bottom of the pot.
- Fifteen minutes before serving, add in shrimp, oysters and green onions—stir well.
- Serve over cooked rice and with potato salad and French bread.

REDFISH COURT-BOUILLON

Recipe by Mary Chailland, Addie's mother

Serves 4 to 6

This dish is the perfect solution to dealing with a glut of redfish caught during a successful fishing trip. It's a slow-cooking dish, but the resulting robust flavors are worth the wait.

INGREDIENTS:

2 tablespoons olive oil

2 large onions, diced small

2 tablespoons tomato paste

2 6-ounce cans low-sodium tomato sauce

2 15-ounce cans low-sodium crushed tomatoes

½ cup red wine

2 15-ounce cans low-sodium chicken broth

4–5 dashes Crystal hot sauce (or to taste)

½ teaspoon Accent or salt (or to taste)

1 large green bell pepper, very finely chopped

2 ribs tender celery, very finely chopped

½ cup finely chopped parsley

2 tablespoons minced garlic

5 green olives with pimentos, finely chopped

1 bay leaf

1 teaspoon sugar

2 pounds redfish filets, cut into 2- to 3-inch pieces

1 lemon, half cut into wedges and the other half into thin rounds

Salt and black pepper, to taste

METHOD:
- In a large, heavy-bottomed pot, heat the olive oil over medium-high heat. Add the onions and cook down until soft, translucent and browned, about 15 minutes.
- Add the tomato paste, stir well and cook until sizzling.
- Next, add the tomato sauce and the crushed tomatoes. Stir well to combine.
- Cook the mixture to reduce to a thickened tomato sauce and to cook down the water in the tomatoes. The bottom may brown a bit, so be sure to scrape the browned bits off the bottom as you go. Cook for about 30 minutes uncovered until it's a thickened sauce.

- Add red wine, chicken broth, hot sauce and Accent (or salt) then stir well and scrape bottom.
- Next, add the bell pepper, celery, parsley, garlic, olives, bay leaf and sugar. Stir well, cover the pot and cook another 30 minutes until veggies aren't crunchy anymore. Stir often to prevent sticking. When the sauce is done, sample it and adjust salt and pepper as needed to suit your taste.
- While the sauce is cooking, preheat the oven to 350 °F.
- Lay the fish filets in a large glass or ceramic baking dish. Season with a little lemon juice, salt and pepper. Also, place a thin slice of lemon on each piece of fish.
- Remove the bay leaf from the sauce, then carefully pour or ladle the sauce over the fish—the sauce will likely not completely cover the fish, and that's okay.
- Bake for 40 minutes to an hour total. About halfway through the cooking time, turn the fish over and carefully stir up the sauce a bit. Take care to not break up the fish filets.
- Serve hot over white rice with a green salad, French bread and cold, pony-sized Miller beers on the side.

CRAWFISH ÉTOUFFÉE

Recipe by Addie K. Martin

Serves 4 to 6

Crawfish étouffée is a tasty and effective way to use up leftovers from a crawfish boil.

INGREDIENTS:

4 tablespoons unsalted butter

5–7 cups already-cooked crawfish boil "extras" (any combination of cubed potatoes, corn kernels, chopped onions, sliced mushrooms, minced garlic and chopped sausage—keep the items separate, though)

1 quart whole milk

2 10.75-ounce cans of concentrated cream of mushroom soup

2–3 cups crawfish tails (3 cups = 1 pound of tails)

⅓ cup thinly sliced chives or green onions

METHOD:

- In a soup-sized pot, melt butter over medium-high heat. Once the butter is melted, add any sausage, onions or mushrooms. Stir well and allow to heat through, about 3–5 minutes.
- If you have garlic, add it at this point. Stir well and allow to cook for about 1 minute, until fragrant.
- If you have corn kernels, add them, and stir well to incorporate. Cook for another 2–3 minutes until corn kernels are heated.
- Add the milk and cream of mushroom soup. Stir well until thoroughly blended.
- Bring the mixture up to a near boil, but do not let it boil. This can take about 10 minutes or so. Once the mixture is near boiling, lower the heat to keep the étouffée at a simmer.
- Add potatoes, stir well and cook 20 minutes uncovered, stirring occasionally to avoid sticking.
- After 20 minutes, stir in the crawfish and green onions.
- Serve over rice and enjoy.

OYSTER AND ARTICHOKE SOUP

Recipe by Addie K. Martin

Serves 6 to 8

While this soup isn't a traditional Cajun dish per se, it is certainly one that twentieth-century Cajun home cooks would have seen in the Times-Picayune's *recipe section and made at home to impress their husbands and guests.*

INGREDIENTS:
½ cup unsalted butter (2 sticks)
2 cups onions, chopped (one large onion)
1 cup celery, chopped (three celery ribs)
1 cup chopped green onions, tops and bottoms mixed
½ teaspoon kosher salt
¼ teaspoon cayenne pepper
2 tablespoons roughly chopped garlic
2 cans large artichoke hearts, drained, rinsed and chopped with rough outer leaves removed beforehand

2 tablespoons all-purpose flour

1 quart chicken stock

3 dozen oysters with liquor (liquor in a separate container)

1 cup heavy cream

½ cup Parmesan cheese

2 tablespoons finely chopped parsley

METHOD:

- In soup pot, melt butter over medium-high heat.
- Add the onions, celery, green onions, kosher salt and cayenne. Cook until onions are wilted and shiny, about 8 minutes.
- Add garlic and cook until fragrant, about 1 minute.
- Add the artichokes and flour and stir thoroughly to combine. Once the flour and artichokes are stirred in, add the chicken stock and oyster liquor (not the oysters). Stir well to ensure that it's thoroughly mixed and nothing is sticking to the bottom of the pot.
- Bring to a boil and reduce to a simmer until mixture is heated through and thickened a bit. Total cook time here should be about 20 minutes.
- Remove from heat and puree with an immersion blender. Make sure to thoroughly blend all of the artichoke hearts.
- Put the pot back on the stove over medium-high heat. Add the heavy cream, Parmesan cheese, oysters and chopped parsley. Stir well and simmer for another 5 minutes, until heated through and oysters begin to curl at the edges.
- Serve hot.

White Beans and Rice with Fried Fish and Tartar Sauce

Recipe by Tynette Constransitch, Addie's maternal aunt

Serves 6 to 8

This combination plate is a classic Cajun delicacy. Try the white beans and rice with shrimp boulettes instead for an elevated experience.

White Beans

INGREDIENTS:

2 pounds white navy beans

2 pounds salted pork, trimmed of fat and cut into chunks

2 tablespoons vegetable oil

2 onions, finely chopped

2 tablespoons minced garlic

2 tablespoons garlic powder

2 tablespoons onion powder

Kosher salt, to taste

1 pot cooked white rice

1 cup finely chopped fresh parsley

Optional: black pepper, to taste

METHOD:

- Rinse the beans and place in a large pot. Cover with water up to four inches above the beans. Boil for 15 minutes, then drain and rinse the beans.
- While the beans are boiling, add the salted pork to a separate pot with water. Boil the meat for 15 minutes as well to tenderize a bit and boil off excess fat impurities. Drain and rise well.
- Add the vegetable oil to the large pot and heat over a medium-high flame.
- Add the onions and cook until tender and translucent, about 5–7 minutes.
- Add the garlic, garlic powder, onion powder, salted pork, beans and kosher salt (to taste). Cover with water about four inches above the ingredients. Stir well to mix thoroughly.
- Cook over a medium-high flame, uncovered, for an hour and a half to 2 hours, until beans are tender and desired thickness is achieved. Stir occasionally to prevent sticking and to ensure even cooking.
- Cook the rice separately from the beans.
- Once the beans achieve desired tenderness and consistency, stir in the parsley. Allow the beans to cook for 10 more minutes then shut off flame.
- Beans will continue to thicken as they stand.
- Note: If you add black pepper, add it when you add the parsley.

FRIED FISH

WET INGREDIENTS:
3 large eggs
¾ cup whole milk
¼ cup yellow mustard
1 tablespoon garlic powder
1 tablespoon onion powder
1 tablespoon Worcestershire sauce

DRY INGREDIENTS:
1½ cups all-purpose flour
1½ cups yellow cornmeal

2 pounds boneless fish filets, preferably redfish, speckled trout or black drum
2 cups canola oil plus more to replenish as needed
Optional: 1 large onion, cut into large chunks
Seasoned salt like Tony Chachere's (if you prefer heat) or Season All (less heat)

METHOD:
- Combine all the ingredients from the wet ingredients section in a mixing bowl and mix thoroughly until combined. Make this at least 30 minutes ahead of when you plan to use it so that flavors meld properly. Store in the refrigerator until ready to use.
- On a plate or platter, combine the ingredients from the dry ingredients section and mix well to combine.
- Put oil in a heavy-bottomed large skillet and properly heat to 350 °F.
- Take the fish filets one at a time and first dip into the wet ingredient mixture. Next, dredge into the dry ingredients and be sure to coat the fish filet thoroughly. Place coated filets onto a plate or platter prior to frying.
- Once the oil is properly heated, add the fish filets a few at a time, taking care to not overcrowd the skillet. (Side note: If you're cooking a large amount of fish, you can add the chunks of onion to help prevent oil from scorching. Onion can be eaten if desired.)
- Fry the fish filets to a golden brown, about 2–3 minutes per side.
- When done, remove the fish filets and set on a platter or plate lined with paper towels to drain excess oil. Sprinkle with seasoned salt while still fresh from the oil.
- If frying a large amount of fish, already-cooked fish can be kept warm in a low-temperature oven.

TARTAR SAUCE

Recipe by Addie K. Martin

INGREDIENTS:
1 cup mayonnaise, preferably Blue Plate brand
2 tablespoons dill pickle relish
2 tablespoons finely chopped yellow onion
1 tablespoon Creole mustard
1 tablespoon lemon juice
½ teaspoon minced garlic
½ teaspoon kosher salt
¼ teaspoon black pepper

METHOD:
· Add all ingredients in a small bowl and mix well to combine. For best flavor, refrigerate for 30 minutes before using. Double recipe for a large group.

SHRIMP BOULETTES

Recipe by Tynette Constransitch, Addie's maternal aunt

Serves 4 to 6

These deep-fried, puffy shrimp balls make a great appetizer or accompaniment to white beans and rice. Dip them in tartar sauce for an extra-special treat.

INGREDIENTS:
1 small yellow onion, large diced
½ cup peeled waxy potato chunks
1½ pounds raw shrimp (small to medium in size)
¼ cup finely chopped green onion tops
1 tablespoon minced parsley
1 teaspoon garlic powder
1 teaspoon onion powder
1 teaspoon kosher salt
1 large egg, lightly beaten
2 cups canola oil

METHOD:

- Add the onion into the food processor and process until no large chunks remain. Drain off the liquid, then scrape the onion into a mixing bowl.
- Next, process the potato in the food processor until it's also finely chopped (no large pieces remaining). Scrape the potato into the same bowl with the onion.
- Finally, process the shrimp to a paste. No large chunks of shrimp should remain.
- Add the processed onion and potato back into the food processor along with the green onion, parsley, garlic powder, onion powder, kosher salt and lightly beaten egg. Pulse all of it until well mixed. Transfer into a mixing bowl and give it a few stirs to make sure it's uniformly mixed.
- Preheat the canola oil over medium-high heat in a heavy skillet or small fryer. Oil should be properly heated to 350 °F before trying to fry the boulettes.
- Once the oil is properly heated, add the boulette mixture one tablespoon at a time. Don't overcrowd the skillet or pot.
- Cook the boulettes 5–7 minutes total, until golden brown and cooked through. Turn boulettes often to ensure even cooking.
- Drain on a plate or platter lined with paper towels and serve hot.

CRAWFISH FETTUCCINE

Recipe by Tynette Constransitch, Addie's maternal aunt

Serves 4 to 6

This decadent and creamy pasta dish can be prepared with either crawfish or shrimp. Garnish with hot sauce for a spicy kick.

INGREDIENTS:

1½ sticks salted butter

1 medium-sized yellow onion, finely chopped

1 medium-sized green bell pepper, finely chopped

1 pound Velveeta cheese, cubed

2 cups seasoned, already-cooked crawfish tails

12–16 ounces evaporated milk

Optional: 1 teaspoon concentrated crab boil

12 ounces egg noodles or fettuccine noodles

2 tablespoons finely minced fresh parsley

METHOD:
- Melt the butter in a large pot over medium-high heat.
- Add the onions and bell pepper and cook until the onions are tender and slightly browned, about 7–10 minutes. Stir often to prevent sticking and ensure even cooking.
- Add the Velveeta cubes and stir constantly until Velveeta melts uniformly, about 5 minutes. The Velveeta will scorch if not stirred constantly.
- Carefully fold in the crawfish tails a little at a time. Take care to not stir too vigorously so as to not break up the crawfish tails. Stir constantly until uniformly mixed into the cheese sauce.
- Next, add the evaporated milk about 1/4 cup at a time, stirring well after each addition to ensure that the milk can be properly absorbed into the cheese sauce mixture. Adding all the milk at once is not advised. At first add only 12 ounces of evaporated milk. If the sauce isn't at a consistency to your liking, add the last 4 ounces.
- Once the milk is thoroughly mixed in, add the crab boil (if you opt to) and stir once again to mix well.
- Reduce the heat to low and cook 20–30 minutes, until desired thickness is achieved. The cheese sauce will stick a bit, so be sure to stir often.
- While the cheese sauce is cooking, prepare the pasta al dente, according to package directions. Once done, drain and rinse noodles with cold water. Set aside until ready to fold into sauce.
- Once sauce achieves desired thickness, fold in the cooled noodles.
- Garnish with parsley and serve hot.

//

SHRIMP FRICASSEE

Recipe by Joy King Guidry, Addie's sister

Serves 4

Fricassee is the thicker, more decadent cousin of gumbo. The method is similar, but this dish uses much less liquid than a gumbo.

INGREDIENTS:

½ cup flour	1 yellow onion, diced
½ cup extra virgin olive oil	½ green bell pepper, finely chopped

1 tablespoon minced garlic

1 pound raw shrimp, peeled (small to medium-sized)

4 small red potatoes, peeled and cut into large chunks

1 bay leaf

2 teaspoons garlic powder

2 teaspoons onion powder

½ teaspoon celery salt

1 teaspoon kosher salt

½ teaspoon black pepper

1 15-ounce can chicken broth

Pot of cooked jasmine rice (preferably Cajun Country brand)

Optional: 2 whole large eggs (still in shell)

Method:

- In a large pot that you have a lid for, add the flour and then the oil. Make sure the flame is up near high. Whisk vigorously but carefully to smooth out any flour clumps. Continue to whisk pretty constantly and cook for around 15 minutes until dark brown. The color of peanut butter is too light, but chocolate is too dark. Somewhere around dark caramel is preferred.
- Add the onion and bell pepper. Stir to thoroughly combine and then turn the heat down to medium-high. Cook for another 10–15 minutes until the onion and bell pepper are softened. Stir often to ensure even cooking and to prevent any sticking. About 10 minutes into that cooking time, add the garlic. Stir well to combine.
- Next, add the shrimp, potatoes, bay leaf, garlic powder, onion powder, celery salt, kosher salt and black pepper. Stir well to combine.
- Add the can of chicken broth. Add more water if needed until liquid reaches the level of the ingredients. Mix well and continue to cook until it reaches a boil. Lower heat, cover pot and simmer covered for about an hour. Once the potatoes are tender and the fricassee is thickened, it is ready.
- While the fricassee is cooking, proceed to cook the rice on the side.
- If desired, in the last 10 minutes, add the two eggs still in their shell. They will cook in their shell in the fricassee. After 10 minutes, remove the eggs, rinse to cool slightly and then peel the eggs.
- Ladle the fricassee over bowls of white jasmine rice. Quarter the eggs and split among the bowls of fricassee. Serve hot.

Peas in a Roux

Recipe by Joy King Guidry, Addie's sister

This unique side dish is a staple in southern Lafourche Parish, especially in Golden Meadow. Boiled eggs are added as a protein stretcher.

Serves 4 (as a side dish)

Ingredients:

⅓ cup flour
⅓ cup extra virgin olive oil
½ yellow onion, finely chopped
1½ teaspoons minced garlic
2 15-ounce cans petit pois peas, preferably Dubon Premier brand (do not drain)
1 teaspoon garlic powder
1 teaspoon onion powder
Kosher salt and black pepper, to taste
2 whole large eggs (still in shell)
Cooked white rice

Method:

- In a quart-sized pot, add the flour and then the oil. Make sure the flame is up near high. Whisk vigorously but carefully to smooth out any flour clumps. Continue to whisk pretty constantly and cook about 10 minutes until dark brown. The color of peanut butter is too light, but chocolate is too dark. Somewhere around dark caramel is preferred.
- Add the onion and the garlic. Stir to thoroughly combine and then turn the heat down to medium-high. Cook for another 5–7 minutes until the onion is softened. Stir often to ensure even cooking and prevent any sticking.
- Add the two cans of peas (with liquid), garlic powder, onion powder, kosher salt and black pepper. Stir well to combine, then add the two large eggs, still in their shell.
- Bring to a boil, then reduce to a simmer. Cook for about 30 minutes. Add liquid as needed as the sauce dries. It should be saucy. Stir occasionally to prevent sticking and ensure even cooking.
- Cook the rice on the side while the peas and eggs cook in the roux.
- After 30 minutes, carefully remove the eggs, peel and add back to peas. Stir well to coat the eggs.
- Serve the peas over the jasmine rice as a side dish alongside seared fresh green onion sausage, fried seafood or eat as is for an entrée.

BOUILLIE

Recipe by Mary Chailland, Addie's mother

Serves 4 to 6

Bouillie is the quintessential Cajun dessert. It can be eaten alone, baked into sweet tart dough or served over a white or yellow cake. Tastes best when eaten on a Sunday afternoon after having a big pot of seafood gumbo first.

INGREDIENTS:

1 can condensed milk

2 large cans evaporated milk

2 cups whole milk

5 large egg yolks

1 cup granulated sugar

3 heaping tablespoons cornstarch dissolved in 1 cup water

1 stick unsalted butter

1 teaspoon vanilla extract

METHOD:

- In a heavy-bottomed pot, combine the condensed milk, evaporated milk and whole milk. Heat over low heat until simmering.
- In the meantime, whisk together the yolks and sugar in a large mixing bowl. Whisk vigorously until the mixture comes off the whisk in thick ribbons.
- Next, whisk the cornstarch and water mixture into the yolk-sugar mixture. Whisk well to combine.
- Once the milk mixture is simmering, take a ladle of the hot mixture and whisk it vigorously into the sugar and yolk mixture. Add a few more ladles of milk until about half of the milk mixture is added to the yolks.
- Pour all of that back into the pot, stir well and cook until thickened, about 15 minutes. During that time, stir often with a whisk.
- Once it reaches desired consistency, remove from heat and whisk in a stick of butter and the vanilla extract.
- Serve hot either alone or over white cake and with a hot cup of coffee. Note that the bouillie will thicken as it stands.
- Note: If you're making this into tart filling, it should be thicker, so cut back the whole milk from 1 cup to ½ cup.

NOTES

INTRODUCTION

1. Frances Frank Marcus, "Who—or What—Can Contain the Mississippi?" *New York Times*, June 19, 1983, http://www.nytimes.com/1983/06/19/weekinreview/who-or-what-can-contain-the-mississippi.html (accessed May 16, 2014).
2. Marcelle Bienvenu, Carl A. Brasseaux and Ryan A. Brasseaux, *Stir the Pot: The History of Cajun Cuisine.* (New York: Hippocrene Books, 2005), 17.
3. The Weather Channel, "Average Weather for New Orleans, LA—Temperature and Precipitation." http://www.weather.com/weather/wxclimatology/monthly/graph/USLA0338 (accessed February 21, 2014).
4. Ibid.
5. Cally Chauvin, *Lafourche Parish: From the Beginning* (Louisiana State Department of Education Curriculum Resource Unit Bulletin 1834, 2006 Revision), 16.
6. Ibid., 15.
7. Kevin McCaffrey (filmmaker, oral culinary historian and writer), interview by the authors, February 1, 2014.
8. Marcelle Bienvenu (food columnist, cookbook author, chef, instructor), interview by the authors, February 4, 2014.
9. Liz Williams (president, SoFAB Institute), interview by the authors, January 25, 2014.
10. George and Carol Terrebonne (owners of the Seafood Shed), interview by the authors, February 21, 2014.

CHAPTER 2

11. James H. Dormon, *The People Called Cajuns: An Introduction to an Ethnohistory* (Lafayette: The Center for Louisiana Studies, University of Southwestern Louisiana, 1983), 47.

12. Ibid.

13. Ibid.

14. Chauvin, *Lafourche Parish*, 16.

15. Williams interview.

16. Ibid.

17. Ibid.

18. Ibid.

19. Ibid.

20. Donald W. Davis, *Washed Away? The Invisible Peoples of Louisiana's Wetlands* (Lafayette: University of Louisiana at Lafayette Press, 2010), 339.

21. Williams interview.

22. Dormon, *People Called Cajuns*, 11.

23. Ibid.

24. Ibid, 7.

25. Ibid., 21–24.

26. Ibid., 17, 19.

27. Ibid., 20.

28. Bienvenu interview.

29. Dormon, *People Called Cajuns*, 24–25.

30. Ibid., 26.

31. Ibid., 26–27.

32. Ibid., 27.

33. Ibid., 29.

34. Ibid.

35. Charles Reagan Wilson, *Cajun South Louisiana* (Hattiesburg: University of Mississippi, 2004), http://www.southernspaces.org/2004/cajun-south-louisiana (accessed December 18, 2013).

36. Dormon, *People Called Cajuns*, 30.

37. Tim Hebert, "Cajuns in the Nineteenth Century," http://www.acadian-cajun.com/hiscaj3.htm (accessed January 6, 2014).

38. Dormon, *People Called Cajuns*, 33.

39. Ibid., 34.

40. Ibid., 35.

41. Ibid.

42. Ibid., 36.

43. Ibid., 12.
44. Bienvenu, Brasseaux and Brasseaux, *Stir the Pot*, 84.
45. Ibid., 86.
46. Ibid., 88.
47. Dormon, *People Called Cajuns*, 35.
48. Ibid., 59.
49. Bienvenu, Brasseaux and Brasseaux, *Stir the Pot*, 24.
50. Ibid., 66.
51. Ibid., 63.
52. Ibid., 67–68.
53. Williams interview.
54. Bienvenu, Brasseaux and Brasseaux, *Stir the Pot*, 81.
55. Ibid.
56. Ibid.
57. Ibid.
58. Dormon, *People Called Cajuns*, 35.
59. Ibid., 12.
60. Ibid., 38.
61. Ibid., 41.
62. Ibid.
63. Davis, *Washed Away*, 125.
64. Dormon, *People Called Cajuns*, 12.
65. Ibid., 35.
66. Ibid., 34.
67. Ibid., 11.
68. Ibid, 38.
69. Ibid.
70. Ibid.
71. Ibid.
72. Ibid., 37.
73. Ibid.
74. Ibid., 12.
75. Shane K. Bernard, *The Cajuns: Americanization of a People* (Jackson: University Press of Mississippi, 2003), xix.
76. Dormon, *People Called Cajuns*, 44.
77. Ibid., 44, 46.
78. Ibid., 44.
79. Hebert, "Cajuns in the Nineteenth Century."
80. Davis, *Washed Away*, 130.

81. Ibid., 130.
82. Don Davis (director emeritus of oral histories at the Louisiana Sea Grant College Program), interview by the authors, January 27, 2014.
83. Davis, *Washed Away*, 149, 152, 155.
84. Bienvenu interview.
85. Chester Constransitch (family member and amateur genealogist), phone interview with the authors, May 20, 2014. (This story was derived from facts obtained in this interview.)

Chapter 3

86. Bienvenu, Brasseaux and Brasseaux, *Stir the Pot*, 18.
87. Ibid., 19.
88. Ibid., 18.
89. Ibid., 20.
90. Ibid.
91. Ibid., 41.
92. Ibid., 20.
93. Ibid., 20–21.
94. Ibid., 21.
95. Ibid., 22.
96. Bienvenu interview.
97. Bienvenu, Brasseaux and Brasseaux, *Stir the Pot*, 128.
98. Dormon, *People Called Cajuns*, 37, 47.
99. Marcelle Bienvenu, "The History of Cajun & Creole Cuisine: America's True Melting Pot." (Lecture given at Nicholls State University, Thibodaux, LA, date unknown.)
100. Ibid.
101. Bienvenu, Brasseaux and Brasseaux, *Stir the Pot*, 129.
102. Ibid., 130.
103. Ibid., 131.
104. Ibid., 134.
105. Bienvenu interview.
106. Bienvenu, Brasseaux and Brasseaux, *Stir the Pot*, 23.
107. Ibid., 24.
108. Ibid., 24–25.
109. McCaffrey interview.
110. Bienvenu interview.

111. Bienvenu, Brasseaux and Brasseaux, *Stir the Pot*, 70.
112. Ibid., 25.
113. Ibid., 65.
114. Ibid., 22.
115. Ibid., 70.
116. Ibid., 72.
117. Ibid., 75.
118. Ibid., 111. (All examples are from this page.)
119. Ibid., 112.
120. Ibid., 18–19.
121. *No One Ever Went Hungry*, DVD, executive producer Kevin McCaffrey (New Orleans, LA: e/Prime Media, 2011).
122. Bienvenu, Brasseaux and Brasseaux, *Stir the Pot*, 117.
123. Davis, *Washed Away*, 217.
124. Bienvenu, Brasseaux and Brasseaux, *Stir the Pot*, 118–19, 121. (All examples come from these pages.)
125. McCaffrey interview.
126. Ibid.

Chapter 4

127. Dormon, *People Called Cajuns*, 51.
128. Ibid., 52.
129. Wilson, "Cajun South Louisiana."
130. Bernard, *Cajuns*, xx.
131. Ibid.
132. Bienvenu, Bienvenu and Brasseaux, *Stir the Pot*, 28.
133. Ibid., 64.
134. Ibid., 65.
135. Ibid., 182.
136. Ibid.
137. Wilson, "Cajun South Louisiana."
138. Ibid.
139. Ibid.
140. Dormon, *People Called Cajuns*, 55.
141. Ibid., 56.
142. Ibid., 57.
143. Ibid.

144. Ibid., 63.

145. Ibid.

146. Ibid.

147. Ibid., 65.

148. Ibid., 64–65.

149. Davis interview.

150. Bienvenu, Brasseaux and Brasseaux, *Stir the Pot*, 36.

151. Ibid., 37.

152. Laura Landry, "Shrimping in Louisiana: Overview of a Tradition," Louisiana Folklife Program, 1990, http://www.louisianafolklife.org/LT/Articles_Essays/creole_art_shrimping_overv.html (accessed December 13, 2013).

153. Chauvin, *Lafourche Parish*, 62.

154. Davis, *Washed Away*, 303.

155. Landry, "Shrimping in Louisiana."

156. Davis interview.

157. Davis, *Washed Away*, 314.

158. Ibid., 318.

159. Ibid.

160. Ibid., 316.

161. Ibid., 307.

162. Ibid., 299.

163. Davis interview.

164. Davis, *Washed Away*, 319.

165. Chauvin, *Lafourche Parish*, 62.

166. Davis, *Washed Away*, 299.

167. Terrebonnes interview.

168. Ibid.

169. Davis, *Washed Away*, 311.

170. Chauvin, *Lafourche Parish*, 62.

171. Ibid.

172. Davis, *Washed Away*, 300.

173. Ibid., 323.

174. Williams interview.

175. Ibid.

176. Davis, *Washed Away*, 313.

177. Ibid.

178. Tom Hymel (seafood industry development director for LSU AgCenter and Louisiana Sea Grant), interview by the authors, January 17, 2014.

179. Ibid.

180. McCaffrey interview.

181. Hymel interview.

182. Forest A. Deseran and Carl Riden, *Louisiana's Oystermen...Surviving in a Troubled Industry* (Baton Rouge: Louisiana Sea Grant College Program, 2000), 2.

183. Louisiana Seafood Promotion Marketing Board, "History: Louisiana Oysters," http://louisianaseafood.com/why-buy-louisiana/historia/historia-louisiana-oysters (accessed December 12, 2013).

184. Davis, *Washed Away*, 339.

185. Ibid.

186. Deseran and Riden, *Louisiana's Oystermen*, 2.

187. Davis, *Washed Away*, 339–40.

188. Ibid., 341.

189. Ibid.

190. Ibid., 333.

191. Ibid.

192. Ibid., 335.

193. Nick Collins (oysterman and co-owner of Collins Oyster Company), interview by the authors, February 2, 2014. (This paragraph and the next four are based on information gathered at that interview.)

194. Davis interview.

195. Davis, *Washed Away*, 384.

196. Ibid.

197. Ibid.

198. Ibid.

199. Ibid., 387.

200. Ibid., 385.

201. Ibid.

202. Ibid.

203. Ibid., 386.

204. Louisiana Crawfish Promotion and Research Board, "History," http://www.crawfish.org/history.html (accessed March 6, 2014).

205. Ibid.

206. Bienvenu, Brasseaux and Brasseaux, *Stir the Pot*, 26–27. (All facts in this paragraph are derived from this book.)

207. Louisiana State University Agricultural Center, *Crawfish Production Manual* (Baton Rouge: Louisiana Cooperative Extension Service, 2007), 2.

208. Ibid.

209. Kate Carpenter, "A Brief History of Crawfish Farming in Louisiana," Louisiana State University AgCenter, 2014, http://www.lsuagcenter.com/en/our_offices/research_stations/Aquaculture/Features/extension/Classroom_Resources/History+of+Crawfish+Aquaculture+in+Louisiana.htm (accessed March 6, 2014).

210. Ibid.

211. *No One Ever Went Hungry*.

212. Bienvenu interview.

213. LSU AgCenter, *Crawfish Production Manual*, 1.

214. Ibid.

215. Ibid.

216. Ibid., 3.

217. Ibid.

218. Louisiana Seafood Promotion Board, "History: Louisiana Saltwater Finfish," http://louisianaseafood.com/why-buy-louisiana/historia/historia-louisiana-saltwater-finfish (accessed December 13, 2013).

219. Ibid.

220. Ibid.

221. Jim Gossen (founder and chairman of Sysco Louisiana Seafood, LLC), interview by the authors, January 29, 2014.

222. Bernard, *Cajuns*, 116.

223. Dormon, *People Called Cajuns*, 66.

224. Bienvenu, Brasseaux and Brasseaux, *Stir the Pot*, 28.

225. Dormon, *People Called Cajuns*, 68.

226. Bernard, *Cajuns*, xvii.

227. Dormon, *People Called Cajuns*, 69.

228. Ibid., 70.

229. Ibid., 71–72.

230. Ibid.

231. Ibid.

232. Bernard, *Cajuns*, xviii.

233. Davis interview.

234. Ibid.

235. Ibid.

236. Bienvenu, Brasseaux and Brasseaux, *Stir the Pot*, 37.

237. Ibid.

238. Ibid., 49.

239. Davis interview.

240. Ibid.

241. Ibid.
242. Ibid.
243. Ibid.
244. Ibid.
245. Ibid.
246. Ibid.
247. Ibid.
248. Ibid.
249. Davis, *Washed Away*, 200.
250. Ibid.
251. Ibid., 203.
252. Chauvin, *Lafourche Parish*, 68.
253. Davis, *Washed Away*, 434.
254. Ibid.
255. Chauvin, *Lafourche Parish*, 69–70.
256. Davis, *Washed Away*, 434.
257. Wilson, "Cajun South Louisiana."
258. Ibid.
259. University of Minnesota, "Washed Away? The Invisible People of Louisiana's Wetlands: A Talk by Don Davis," https://events.umn.edu/007005 (accessed January 6, 2014).
260. Davis, *Washed Away*, 131.
261. Ibid.
262. Ibid.
263. Terrebonnes interview.
264. Ibid.
265. Bernard, *Cajuns*, 38.
266. Bienvenu, Brasseaux and Brasseaux, *Stir the Pot*, 58.
267. Dormon, *People Called Cajuns*, 74.
268. Davis, *Washed Away*, 143.
269. Bernard, *Cajuns*, 5.
270. Ibid., 15.
271. Dormon, *People Called Cajuns*, 74.
272. Davis, *Washed Away*, 143.
273. Bernard, *Cajuns*, 25.
274. McCaffrey interview.
275. Bernard, *Cajuns*, 33.
276. Ibid., 18.
277. Dormon, *People Called Cajuns*, 75.

278. Terrebonnes interview.
279. Bienvenu, Brasseaux and Brasseaux, *Stir the Pot*, 82.
280. Ibid.
281. Ibid., 81–82.
282. Bienvenu interview.
283. Terrebonnes interview.
284. Bernard, *Cajuns*, 47.
285. Ibid., 48.
286. Ibid., 36.
287. Bienvenu, Brasseaux and Brasseaux, *Stir the Pot*, 28, 52.
288. Ibid., 29.
289. Ibid.
290. Ibid.
291. Ibid., 96.
292. Ibid., 97.
293. *No One Ever Went Hungry*.
294. Bienvenu, Brasseaux and Brasseaux, *Stir the Pot*, 97.
295. Ibid., 98.
296. Ibid., 98–99.
297. Ibid., 30.
298. McCaffrey interview.
299. Bienvenu, Brasseaux and Brasseaux, *Stir the Pot*, 108–9.
300. Ibid., 30.
301. Bienvenu interview.

Chapter 6

302. Ibid.
303. Rudy King (family member), interview by the author, May 22, 2014. (This story was derived from facts obtained in this interview.)

Chapter 7

304. Terrebonnes interview.
305. Bernard, *Cajuns*, xxii.
306. Dormon, *People Called Cajuns*, 80.
307. Ibid.

308. Bernard, *Cajuns*, 87.
309. Ibid.
310. Dormon, *People Called Cajuns*, 89.
311. Bernard, *Cajuns*, 81.
312. McCaffrey interview.

CHAPTER 8

313. Collins interview.
314. Terrebonnes interview.
315. *No One Ever Went Hungry*.
316. Bienvenu, Brasseaux and Brasseaux, *Stir the Pot*, 56–57.
317. Ibid., 56.
318. Lee Darce, e-mail messages to the author, February 21–26, 2014.
319. Breaux Bridge Crawfish Festival website, http://www.bbcrawfest. com/index.html, and Louisiana Crawfish Festival website, http:// louisianacrawfishfestival.com/food/ (both accessed June 9, 2014).
320. Bienvenu, Brasseaux and Brasseaux, *Stir the Pot*, 125.
321. *No One Ever Went Hungry*.
322. Bienvenu interview.
323. Ibid.
324. Terrebonnes interview.
325. Bienvenu, Brasseaux and Brasseaux, *Stir the Pot*, 28–29.
326. Ibid., 176.
327. Williams interview.
328. McCaffrey interview.
329. Bienvenu, Brasseaux and Brasseaux, *Stir the Pot*, 29, 47.
330. Ibid., 30.
331. Ibid., 31.

CHAPTER 9

332. Hymel interview.
333. Davis interview.
334. Ibid.
335. Terrebonnes interview.
336. Gossen interview.

337. Brian Landry (executive chef at Borgne restaurant), interview by the authors, February 6, 2014.

338. Tom Hymel, "Louisiana Seafood Industry Education and Value-Added Programs," (Lecture given at the annual Louisiana Fisheries Summit, Houma, LA, March 13, 2014.)

339. McCaffrey interview.

340. Hymel interview.

341. Ibid.

342. Ibid.

343. Hymel, "Seafood Industry Education."

344. Hymel interview.

345. Ibid.

346. Williams interview.

347. Hymel interview.

348. Ibid.

349. Don Schwab, "State of the Shrimp Industry." (Lecture given at the annual Louisiana Fisheries Summit, Houma LA, March 12, 2014.)

350. Gossen interview.

351. Schwab, "Shrimp Industry."

352. Gossen interview.

353. Ibid.

354. Ibid.

355. Davis interview.

356. Kevin Voisin, "State of the Crab Industry." (Lecture given at the annual Louisiana Fisheries Summit, Houma, LA, March 12, 2014.)

357. Ibid.

358. Landry interview.

359. Ibid.

360. Darren Bourgeois, "Best Practices for Producing High Quality Seafood in Louisiana." (Lecture given at the annual Louisiana Fisheries Summit, Houma, LA, March 12, 2014.)

361. Louisiana Seafood Promotion Marketing Board, "Certified Louisiana Seafood Is the Best Seafood," http://certified.louisianaseafood.com/ (accessed April 17, 2014).

362. Bourgeois, "Best Practices."

363. Hymel, "Seafood Industry Education."

364. Ibid.

365. Hymel interview.

366. Tom Hymel, e-mail messages to author, May 19, 2014.

367. Hymel, "Seafood Industry Education."
368. Louisiana Department of Wildlife and Fisheries, *We Manage Fisheries*, printed brochure (Baton Rouge, 2012).
369. Schwab, "Shrimp Industry."
370. Ibid.
371. Voisin, "Crab Industry."
372. Gossen interview.
373. Hymel interview.
374. Ibid.
375. Ibid.
376. *No One Ever Went Hungry.*
377. Williams interview.
378. Ibid.
379. Terrebonnes interview.
380. Ibid.
381. Ibid.
382. Schwab, "Shrimp Industry."
383. Gossen interview.
384. Collins interview.
385. Gossen interview.
386. Gulf Wild, "FAQ Page," http://www.mygulfwild.us/GW/faq/ (accessed May 21, 2014).
387. Gossen interview.
388. Ibid.
389. Ibid.
390. Terrebonnes interview.
391. Gossen interview.
392. Ibid.
393. Ibid.
394. Landry interview.
395. Ibid.
396. Ibid.
397. Ibid.
398. McCaffrey interview.
399. Davis interview.
400. Ibid.
401. Ibid.
402. Ibid.
403. Louisiana Department of Wildlife and Fisheries, *We Manage Fisheries*.

404. Chauvin, *Lafourche Parish*, 15.

405. American Public Media, "Can the Plan to Save the Coast Really Work?" http://americanradioworks.publicradio.org/features/wetlands/plan1.html (accessed January 6, 2014).

406. Davis interview.

407. Ibid.

408. Louisiana Department of Wildlife and Fisheries, *We Manage Fisheries*.

409. Gossen interview.

410. Ibid.

411. Hymel interview.

412. Williams interview.

INDEX

ABOUT THE AUTHORS

Addie K. Martin is a writer and blogger whose work focuses on food and culture writing. Using what she learned earning her bachelor's degree in culinary arts, she publishes Culicurious, and in partnership with husband Jeremy, they publish Culture Curious, an experiential travel blog. Addie enjoys reading, cooking, researching and writing about her experiences in food, life and travel.

Jeremy Martin is an engineer and writer living a double life in New Orleans. By day the left side of Jeremy's brain is absorbed in calculations and constructions, but by night the right side of his brain comes to life, exploring history, culture, travel, literature and poetry in his writing. He runs the travel website Culture Curious with his wife, Addie, and maintains his own blog at The Restless Lens. Jeremy is actively engaged in the journey to discover the ideal balance between the left and the right sides of his brain; the fun part is finding it.

www.ingramcontent.com/pod-product-compliance
Lightning Source LLC
Chambersburg PA
CBHW070346100426
42812CB00005B/1439